THIS IS NO DREAM

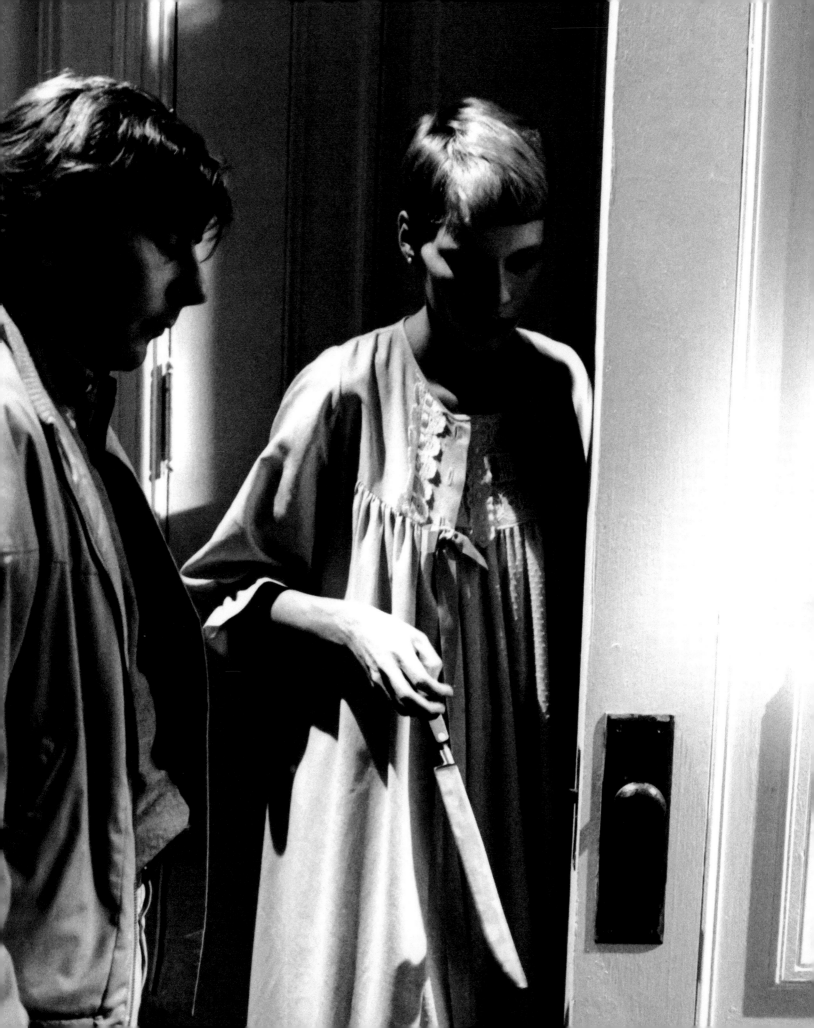

THIS IS NO DREAM
making rosemary's baby

JAMES MUNN BOB WILLOUGHBY

REEL ART PRESS

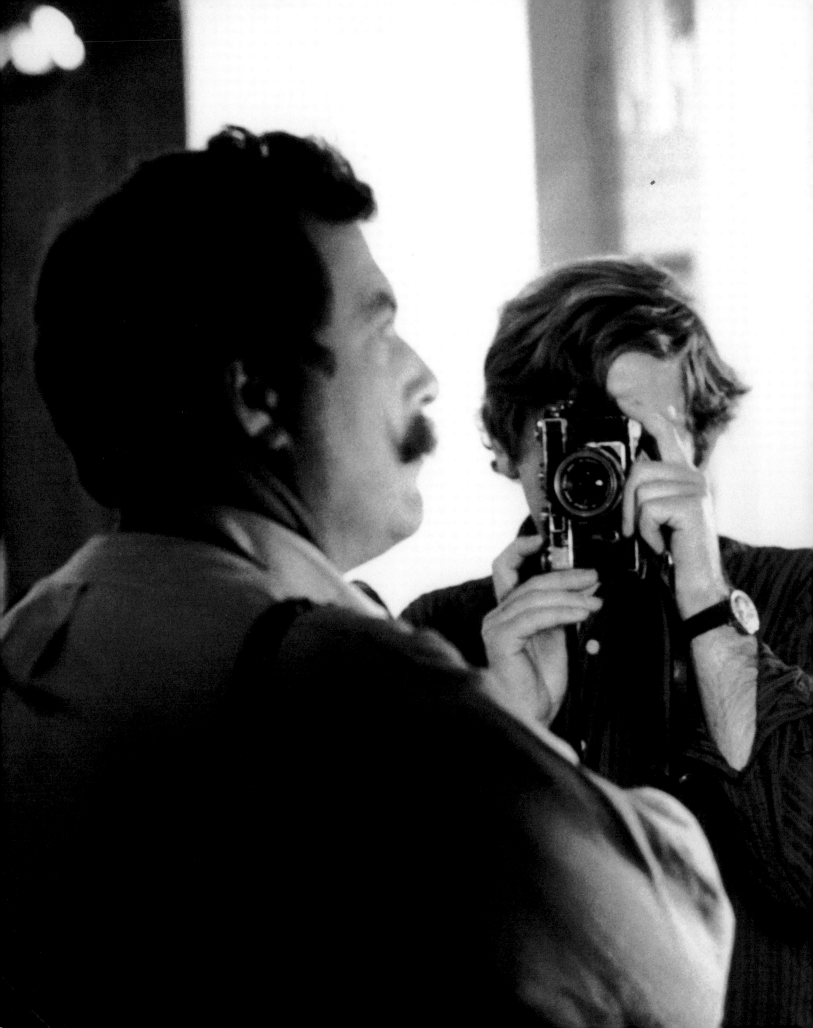

If you're an audience member or a movie critic, you sit in a dark cinema and pray for a fascinating tale expertly told. If you are a producer, director, screenwriter or performer, you pray for a well-received and financially successful film. On June 12, 1968, prayers were answered: *Rosemary's Baby* hit American theaters.

It began with author Ira Levin, who was struck with the idea that "a fetus could be an effective horror if the reader knew it was growing into something malignly different from the baby expected." He set his story in present day Manhattan, he made the mother-to-be a young woman who had just moved into a mysterious apartment building with her actor husband, and he had the baby's father just happen to be the devil incarnate. And with that, *Rosemary's Baby* was born. For the bulk of 1967, Levin's novel rested comfortably near the top of many a bestseller list. It was practically a given that a movie version would be made and, by August 1967, cameras were ready to roll.

This Is No Dream: Making Rosemary's Baby is an illustrated history of the classic horror film, from director and casting choices to the kudos and condemnation it received upon its release. Along the way, director Roman Polanski fell deeply behind schedule while producers William Castle and Robert Evans fought to keep him from being fired. In addition, star Mia Farrow faced an ultimatum from husband Frank Sinatra—career or marriage—while method actor John Cassavetes nearly came to blows with his fiercely disciplined director. And Bob Willoughby captured it all.

Among other things, this book is a showcase for the work of Willoughby, a veteran set photographer who shot for such movies as *Ocean's 11* (1960), *My Fair Lady* (1964), *Who's Afraid of Virginia Woolf?* (1966) and *The Graduate* (1967) and counted Audrey Hepburn, the Rat Pack and various jazz greats among his most frequent subjects.

In the end, *Rosemary's Baby* is a film where a veteran B-movie producer/director, a hot-shot studio executive early in his career, a Polish director making his first American feature and a television actress looking to make her mark in motion pictures all seized a fresh opportunity—and achieved monstrous success.

This is the story.

Roman Polanski shoots Bob Willoughby.

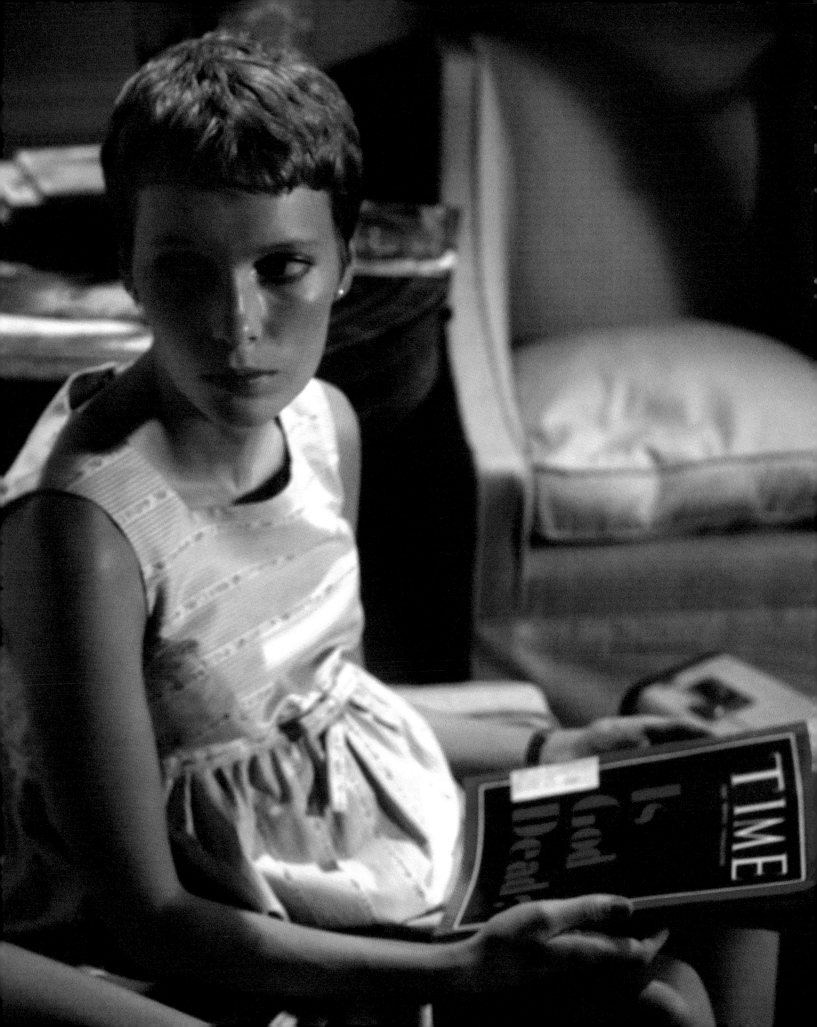

WRITER James Munn

SPECIAL PHOTOGRAPHER Bob Willoughby

FOREWORD Taylor Hackford

EDITOR Tony Nourmand

ART DIRECTION AND DESIGN Graham Marsh

PAGE LAYOUTS Jack Cunningham

TEXT EDITOR Alison Elangasinghe

EDITORIAL ASSISTANT Rory Bruton

CONTENTS

ROSEMARY'S SPELL

Making actions ambiguous, keeping situations real.

My first Roman Polanski movie, *Knife in the Water* (1962), captured me totally–a unique cinematic vision by an unknown, 28-year-old Pole from Communist Europe that was so provocative it made American films I saw in the early sixties seem vapid and old fashioned. With only three characters on a boat in the middle of a lake, he was able to keep me transfixed with his unsettling camera angles and underlying sexual tension. By pitting the impotency of comfortable middle-class privilege against the wanton desire of rebellious youth, he seemed to be predicting the explosion of social unrest that followed in the next decade.

I immediately became a Polanski fan and voraciously consumed his subsequent UK debut, *Repulsion* (1965), and his follow-up, *Cul-De-Sac* (1966), both critically acclaimed. His fourth feature, *Dance of the Vampires* (1967), was picked up for US distribution by MGM, but that studio's decision to market the film as a full-blown comedy with a new title, *The Fearless Vampire Killers*, was a mistake, and the film suffered both critically and commercially. However, I loved Roman's satirical take on this old vampire genre, and I still believe Jack MacGowran's Professor Abronsius to be one of the great unrecognized comedic performances.

Hollywood has always gone overseas to import talented directors, so I was not surprised in 1967 when Paramount gave this feisty Eastern European upstart an assignment to write and direct Ira Levin's bestseller *Rosemary's Baby*. Both Paramount's Robert Evans and horror genre producer William Castle have taken credit for choosing Roman, but it couldn't have been much of a stretch–he'd already mined this territory brilliantly in *Repulsion*. Roman adapted the novel faithfully, cannibalizing

Levin's dialogue for his script, but where he was truly inspired was in his casting. Mia Farrow was not then a movie star–she was best known for a role on the TV series *Peyton Place* (and as Frank Sinatra's extremely young wife), but Roman transformed her into a compelling and sympathetic presence as Rosemary. By telling the story from this waif-wife's point of view, he forced the audience to join her step-by-step descent into paranoia until we, too, are consumed by dread and horror when she finally discovers the horrible truth.

What made the film work for me was Roman's visual restraint: making actions ambiguous, keeping situations real, refusing to reveal the twist until the very end. His conspirators are not ghouls and ogres but quirky New Yorkers who we recognize and sympathize with: John Cassavetes as a frustrated New York actor, realizing that his dreams of a successful career are expiring. (Polanski's choice of this actor/director was prescient, because the camera sees behind his smiling, sympathetic demeanor to reveal the incredibly smart and ambitious artist that Cassavetes was, driven to extremes to actualize his ambition.) Ruth Gordon and Sidney Blackmer as their nosey neighbors in the Dakota were another piece of inspired casting. (Roman played up their comedic qualities, which deflected away the scent of suspicion.)

I was most impressed with Roman's ability to take mundane, everyday situations and skew them ambiguously so that the audience member who hadn't read the novel didn't know whether Rosemary's pre-natal visions were supernatural or imagined. It was amazing that they didn't catch on sooner. And then, when the horrible truth is finally revealed, Polanski, ever the provocateur, makes us re-evaluate our puritan perceptions

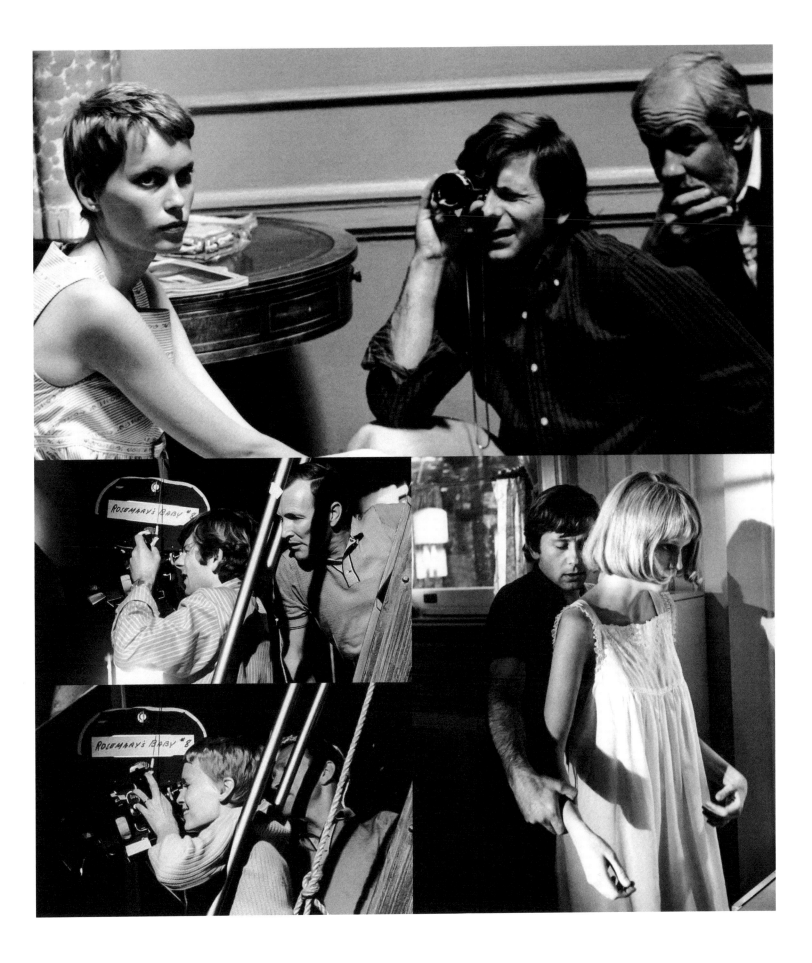

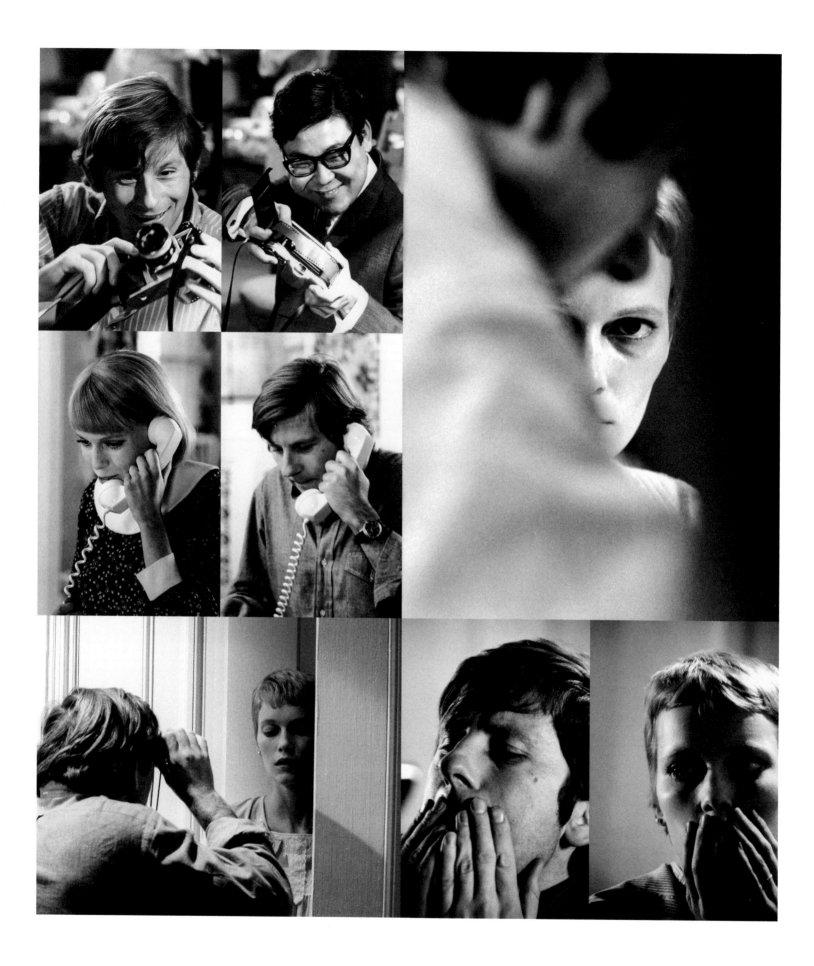

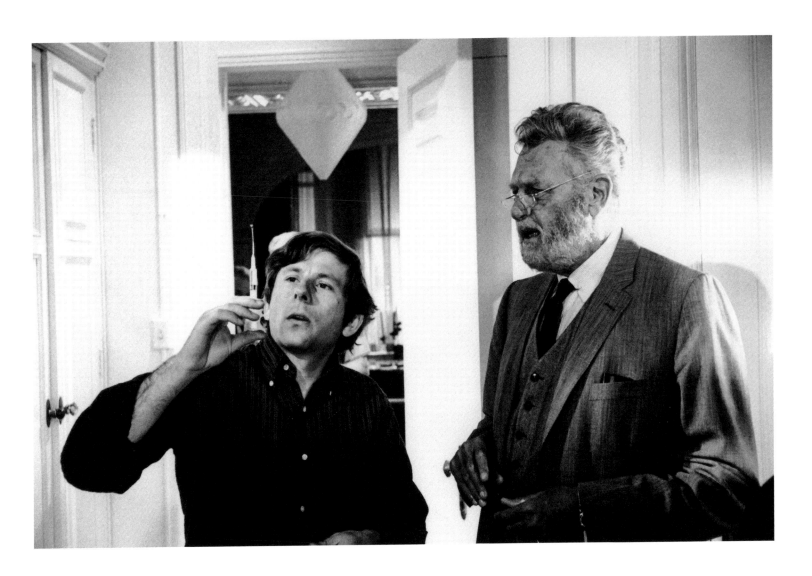

of morality by having mother love triumph over our Christian obsession with destroying the devil.

I saw *Rosemary's Baby* once, enjoyed it and then filed it away in my memory as another great Polanski film. Years passed, during which I pursued my own career as a feature filmmaker. In 1998, I read a draft of *The Devil's Advocate*, an adaption of a bestselling novel that Warner Bros. had been trying to make for years. I certainly wasn't knocked-out by what I read—monsters started appearing on page five and reappeared frequently throughout. There was no subtlety or nuance in that script. However, I liked the premise of using the legal profession as a modern metaphor for the moral corruption of our society. I approached my friend, Tony Gilroy, with whom I'd worked on *Dolores Claiborne* (1995), to come aboard to write a "page one revision," but he demurred: "It's just another devil movie."

I argued, "This is an opportunity to create a stylized satire on the wholesale narcissism of our culture at the end of the 20th century." He was intrigued and finally came aboard.

We screened various supernatural devil movies, but nothing inspired us. We wanted this story to be a moral tale, not a monster movie. Then I remembered *Rosemary's Baby* and Roman's refusal to reveal the twist until the very end of the film. He kept the story and characters real, sucking the audience into Rosemary's point of view until it was too late to escape. This became our inspiration for *The Devil's Advocate*—not Roman's visual style or *mise-en-scéne*, but his control of what the audience knows, taking them on a journey, building suspense and dread until a final, shocking revelation.

Taylor Hackford

THE STORY

A young couple, Guy and Rosemary Woodhouse, move into their dream apartment in the Bramford, a Manhattan apartment building with a reputation for sinister goings-on. In the building's laundry room, Rosemary meets Terry, who is staying with Minnie and Roman Castevet, an elderly couple living down the hall from Guy and Rosemary. Rosemary's friend Hutch tells her and Guy of the rumors surrounding the building and its connection to witchcraft.

After Terry's mysterious and fatal fall from an upstairs window, the Woodhouses begin spending time with the Castevets. Since meeting with the Castevets, Guy lands a choice acting role he had previously lost to fellow thespian Don Baumgart, who subsequently went blind and had to withdraw. Guy feels he is neglecting Rosemary due to his new acting job and showers her with roses, helpfully adding, "Let's have a baby."

An evening of insemination is carefully planned: a lit fireplace, soft music, a romantic dinner. Minnie drops by to deliver dessert, a chocolate mousse that Rosemary thinks has "a chalky undertaste." A dizzy Rosemary is taken to bed by Guy, where she experiences hallucinations (or a drugged-induced version of reality) in which she is raped by the devil. The morning after, Rosemary finds scratches on her body that Guy blames on his long fingernails. She is taken aback that, while she was unconscious, Guy went ahead with their "baby night."

Rosemary sees Dr. Hill, who confirms that she is pregnant. Rosemary tells Guy, and Guy insists on immediately telling the Castevets, with Minnie suggesting that Rosemary change doctors and see a Dr. Sapirstein instead. Sapirstein prescribes a health drink, made by Minnie, that Rosemary takes daily. But Rosemary soon begins to experience pain and fears that something is wrong with the baby. Hutch, shocked at her gaunt appearance, asks to meet her the following day in front of the Time & Life Building so he can impart some important information to her. Hutch never shows up, and it is learned that he has suddenly taken ill and has slipped into a coma. A few weeks later, Rosemary decides she wants to have a party and invite only her friends, not the Castevets ("You have to be under sixty to get in."). Her girlfriends beg her to see another doctor, Rosemary argues with Guy about it, and suddenly her pain stops.

Returning to a more healthy state, Rosemary begins to plan

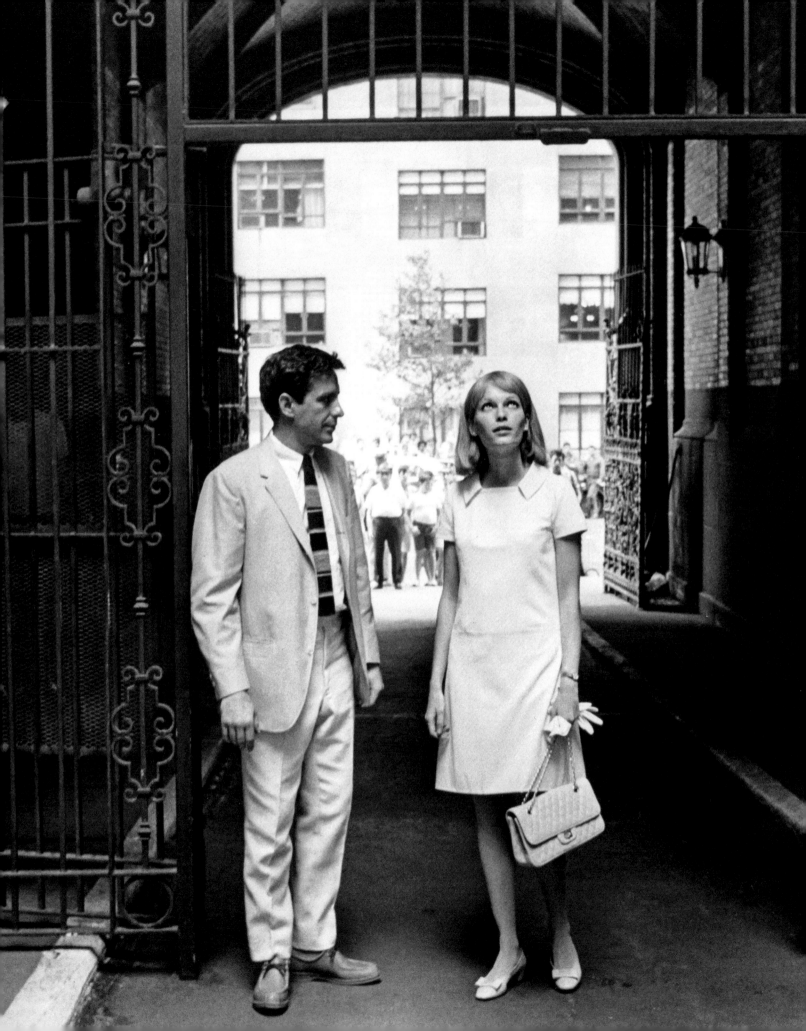

for the birth by packing a suitcase for the hospital and buying various baby items. She gets a call that Hutch has died and, at his funeral, his secretary Grace gives her a book that Hutch intended to give Rosemary, stating that a name in the book, or possibly the name *of* the book, is an anagram. Rosemary learns that Minnie's husband Roman is from a family of witches and expresses her wild fears to Dr. Sapirstein, who calms her down and tells her that Roman is dying and the Castevets will be leaving on vacation sometime before Rosemary's due date.

Rosemary continues to read up on witches and witchcraft, slowly convincing herself that a coven of witches resides in the Bramford and that they have their sights on her baby. She runs to Dr. Hill to tell him her theories. While she is resting, content that she is safe at last, Dr. Hill calls Guy and Dr. Sapirstein to come and take her home. Back at the apartment building, Rosemary bolts and runs back to the apartment and locks herself in. The coven enters the apartment anyway and subdues her just as she is beginning to go into labor.

In a dream, Rosemary gives birth to a healthy baby boy. In reality, she is told by Guy and Dr. Sapirstein that her infant has died. After hearing a baby cry through the apartment walls, Rosemary investigates to find that the coven, assembled in the Castevet apartment, has taken Rosemary's baby and is celebrating its birth—the birth of the son of Satan. Her horror at the situation gradually falls away and motherly instincts take its place. Rosemary looks down at her baby, seeming to accept the responsibility of raising the child.

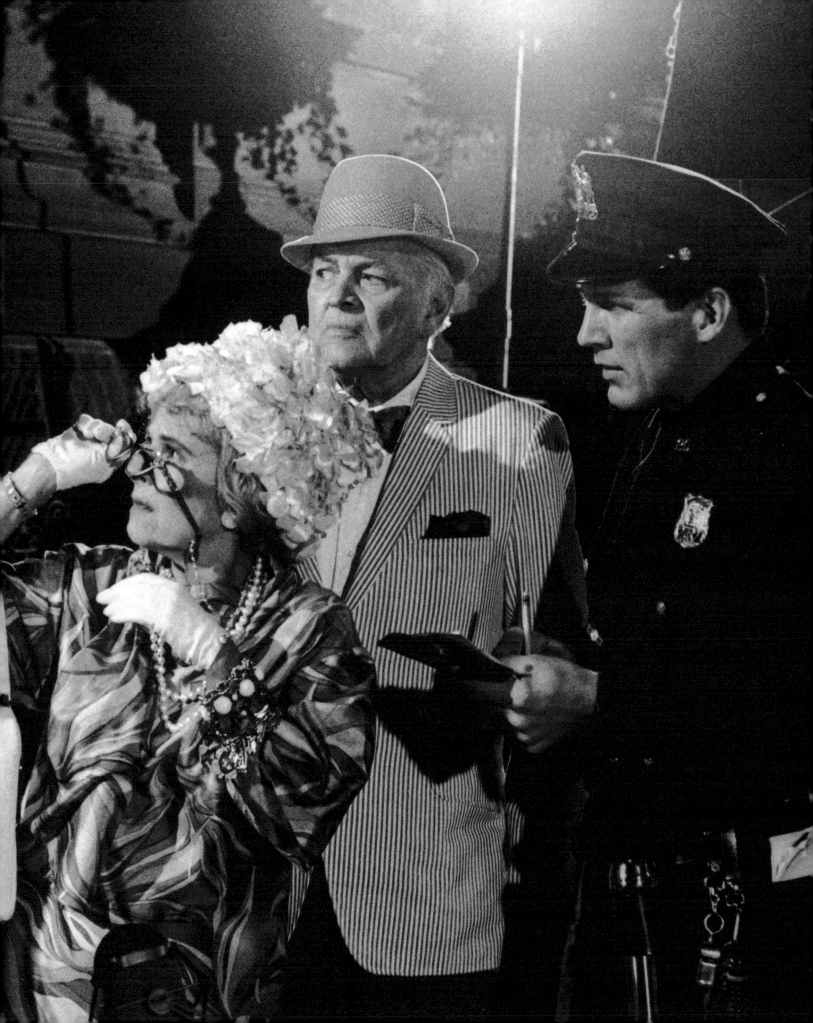

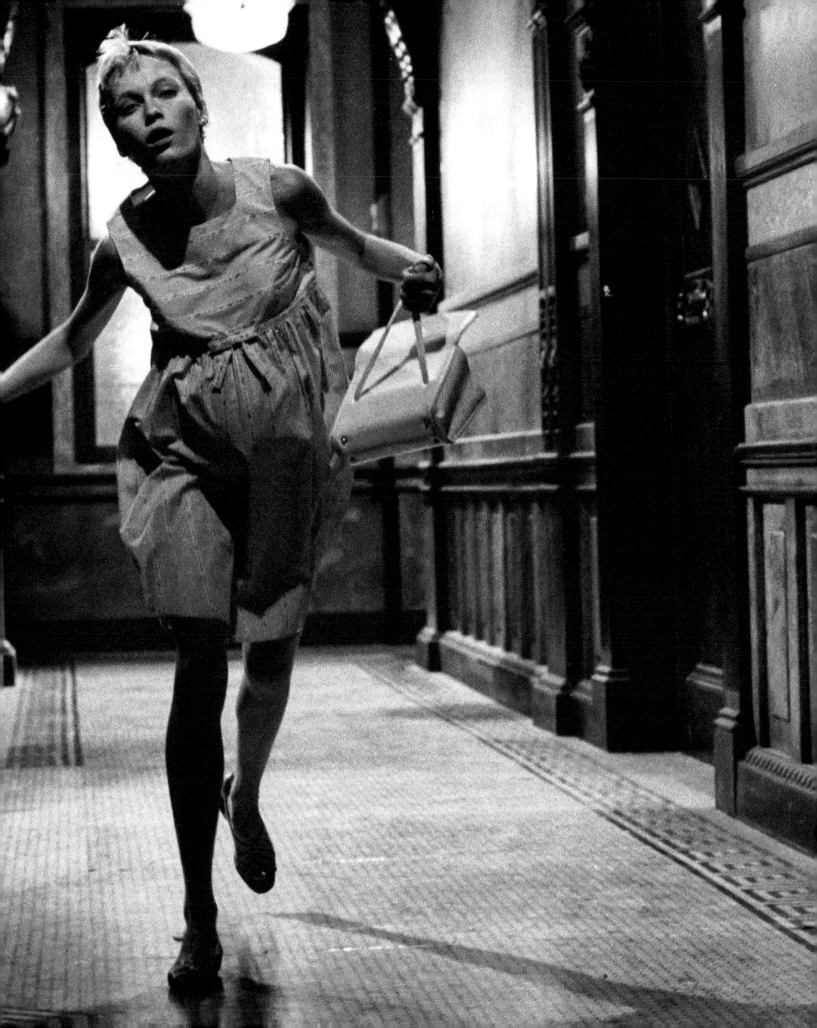

THE NOVEL

I always felt that pregnant women really shouldn't read the book.

"Every novel he has ever written has been a marvel of plotting," wrote horror novelist Stephen King about author Ira Levin. "He is the Swiss watchmaker of the suspense novel; in terms of plot, he makes what the rest of us do look like those five-dollar watches you can buy in the discount drugstores."

Levin's fiction is characterized by extraordinary evil in ordinary settings: suburban wives turned into submissive androids, a clean-cut war veteran who becomes a serial killer, 94 Hitler clones unleashed on the modern world and an unsuspecting young woman carrying the son of Satan. The world of these characters is familiar and commonplace, while its sinister threats grow from low-pitched to lethal.

Ira Levin began his professional writing career with a 30-minute television script he submitted to CBS, which was holding a contest for college seniors. Though Levin, then an NYU student, did not win, CBS at least thought his runner-up effort was commercially promising, thereby prompting the fledgling writer to find an agent and sell it to NBC. More teleplays followed—some produced and aired, some not—before the then-22-year-old Levin decided to write his first novel, *A Kiss Before Dying*, released by Simon & Schuster in 1953.

Levin's tale of a young, charming, seemingly wholesome killer was an auspicious achievement—a commercial success as well as a critical triumph. Anthony Boucher, in his review for *The New York Times*, called it "an architecturally perfect plot of multiple murder so rich in legitimate surprises that the slightest hint here of its development might mar your pleasure ... Levin combines great talent for pure novel writing—full-bodied characterization, subtle psychological exploration, vivid evocation of locale—with strict technical whodunit tricks

as dazzling as anything ever brought off by Carr, Rawson, Queen or Christie." *A Kiss Before Dying* would earn Levin the 1954 Edgar Award for Best First Novel, an award named in honor of Edgar Allan Poe and bestowed by the Mystery Writers of America.

He was drafted into the Signal Corps in 1953 and worked his way into their public information office, eventually persuading them that he could write a script about the Corps that might possibly find a home on television. *Notebook Warrior*, Levin's tale of a young violin-playing draftee, starred Ben Gazzara and Sidney Blackmer and aired on September 14, 1954.

While still in the military, and with a wildly successful first novel under his belt, Levin was asked to adapt a book by Mac Hyman called *No Time for Sergeants*, with television rights acquired by The Theater Guild. "It was a kind of odd situation," Levin recalled. "They had the television rights before the play was on. The book had come out, had been a great success, and they had bought the television rights before Maurice Evans bought the stage rights. So he had engaged a couple of writers, and I think he didn't like the first draft they turned in and he saw my television draft, which he liked, so I wound up writing the stage play of *Sergeants*." The hit play opened at the Alvin Theater on October 20, 1955, enjoyed a run of 796 performances, became a hit 1958 movie and gave Andy Griffith, the star of both stage and screen versions, an immeasurable career boost.

Similar good fortune did not visit *Drat! The Cat!*, Levin's first—and final—foray into the world of Broadway musicals. The show, which took Levin ten years to write, starred Elliott Gould and Lesley Ann Warren as a mismatched couple who naturally end up in love before the curtail falls. Levin wrote the musical's book and

Ira Levin

lyrics and Milton Schafer wrote the score for the comic tale about Alice, a wealthy young woman (Warren) who tires of her privileged life and becomes a cat burglar. The thief is pursued by dim-bulb policeman Bob (Gould), who by chance meets and immediately falls for Alice.

Gould's then-wife Barbra Streisand invested in the show and recorded two of its songs—"I Like Him" and "He Touched Me" (sung onstage by Gould as "*She* Touched Me"). The latter tune reached number 2 on the Billboard charts in November of 1965 and has been recorded by numerous artists over the years.

Broadway historian Ethan Mordden claimed *Drat! The Cat!* had "the three essentials of musical comedy: sharp script, good score, and clever staging." It also had the disadvantage of opening at the tail end of a 25-day newspaper strike. Reviews from Walter Kerr of the *New York Herald Tribune* and Martin Gottfried of *Women's Wear Daily* were indeed favorable, but the show failed to snag the essential rave from Howard Taubman of *The New York Times* and, on October 16, 1965, the show closed after only eight performances. Author Ken Mandelbaum, well-versed in American musical theater, called it "Perhaps the most

delightful show to ever run a single week." *Drat! The Cat!* has since attracted a cult following and was the subject of a studio recording in 1998.

In the aftermath of failure, Levin began to ponder his next project, returning to a thought that struck him years before about a pregnancy rife with suspicion, paranoia and, ultimately, horror. "I anchored my unbelievable story in the reality of [present-day] Manhattan ... as much to make myself believe it as to win the belief of readers," Levin explained. "I saved the daily newspapers, checking back through them on the transit strike, the incoming shows, the mayoral election."

"I always have to know where I'm going to end," said Levin. "I don't know how I'm going to get there, but I at least have to have the end in mind and then I sort of take a chance on being able to find my way there. I really couldn't get started on it until I knew that she was going to accept the baby at the end, but then I didn't much care about the middle 'cause I figured I would take care of it when I got there, and I did ... I do like to keep a little element unreconstructed at the end—a little of the horror's still loose 'cause I think that makes a work sort of stay in the mind more."

Prior to fleshing out the story, Levin created character descriptions for Rosemary and Guy—revealing characteristics not always spelled out in the novel or the film, yet ones in concert with the Rosemary and Guy that readers and movie audiences have come to know. Of Rosemary, Levin wrote: "She likes sex, and would like a little more. Would love to have children—this is her career—and thinks that Guy will want them too once they move into their larger apartment ... She doesn't miss God at all." Guy's description is decidedly less than flattering: "He is totally self-centered, a mirror looker, an actor. He thought he would be a star by now and is frustrated that he isn't. He can be a complainer or a charming extrovert, depending on how things are going for him. He married Rosemary because she accepted him so unquestioningly, undemandingly, adoringly. And he liked the

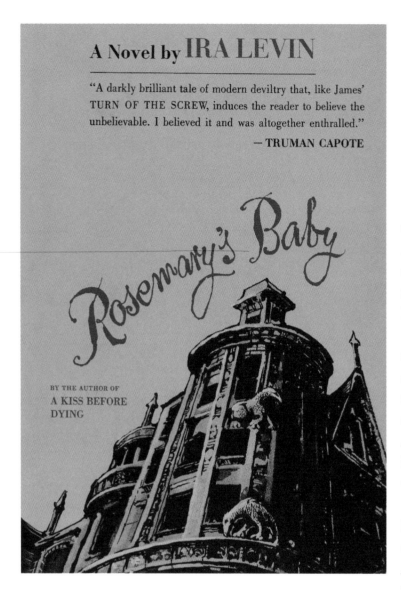

A Novel by **IRA LEVIN**

"A darkly brilliant tale of modern deviltry that, like James' TURN OF THE SCREW, induces the reader to believe the unbelievable. I believed it and was altogether enthralled."
— TRUMAN CAPOTE

Rosemary's Baby

BY THE AUTHOR OF
A KISS BEFORE
DYING

image of the young husband. No real giving of himself, though."

The author was uncertain if his cracked, sinister version of Madonna and Child would find a publisher, let alone intrigue the population at large. One person he did *not* want to read the book, at least for a few months, was his wife Gabrielle, who was pregnant at the time. "I tend not to let anybody read anything till I'm finished anyway," Levin explained, "but in that case I certainly felt that it might have been a little stressful for her." Quipped the author, "I always felt that pregnant women really shouldn't read the book." The family obstetrician, however, was reported to have loved it.

Upon the novel's release, the reviews were strong enough to erase any residual sting from Levin's Broadway misfire two years prior. "Mr. Levin's suspense is beautifully intertwined with everyday incidents," opined Thomas J. Fleming in *The New York Times*. "The delicate line between belief and disbelief is faultlessly drawn." Truman Capote called it "a darkly brilliant tale of modern devilry that induces the reader to believe the unbelievable. I believed it and was altogether enthralled."

Stephen King commented years later that "one of the things that's so unsettling about *Rosemary's Baby* is the fact that a kind of normality surfaces again at the end that makes you really uneasy. Because this is motherhood, and yet the child is the devil—or the son of the devil." Said George Romero, director of *Night of the Living Dead*, "*Rosemary's Baby* was really landmark in that way," citing "a new normality at the end rather than what was normal in the first 20 pages."

Rosemary's Baby was a rarity at the time—the blockbuster horror novel. For the bulk of 1967, Levin's runaway hit rested comfortably in the top ten of *The New York Times*, *The New York Daily News* and *Time* magazine's bestseller lists. It has been translated in dozens of languages, though the name of the book didn't always survive the translation. "The Italians have a way of giving away the plot in the very title," remarked Levin. "*Rosemary's Baby* they called *The Seed of the Devil*."

Though the author hoped his creepy, terrifying work would sell to the movies, he was unconvinced that any studio would snap it up. Yet, even prior to the book hitting stores in April 1967, the property became much sought after in Hollywood circles. It grew more and more likely that a movie version would be made. Before the book reached the general public, Levin was to find out by whom.

Left: Original book jacket.
Opposite: Page 102 of Ira Levin's orginal manuscript.

Jackie smiled warmly at her. "Try to sleep," she said. "We'll be waiting up on deck." She withdrew, her satin gown whispering.

Rosemary slept a while, and then Guy came in and began making love to her. He stroked her with both hands - a long, relishing stroke that began at her bound wrists, slid down over her arms, breasts, and loins, and became a voluptuous tickling between her legs. He repeated the exciting stroke again and again, his hands hot and sharp-nailed, and then, when she was ready-ready-more-than-ready, he slipped a hand in under her buttocks, raised them, lodged his hardness against her, and pushed it powerfully in. Bigger he was than always; painfully, wonderfully big. He lay forward upon her, his other arm sliding under her back to hold her, his broad chest crushing her breasts. (He was wearing, because it was to be a costume party, a suit of coarse leathery armor.) Brutally, rhythmically, he drove his new hugeness. She opened her eyes and looked into yellow furnace-eyes, smelled sulphur and tannis root, felt wet breath on her mouth, heard lust-grunts and the breathing of onlookers.

This is no dream, she thought. This is real, this is happening. Protest woke in her eyes and throat, but something covered her face, smothering her in a sweet stench.

The hugeness kept driving in her, the leathery body banging itself against her again and again and again.

The Pope came in with a suitcase in his hand and a

NEGOTIATIONS

Read it. If you don't like it, your next ski trip is on me.

By 1967, director Alfred Hitchcock was a veteran of 51 feature films, many of them hugely popular thrillers produced by big studios and featuring major stars of the day—name actors like Cary Grant, Grace Kelly and James Stewart. His nickname "The Master of Suspense" was well earned and unshakable, even when mid-1960s fare *Marnie* (1965) and *Torn Curtain* (1966) failed to reach the heights of films like *Vertigo* (1958), *North by Northwest* (1959) and *The Birds* (1963).

By 1967, director William Castle was a veteran of 52 features, nearly all of them schlocky horror films shot quickly, produced on the cheap and featuring largely unknown actors, with the odd Vincent Price or Joan Crawford star turn popping up from time to time. Though far from art, the films were critic-proof hits and enormous fun for movie audiences lured to the theater by Castle's silly, inspired and now-legendary promotional stunts. For *Macabre* (1958), insurance policies were sold in the lobby; beneficiaries were paid $1,000 each if the patron dropped dead of fright. *House on Haunted Hill* (1959) had a feature called Emergo, where an onscreen skeleton seemingly left the picture to fly out over the real-live audience at a key point in the plot. Most outlandish of all was the gimmick for *The Tingler* (1959), where tiny buzzers were attached to select theater seats for the scene in which the creature escapes into the theater.

Both Hitchcock and Castle were offered the movie rights to *Rosemary's Baby*. Hitchcock passed, allowing the B-movie director the chance to make an A film at last.

For William Castle, the one that got away was a property called *If I Die Before I Wake*, a novel by Sherwood King that he hoped to adapt and direct for the big screen. Castle had mentioned it to Orson Welles, who in turn brought it to the attention of Harry Cohn, head of Columbia Pictures. Cohn liked the property and hired Welles to direct the tale, with Castle on board only as assistant director. The film was retitled *The Lady from Shanghai* and released in spring of 1948.

"I wanted to prove to the industry, to my fellow peers, that I could do something really brilliant," Castle said. In early 1967, he got his chance: literary agent Marvin Birdt stopped by Castle's office on the Paramount lot armed with galleys of a new novel bearing the labels "Unrevised proofs. Confidential." and titled *Rosemary's Baby*.

"I got into Bill's office very early one morning and there was this big envelope with a manuscript in it," Castle's then-assistant Hawk Koch recalled, "and nobody was there yet and so I picked it up and read it. I was the first one in Bill Castle's company to read the book, and I said to Bill, 'Whoa, you gotta buy this—this is fantastic!'" Castle read the title and thought, "It's probably a story about an unwed mother." At Birdt's insistence, Castle read the galleys that night and was knocked sideways, thinking it one of the most powerful books he ever read. "What a motion picture it'll make," Castle said. "Even if they ban it, Catholics will go." Terry Castle recalled, "He said to my mom, 'You have to read this tonight, because I want to mortgage the house in the morning and buy the rights to this book.' And my mom spent the night reading *Rosemary's Baby*. She said, 'It's great,' and so he mortgaged the house."

Birdt suggested making an offer of $250,000, which Castle thought an impossible figure. Yet he knew he had to make a move. Castle called Birdt and asked him to submit a bid of $100,000 cash, an additional $50,000 if the book becomes a bestseller, and 5 percent of 100 percent of the net profits. "I'll submit the offer,"

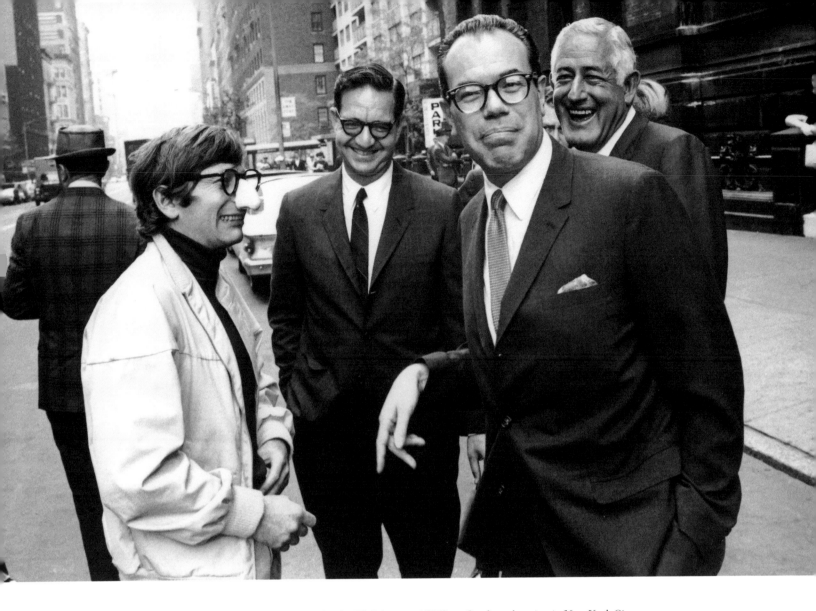

Roman Polanski, Gulf & Western executive Martin Davis, Charles Bluhdorn and William Castle on location in New York City.

the agent replied. "But I doubt if they'll accept it." After a tense 24-hour wait, William Castle finally got the call he wanted: The rights to *Rosemary's Baby* were his.

"Bill went to New York and right away wrote a check," Koch said. It wasn't long before others wanted in on the act, namely Robert Evans, the newly installed producer on the Paramount lot who had just begun his career with *The Detective*, which was slated to star Frank Sinatra, Lee Remick and Sinatra's wife Mia Farrow and begin shooting later in the year.

While Castle's baby was in its infancy, Paramount was enjoying an uptick in business after a particularly slow period in the early sixties. Two years before, in 1965, a proxy fight was developing between Executive Vice President George Weltner and a group

of directors determined to oust the current management. At the same time these waters were churning, Gulf & Western Industries made an offer to buy the studio at the generous price of $83 a share. Thus, on October 19, 1966, Paramount became the first studio owned by a conglomerate. Charles Bluhdorn, Gulf & Western's Chairman, was now calling the shots and took an active interest in all films produced under his watch.

In 1959, Robert Evans, a self-admitted "lousy actor," gave a sort of unheralded farewell performance in *The Best of Everything* and traded acting for producing, with "the property is king" as his motto. "No one wanted me," Evans recalled. "There's nothing worse than a pretty boy actor who wants to be a producer ... and I bought a property called *The Detective* to get my foot in the door.

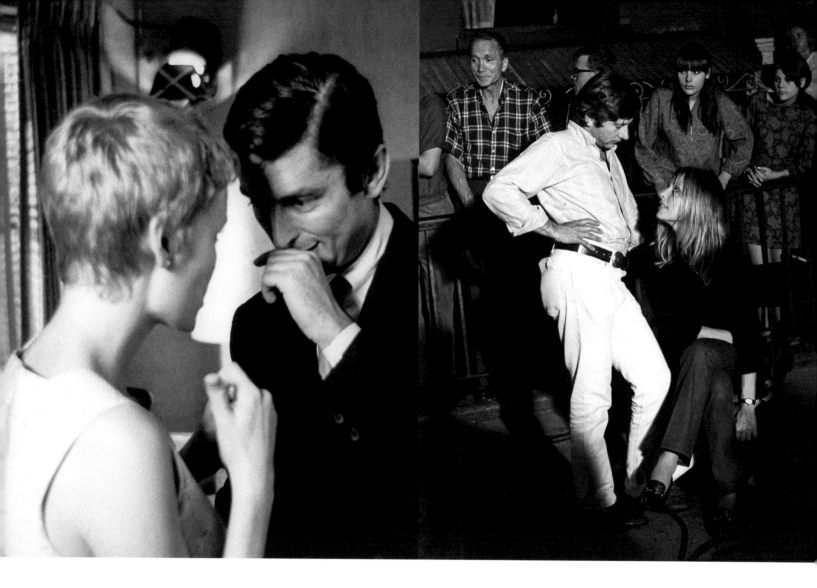

Left: Mia Farrow and Robert Evans. Right: Roman Polanski and Sharon Tate.

So I went to 20th Century Fox and demanded a three-picture deal. And got it. Without the property, they wouldn't have given me anything."

A laudatory profile of Evans by Peter Bart appeared in *The New York Times* and caught Bluhdorn's eye. Bluhdorn subsequently snagged Evans, Evans hired Bart as his colleague, and together Evans and Bart began looking for the next big project amid hundreds of scripts. "Nothing clicked, it all just felt tired," said Evans. "We were looking for the unexpected, something that sounded new." Eventually, Evans caught wind of Castle's unexpected, new and newly acquired property and insisted on seeing him.

"Bob Evans tells me you have a great book—*Rosemary's Baby*," Bluhdorn said to Castle. "Would you like to make the picture for us?" From there the back-and-forth negotiations took off: Bluhdorn asked Castle how much he wanted to produce, Castle stressed that he was to be producer and director. Castle wanted to involve lawyers, which Bluhdorn would have none of. "I knew I was on dangerous ground," Castle said. Numbers were bandied about—Castle wanted $400,000 and 60 percent of the profits. Laughter from Bluhdorn. Bluhdorn countered with $150,000 and 30 percent of the profits. Indignation from Castle. Bluhdorn: "$200,000 and 40 percent of the profits." This was beyond what Castle wanted, but, as he recalled, "One thing stopped me from saying 'Yes.' I knew what I had, he didn't." Castle proposed $250,000 and 50 percent of the profits, to which Bluhdorn conceded, "It's a deal." In the end, Castle's contract was to produce it with Bluhdorn, Evans and

Paramount. Yet one element was left unresolved.

"Wouldn't it be wonderful if [Roman] Polanski, with his youth, directed *Rosemary's Baby* and you, with your experience, produced?" asked Bluhdorn. "You could teach each other so much." Castle was adamant. *He* was going to direct it—no one else. It was *The Lady from Shanghai* all over again. Bluhdorn encouraged Castle to at least meet with the young director and keep an open mind. If Castle didn't want Polanski after that, then Castle could direct *Rosemary's Baby*. "You have the word of Charles Bluhdorn," he added, which Castle believed.

Roman Polanski's breakthrough came in 1962 with the spare, moody drama *Knife in the Water*, which earned him international attention and an Oscar nomination for Best Foreign Language Film. From there he made the suspenseful *Repulsion* (1965), starring Catherine Deneuve as a psychologically tormented young woman. It would be the director's first English language film; his second would come a year later with *Cul-De-Sac* (1966), a macabre comedy about a couple of gangsters hiding out at a seaside castle inhabited by a mousey middle-aged man and his promiscuous French wife.

With his next film, Polanski learned a difficult lesson about protecting the final cut. Though the director was pleased with the European version of *The Fearless Vampire Killers* (1967), he was compelled to take his name off the North American version, a move nevertheless forbidden by his MGM contract. To Polanski, the original film was mauled by producer Martin Ransohoff, who cut twenty minutes of footage, dubbed actors with more American-sounding voices, added a silly cartoon prologue and altered the score. Though a regrettable development, Polanski at least got to do the film with future wife Sharon Tate, whom he met in London in 1966. Years later, Polanski's edit of the offbeat comedy was released to appreciative audiences.

Polanski entered the picture as the preferred director of Robert Evans, who lured the Polish wunderkind to Hollywood on the pretext that he would direct the skiing drama *Downhill Racer*. An avid practitioner of the sport, Polanski was intrigued enough to fly to Hollywood to meet with the producer. Once on the lot and in Evans's lair, Polanski was instead handed the galleys of *Rosemary's Baby*. "Read it," Evans said. "If you don't like it, your next ski trip is on me."

Polanski returned to his hotel and, fighting jet lag, began to read Levin's story. It failed to immediately grab him. "I looked at the first page," the director said, "and it seemed to be a kind of ridiculous Doris Day comedy." Slowly he was sucked into the story, and by 4:00 a.m. was still awake and reading. It was an easy decision: Polanski wanted *Rosemary's Baby* to be his first American movie—as long as Paramount didn't make any changes to the narrative. "It wasn't the kind of story I would ever have written myself," Polanski said, "but there were some fascinating cinematic elements to it."

Hawk Koch remembered Castle's struggle over the directing duties: "The only problem was, and this is what really killed Bill, was, in the contract, he was for sure the producer, but it was 'best efforts' to make him director. And once the rights were signed away, Bob Evans really thought that Roman Polanski would be the right guy to direct the movie ... this was going to be an A horror movie. This was going to be his Hitchcock film, and Paramount wouldn't let him do it."

Castle had a built-in dislike for the energetic young director poised to take his opportunity away from him. When they met at last, Castle had three important questions for him: Would he make any significant changes to Levin's tale? Would he use any bizarre camera techniques to tell the story? Who would he pick to write the screenplay? Polanski's answers—"No," "No," and "Me, of course"—won Castle over. Promising to stick close to the book, Polanski assured the producer, "Bill, we can make a wonderful picture together. I have been looking for a long time for a

Rosemary's Baby. To work with you would be my privilege." Castle called Bluhdorn. "Charlie, you were right. Roman Polanski is the only one who can direct *Rosemary's Baby*."

Ira Levin, for one, was relieved. "[Castle] bought *Rosemary's Baby*, and I was not overjoyed when he did, and I remember the day when he called and said that he had decided not to direct it himself. He was getting Roman Polanski, and was I terribly unhappy? I said, 'No, I think I can get over that disappointment.'"

For Polankski, his personal beliefs became a key consideration when crafting the screenplay. "I no more believed in Satan as evil incarnate than I believed in a personal god," he said. "The whole idea conflicted with my rational view of the world." Ambiguity was the solution. The audience sees the story entirely through Rosemary's eyes, simultaneously learning what she learns (though, by choosing to attend a horror tale, the audience naturally suspects sinister goings-on way before she does). Polanski clung to this subjective viewpoint to give himself an out: Rosemary's experiences could have merely been the result of her mental state and not the reality of her physical surroundings. Though one suspects most audiences take the story literally—for one thing, it's way more fun—there exists the alternate route of fantasy and coincidence. The rape *could* have been a dream. Guy *could* have scratched her when making love to her. The coven *could* have been a paranoid's hallucination. "Better to leave it obscure and ambiguous," said Polanski. "It doesn't all have to be so obvious. The obvious is boring."

And yet, Polanski was profoundly faithful to Levin's story, which was set in 1965-66. Much of the dialogue is lifted straight from the novel, as was Pope Paul VI's New York City visit in October of that year. Also appearing in novel and film were the April 8, 1966 cover of *Time* magazine that reads "Is God Dead?" and Rosemary's visit to Vidal Sassoon's salon. Written out of the script was a scene where Rosemary, frustrated with Guy's preoccupation with rehearsals, decides to spend a few days alone at Hutch's cabin outside of town to, as Hutch puts it, "sit quietly and find out who you are; where you've been and where you're going." Perhaps the most notable absences, however, were descriptions of the baby and Rosemary's lengthy conversation with her newborn.

Polanski returned home to London and got to work writing the screenplay, a three-week effort that resulted in a 260-page draft. He would soon return to Hollywood and start editing it into shape. At Paramount, he was assigned a secretary named Thelma Roberts, who proved to be valuable in helping her boss circumnavigate the studio's bureaucracy and avoid a bevy of annoyances. "[Her] memories went back before the dawn of the talkie era," he said. "A smart, tough-talking lady with dyed red hair, she gave an impression of primness and chilly efficiency, but this was deceptive. Thelma's icebound exterior masked a warm, generous nature. She fussed over me like a mother hen."

William Castle helped find a home for Roman and Sharon for the duration of the shoot, acquiring the old Santa Monica beach house that once belonged to Cary Grant and was at the time owned by Brian Aherne, who was in Europe for a spell and was looking to lease it. The place had a garden, a pool, a decorative pond, huge closets, a grand staircase and lots of wood paneling. If it in any way resembled a movie set, that was not by accident—the residence, built in 1929, was designed by MGM art director Paul Crawley. The house was overly large and not quite Polanski's style, but Sharon loved it, making the decision to move in an easy one.

Rosemary's Baby, also known in inner circles as *Production No. 10444*, was given a budget of $1.9 million, with $150,000 going to Polanski. In the spring and summer of 1967, Paramount was busy completing all the required procedural shenanigans, including submitting the screenplay to the soon-to-be-abandoned Motion Picture Production Code. A June 29 letter to Marvin Birdt from Geoffrey Shurlock, the head of the Production Code, itemized the objections: "No use of 'Jesus' or 'Christ' as an expletive; no 'whore,' even if said by a nun in a dream sequence; eliminate 'fun in a necrophile sort of way'; eliminate 'shit.'" The letter goes on: "Rosemary is described as 'being surrounded by a dozen naked men and women.' We could not approve actual nudity."

WILLIAM CASTLE ENTERPRISES

OFFICES AT
PARAMOUNT STUDIOS
5451 MARATHON STREET
HOLLYWOOD, CALIF. 90038

TELEPHONE (213) 469-2411

Mr. Ira Levin
200 Danbury Rd.
Wilton, Conn. 06897

Dear Ira:

Sorry for the delay. I am pleased to
report that the Valenti office approved
the picture without a cut, which means
that this will be the first time, to my
knowledge, that a picture has been ap-
proved, with the daring of "Rosemary's
Baby," completely as conceived and shot.

Warm Regards,

William Castle

P.S. I think you can start spending some
of your money now.

WC:k

THE CAST

I could play the devil out of the part—no pun intended.

Polanski started the casting process by working with Paramount casting head Hoyt Bowers in creating sketches of each of the film's minor characters as the director envisioned them when drafting the script. The next step was to find actors that matched the drawings, and casting director Joyce Selznick, niece to David O. Selznick, proved instrumental in bringing much of the talent to Polanski's attention. Charles Grodin was a good example. Selznick stopped by the set of the television western *The Guns of Will Sonnett*, where Grodin was playing a villain named "Bells" Pickering. (Every time "Bells" shot someone dead, he put a little bell on his holster, making the ensuing jingling sound a testament to his success as a killer.) During a break in filming—with Grodin in full cowboy garb and muttonchop sideburns—Selznick took the actor to see Polanski. "He suddenly got excited and started to jump up and down like a boy," Grodin recalled after Polanski had compared the actor with his character sketch of Dr. Hill, Rosemary's first obstetrician. "'Yes, yes, you be doctor! Good, good! You shave your face, you be in movie. Good!'"

Casting the part of Rosemary would require more deliberation from a handful of people, though most of the opinions seemed to point to one person: Mia Farrow, the daughter of actress Maureen O'Sullivan and director John Farrow. At age 20, Farrow had made a few movies and television appearances, but if she was a household name at all prior to 1965, it was because of her work as Allison MacKenzie on the TV series *Peyton Place*. She would became a household name in capital letters during her romance with Frank Sinatra, which culminated in a Las Vegas marriage on July 19, 1966. Their age difference—29 years—did not go unnoticed by the press, though the couple themselves seemed blithely unconcerned.

"I couldn't quite fathom the Mia-Sinatra relationship," Polanski would later remark. "Sinatra never disguised that his was a man's world ... Mia, on the other hand, was a sensitive flower child ... They didn't appear to have a single thing in common, yet it was apparent to all who saw them together that this was no marriage of convenience and that Mia was deeply in love with her husband."

By 1967 they were planning to work together for the first time in *The Detective*, a crime drama that was to be produced by Robert Evans for 20th Century Fox. Filming was slated for October, with Farrow playing Norma MacIver, the wife of a suicide victim, opposite Sinatra's Detective Joe Leland, a man pursuing a gruesome killer. The cast also included Lee Remick, Jack Klugman and Robert Duvall and was to be directed by Mark Robson. It would be a welcome period of togetherness for the couple, who were separated earlier in the year when Farrow went to England and Germany to shoot *A Dandy in Aspic* (1968). "Already I was wondering what it would be like to be in scenes with Frank," Farrow said, "and worrying that I would disappoint him."

Meanwhile, Polanski's search for Rosemary was underway, with Paramount arranging auditions with actresses known and unknown, under contract and not, all to no conclusion. He briefly entertained the notion of putting his girlfriend in the role. "I'd hoped that someone at Paramount might put Sharon's name forward," the director said, "but nobody did, and I felt it would be out of line for me to do so."

Tuesday Weld, who embodied Polanski's vision of Rosemary—"a robust, healthy, all-American girl"—remained his initial choice for the leading role. Evans preferred Farrow, Castle

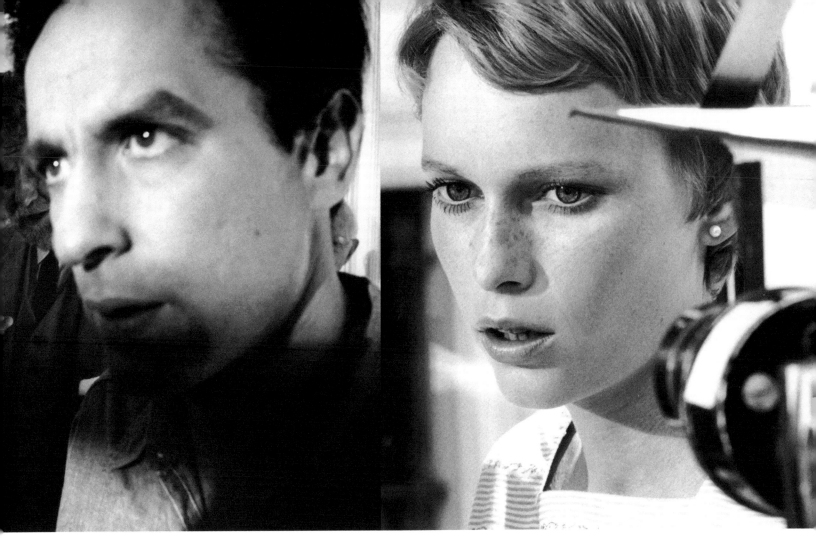

Left: John Cassavetes. Right: Mia Farrow.

agreed with Evans, and even Ira Levin claimed to be one of the first to suggest the actress for the part. "Roman was worried that Mia's ethereal quality might evaporate on film," Evans said. "I argued that this was exactly what would give the picture something unexpected–real magic." Polanski screened a few episodes of *Peyton Place* and immediately understood, conceding that "although Mia didn't fit Levin's description or my own mental image of Rosemary ... her acting ability was such that I hired her without a screen test."

Sinatra had concerns about the project and, after reading the script, expressed difficulty seeing his wife in the part. Farrow naturally saw *Rosemary's Baby* as an important opportunity to prove herself as a performer. But then there was the matter of timing, with *Rosemary's Baby*'s end date dangerously close to *The Detective*'s start date. Farrow wondered if Sinatra would

simply tell her not to do it, but no such directive came, and he remained, at best, coolly supportive. "Riddled with ambivalence, self-doubt, and anxiety," recalled Farrow, "I accepted the role."

Casting the role of Guy Woodhouse, Rosemary's husband and the story's catalyst, was trickier. "What I like about his character," explained Polanski, "is that he's not a particularly pleasant person. If he'd been charming and likable the audience would have been immediately suspicious of him, as this is one of the basic principles of the thriller genre. Played this way, he'd made you think he doesn't have anything to do with what's going on. We sense from the way he acts that he might be involved, but then quickly think, 'No, it would be too crude. He can't have anything to do with this.'"

Steve McQueen, Paul Newman, James Fox and Robert Wagner were briefly mentioned. Laurence Harvey tested for it. Dean

Charles Grodin

Jones went to Paramount to read for the director. Warren Beatty wanted to be asked so he could turn it down, joked Robert Evans. Jack Nicholson was considered, but rejected due to his vaguely sinister, devilish countenance. Even the idea of casting photographer Peter Beard was bandied about. In the end, Beard had the look, but lacked the acting chops. Guy had to be a struggling, up-and-coming actor who, with the right break, would achieve important success. And he had to have a handsome, clean-cut quality that would appeal to producers of television commercials.

To Castle and Polanski, Robert Redford was that man. "Roman wanted Redford," explained Evans, "but Redford was feuding with Paramount's legal department over *Blue*, a western he'd walked out on anticipating, rightly, *disaster*. Anyway ... Redford was attracted to *Rosemary's Baby* but sold more on *Downhill Racer*." It all came to an unfortunate conclusion when Polanski and Redford discussed the matter over a meal at Oblath's, a bar and restaurant across the street from Paramount. Polanski had told Evans where they were meeting, Evans mentioned it to Bernard Donnenfield—Evans's partner in charge of business affairs—and Donnenfield sent a Paramount lawyer to the restaurant to serve Redford with papers for breach of contract.

"Bill, have you found anyone to play the male lead?" It was John Cassavetes posing the question to William Castle as the two were traversing the Paramount lot. Castle told Cassavetes that they had not. "Well, what about me?" the actor asked him. "I could play the devil out of the part—no pun intended." Castle told him he would run it by Polanski.

Cassavetes had been acting on screen and in television since 1951 and began shifting his focus to directing in 1959 with the film *Shadows*. An acclaimed performance in a hit movie arrived in June of 1967; by early 1968 Cassavetes was rewarded with an Oscar nomination for Best Supporting Actor in *The Dirty Dozen* (1967). "There are some bizarre and bold performances, if one cares for that sort of thing," wrote Bosley Crowther in his review for *The New York Times*, calling Cassavetes "wormy and noxious as a psychopath condemned to death."

Evans considered Cassavetes "too dark and brooding" and "on-the-nose casting" to play Rosemary's husband, while Polanski—aware of the actor's seriousness and reputation for being difficult—thought he would function just fine in the role. "Quality number one is that the actor fits the part," explained Polanski. "I needed somebody who looks like an actor—can be a bit Actors Studio—and I thought John Cassavetes would fit the part perfectly." With Redford out of the picture and filming soon to begin, the choices were few. Evans eventually came around to the idea and, three days prior to the start of rehearsal, Cassavetes was hired.

For Minnie and Roman Castevet, Polanski had the idea of hiring stage legends Alfred Lunt and Lynn Fontanne. Lunt, however, was rumored to be in poor health, making it unlikely that Fontanne would leave his side to appear in a film without him. Their casting would have been clever, but what was most important to the director was to find two actors who would convey ordinary qualities that conceal the couple's malevolent motives.

Ruth Gordon had acted in films and on stage most of her life and, with husband Garson Kanin, wrote a handful of screenplays—

Ruth Gordon

including *A Double Life* (1947), *Adam's Rib* (1949) and *Pat and Mike* (1952)—and counted Katharine Hepburn and Spencer Tracy among their closest friends. Though she was far from the "tall, broad, white-haired woman" Levin describes in the novel, William Castle thought the 70-year-old actress an ideal choice for Minnie. Polanski was unconvinced, but agreed to have lunch with Castle and Gordon to explore the matter. When chaperone Castle deliberately failed to show up, the two were forced to drive the conversation themselves. "She's perfect for the part," the director admitted afterwards. "Sign her."

Casting Minnie's husband Roman turned on a chance visit between Sidney Blackmer and William Castle in Castle's office. The 71-year-old Blackmer's career had spanned six decades and was graced by a Tony Award in 1950 for the William Inge play *Come Back, Little Sheba*. More recently, Blackmer had occupied his time by appearing on such television shows as *Bonanza*, *Gentle Ben* and *Daniel Boone*. Castle asked Blackmer if he was wearing a toupee. The actor confirmed that he was, and Blackmer obliged when Castle asked him if he would take it off and put it on backwards. Castle immediately got on the phone to Polanski: "I've found Ruth Gordon's husband ... I'm sending him right down ... He's perfect!"

The name "Angela Dorian" was a variation on the famously shipwrecked vessel, the Andrea Doria, and served as the stage name of one Victoria Vetri, a 22-year-old beauty who would soon be named *Playboy* Playmate of September 1967. Polanski asked her how she looked in dark hair and if she could look Italian. "I *am* Italian," she responded. She got the part of Terry Gionoffrio, the young woman Rosemary befriends in the laundry room, and even got to hear her real name in the scene. "I'm sorry, I thought you were Victoria Vetri, the actress," Rosemary says. In the book, the name said was Anna Maria Alberghetti's, which could not be used for the film. Polanksi asked Angela if she could think of an Italian name, thus "Victoria Vetri" jumped on the page as part of the scene's dialogue.

Above and opposite: Ralph Bellamy.

Rosemary's Baby proved to be a dandy vehicle for a number of familiar show business veterans, among them Elisha Cook, Jr., who had appeared in Castle's *House on Haunted Hill* (1959) and built a long steady career out of playing henchmen, gunsels, petty thugs and various other unsavory characters. *Rosemary's Baby* gave him the chance to play the relatively benign figure of Mr. Nicklas (Mr. Micklas in the novel), the Bramford's apartment manager. Throughout his career, Cook relished short, shady roles over longer parts. "That way they remember me," he said.

For famed *Hamlet* actor Maurice Evans, Polanski's film was a follow up to Evans's stint as Dr. Zaius, an elder statesman orangutan in the science fiction film *Planet of the Apes* (1968).

It was also a reunion of sorts between the actor, who had produced the Broadway production of *No Time for Sergeants* in 1955, and Ira Levin, its author. "A strange coincidence if ever there was one," recalled Evans.

Hope Summers had a small-town-matron quality no doubt enhanced by her role as Clara in *The Andy Griffith Show*, making her line, "Hail Satan!" all the more jarringly memorable. Luther Adler, Raymond Massey and even William Castle–the choice of Polanski and Evans–were considered for the part of Dr. Abe Sapirstein, which eventually went to Castle's old friend Ralph Bellamy. "Polanski reluctantly agreed to Bellamy," Castle recalled, "but insisted that he go to Frank Hoffer, my tailor in Beverly Hills, for a wardrobe exactly like mine." Castle would find out why when cast and crew got to New York.

One of the last old pros added to the cast was Patsy Kelly, a vaudeville star at 12 who claimed that "what I always wanted to be was a fireman." Later, she grew into a deft wisecracker, goosing up such films as *Going Hollywood* (1933), *Topper Returns* (1961) and *Please Don't Eat the Daisies* (1960). In 1967 she was added to the cast of *Rosemary's Baby* as Minnie's friend and fellow witch Laura-Louise, a rare dramatic role in a filmography full of comedies and musicals. "Drama, schrama," she replied to an inquisitive reporter. "It's all just acting!" Her performance as Laura-Louise had undeniably comic undertones–this was Patsy Kelly, after all–that neatly counterbalanced the surrounding wickedness.

On the other side of the age spectrum were young bit players making their first major film, though not everyone's hiring was quite the same. Jack Knight, who played the cop interrogating the Castevets after Terry's "suicide," went through one of the lengthier audition processes, competing against three or four other cop types.

"I was under contract to the studio and they probably wanted to use the contract people because they're paying them," said Marianne Gordon, who played Rosemary's friend Joan and was, in real life, friends with Sharon Tate. "I met Roman, I told him that I knew Sharon and we talked on. He was kind of easy to talk

Left: Maurice Evans. Right: Sidney Blackmer.

to ... easier for me because of Sharon. When you feel like you know someone, it's a little bit more of a comfort than just meeting someone for the first time." Gordon confessed to having no idea what the movie was about. "I never told them this," she said, "but I didn't complete reading the script, it upset me so much. I remember being in bed and reading the script and, when it began to seem macabre, I thought, 'Oh, what is this?' And then I read a little more and I thought, 'I don't want to finish this' and I had to put it down. I thought, 'I think all I have to do is read my part and I can get the gist of what it's kind of supposed to be at the reading.'"

Ernest Harada, who played Young Japanese Man in the final

scene, didn't even have to show up to get hired. "My agent said, 'Oh my God, I got you this job on *Rosemary's Baby*! ... He picked you out personally from all my clients,'" Harada said. "I found out later my picture had accidentally dropped from her portfolio and landed at Polanski's feet. And he said, 'Him! I want him!'"

As with Harada, actor Ken Luber got hired for the film without really trying. "I had a friend who was an actress who had an audition at Paramount, and she asked me if I would read this scene with her," recalled Luber. "Which I did. And the guy who read us said to me after the reading, 'I'd like to take you downstairs,' and he brought me to Roman Polanski, and he said

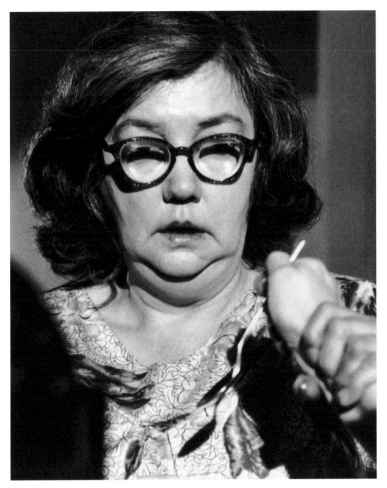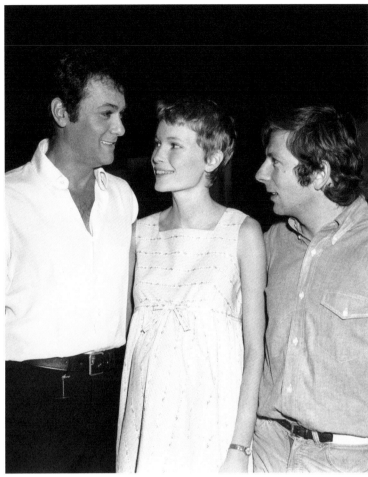

Left: Patsy Kelly. Right: Tony Curtis with Mia Farrow and Roman Polanski. Overleaf: Elisha Cook, Jr.

to Polanski, 'I've got this guy for the party scene.' Polanski looked at me, and he said, 'Turn around,' so I turned around, and he said, 'He's in.' So that was how I got the role." Though suitably excited about being cast in a major film, the money held more appeal than the actual work. "For me, it was really a paycheck, you know," Luber said. "I didn't have a car, I lived in Hollywood—on Gardner, like a block off of Sunset—so I'd walk over to Melrose, catch a bus and go down to the studio. I was getting paid. It was rent. That's the first thing you think of, 'I can live another month.' So I was happy about that."

Earning a salary at Paramount did not bother actor Craig Littler either: "All of a sudden I'm making, instead of 80 bucks a week

working graveyard at a Santa Monica Boulevard and Highland gas station, I'm making $250 a week, which is a fortune. And I'm walking around Paramount, eating in the commissary with all these huge stars. Charles Bluhdorn loved the women and had all these beautiful models and I would screen test with them. Then *Rosemary's Baby* came along, Joyce [Selznick] had me meet Polanski and I got this little role in the party scene."

Also on board as an extra was one Michel Gomez, an aspiring actor from Venezuala who also went by the names James Simon Gomez Parra, Jaime Gomez and Michel Rostand. After *Rosemary's Baby*, there would be more aliases and a doozy of a scandal that would compel the actor to flee from state to state.

THE CREW

I intend no disrespect to Mr. Sassoon, but he had nothing to do with my haircut.

In the early 1950s, Richard Sylbert began a distinguished career as an art designer and would eventually go on to become production designer for such sixties classics as *Splendor in the Grass* (1961), *The Manchurian Candidate* (1962), *Who's Afraid of Virginia Woolf?* (1966) and *The Graduate* (1967). Polanski had admired Sylbert's work for years beginning with *Baby Doll* (1956) and finally met him in

Elisha Cook, Jr. with make-up artist Allan Snyder.

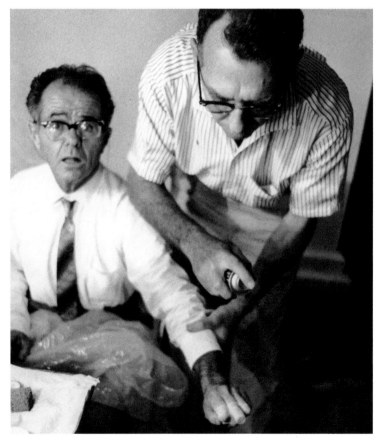

London during the production of *Repulsion*. He knew he wanted Sylbert for his next feature, *Cul-De-Sac*, "but of course they would not pay what he was getting at that time. It was a rather sort of cheapo-cheapo production."

Polanski finally got his wish when Castle let him hire the high-priced Sylbert for *Rosemary's Baby*, making the designer the first person added to the team. Officially, Sylbert was still working in Los Angeles on *The Graduate*, but secretly he was scouting locations in New York. Finding the right apartment building—the place where 80 percent of the movie takes place—was an easy task. The Dakota, a gothic-style structure located on 72nd Street and Central Park West, would become the Bramford in the film (named by Ira Levin after *Dracula* author Bram Stoker). Finding other spots to shoot was equally effortless. "Roman didn't know New York," Sylbert said. "I spent 35 years there. There's not a place in the book I didn't know."

"I could at last afford to employ him," Polanski said of Sylbert. "I was doubly delighted because the real star of the picture would be the New York apartment where Rosemary and Guy go to live. Built on the Paramount lot, this set required much more than a conventional design job." Besides having a keen eye, Sylbert was savvy about the way American moviemaking worked—the nuts and bolts of production as well as the games and high drama. For a European director new to Hollywood, Sylbert proved to be an invaluable source of information.

On location in New York City.

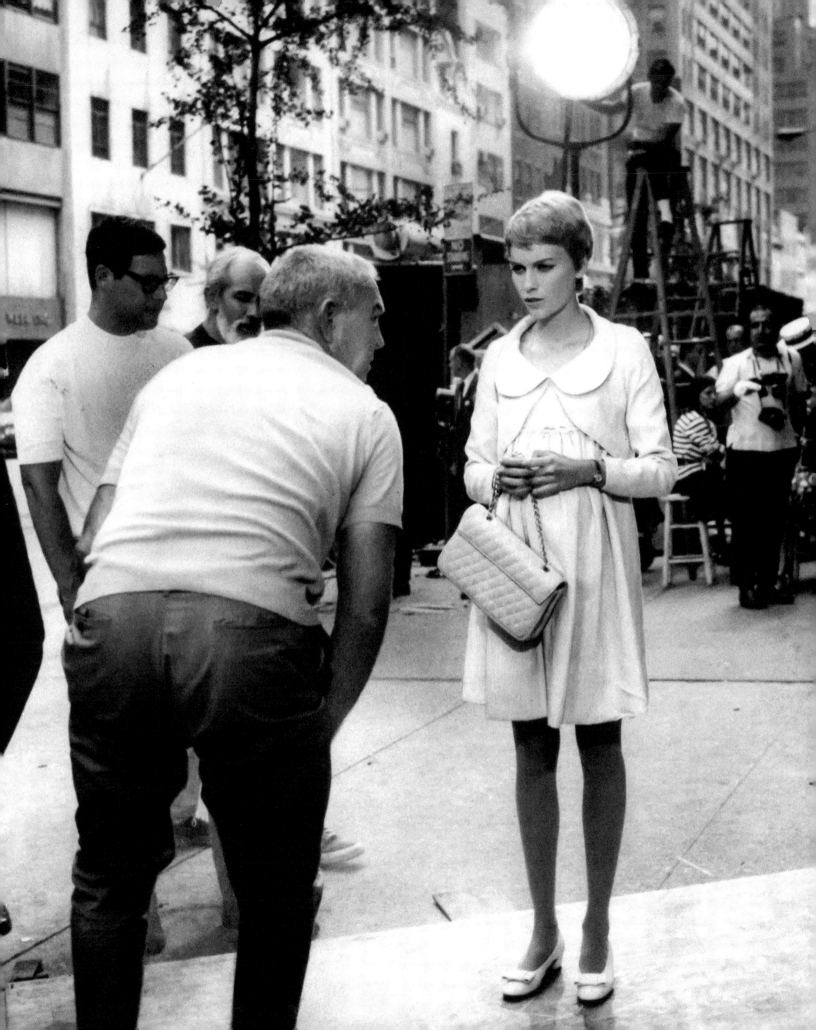

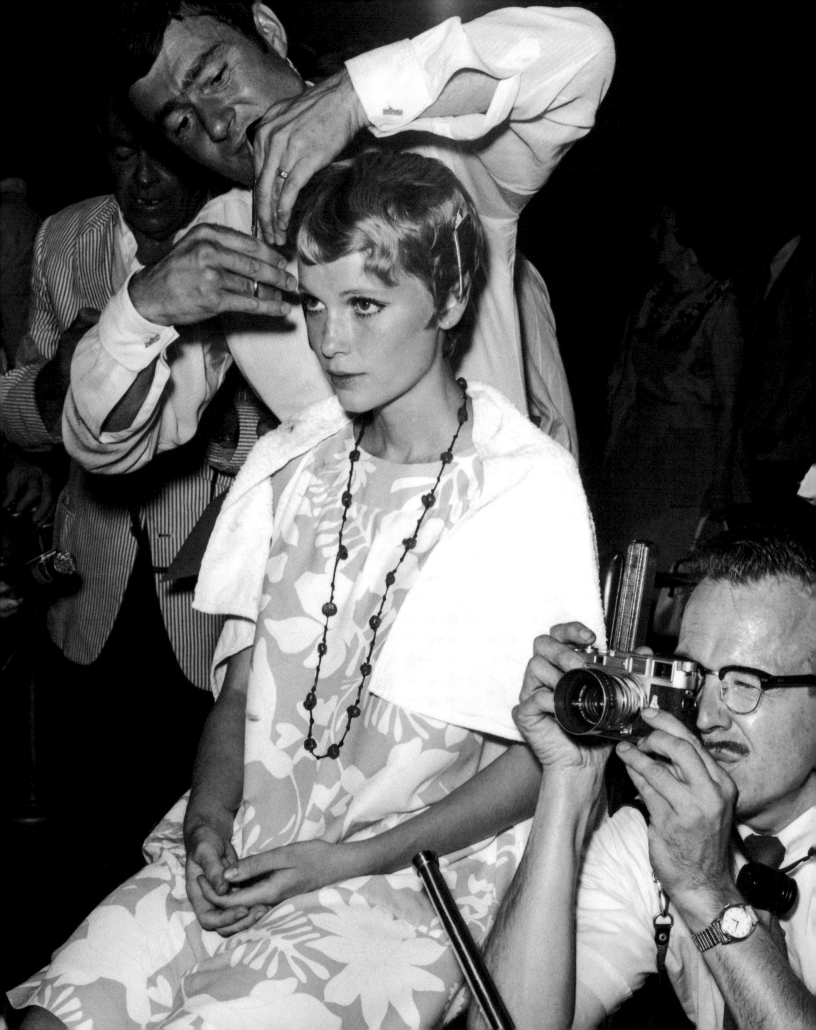

Sylbert recreated as many details of the Dakota as possible when designing the Bramford, a task made easier by visiting longtime Dakota resident Lauren Bacall and mapping out a floor plan. "We had to make physical changes because our place has ten apartments in a row, while the Dakota has only four to a floor, one at each elevator," explained Sylbert. "They're big, ten-room apartments, with fireplaces and a view of Central Park."

Art director Joel Schiller and set decorator Robert Nelson set about finalizing Sylbert's vision of the Bramford apartments. The Woodhouse place would be characterized by cheerful colors and tasteful furniture—the home of someone with enough money to spend on the necessities, but not enough to make extravagant visual statements. Added to the interiors were original sculptures by crew member Mark Bussen, whose main job on the film was to sweep the stages and take out the trash. Nelson had seen photos of Bussen's work and decided to lease a few pieces for the production.

Sylbert grew up in the Flatbush neighborhood of Brooklyn, making Schiller wonder out loud to Nelson if Sylbert's parents' place might give them the proper guidance to creating the Castevet apartment. They located someone Sylbert knew in his early years and asked for a description: "It had that typical nouveau riche thing. It had a credenza with those hurricane lamps with the red crystals hanging down ... kind of gaudy." To that adornment Nelson added a cane-and-mahogany sofa, various cane tables, mismatched chairs and cheap knick-knacks. The resulting look was one of faded vulgarity and clownishness. Sylbert loved it.

Nelson closely modeled Hutch's apartment on the simple hominess of Katharine Hepburn's Manhattan

Above: Costume designer Anthea Sylbert and Mia Farrow.
Opposite: Mia Farrow getting her hair cut by Vidal Sassoon.

residence. Maurice Evans, who played Hutch, liked it so much that he wanted to copy it for one of the cabins he owned in the Adirondacks.

For what some consider the centerpiece of the film—the nightmarish rape sequence—Sylbert looked at Satanic mythology to inform his choices. Yet he also had a clear blueprint: Levin's novel and Polanski's script were meticulous in describing how it unfolds. (There are four dream sequences in the finished film: the nuns at school, the rape sequence, friends fawning over the baby, and Guy telling Rosemary that she just gave birth to a healthy boy.) "We got clear away from the usual method of treating dreams—the fog, etc.—because dreams, in reality, can be real, although broken up in the mind," Sylbert said.

To shoot the film, both Robert Evans and Richard Sylbert suggested cinematographer William A. Fraker—"someone to watch," as Sylbert put it—who had just finished a rather restrictive assignment at Universal and worried that *Rosemary's Baby* would be more of the same. Polanski put him at ease, and Fraker was soon to discover a much freer environment at Paramount.

In his professional life, Fraker was nearly always behind a

camera, as still photographer, assistant cameraman, camera operator, camera assistant and, much later, director. He cut his teeth on the television show *The Adventures of Ozzie and Harriet*, where he worked for seven years, first as a second assistant and finally as a camera operator. "If there's any success I have achieved or will achieve," Fraker said, "I attribute the major portion of it to Ozzie." Among his influences were Conrad Hall, who shot *Cool Hand Luke* (1967) and *In Cold Blood* (1967), and Ted McCord, whose varied work included *The Treasure of the Sierra Madre* (1948) and *The Sound of Music* (1965). Of McCord, Fraker commented, "He would spend two hours setting up the background and 15 minutes on the star. You glamourized the actor, but the background creates the mood."

For costumes, Richard Sylbert recommended Anthea Sylbert, who was married to Richard's twin brother Paul. A year earlier, she had designed the costumes for *The Tiger Makes Out* (1967), her first film. *Rosemary's Baby* would be her second. "He wanted everything to look ordinary," Anthea said about Polanski's vision. "People are at ease by ordinary, and in fact, are put at ease by garish. He didn't want anything in the film to seem sinister." The story opens in 1965, "the year that skirts were getting shorter," Anthea said. "And Rosemary's dresses get subtly shorter through the movie."

"My idea for Rosemary was that she was an aspect of the Madonna, pure, innocent, yet strong," she explained. "God chose Mary to bear his son; the devil chose Rosemary to bear his. All her clothes were designed to achieve this idea."

One of Anthea's biggest challenges was to take Rosemary through four phases of pregnancy, with four different fake bellies made by The House of Westmore in Hollywood. The Sunset Bouelvard salon was owned by the Westmore brothers, who specialized in makeup and hair as well as prosthetic special

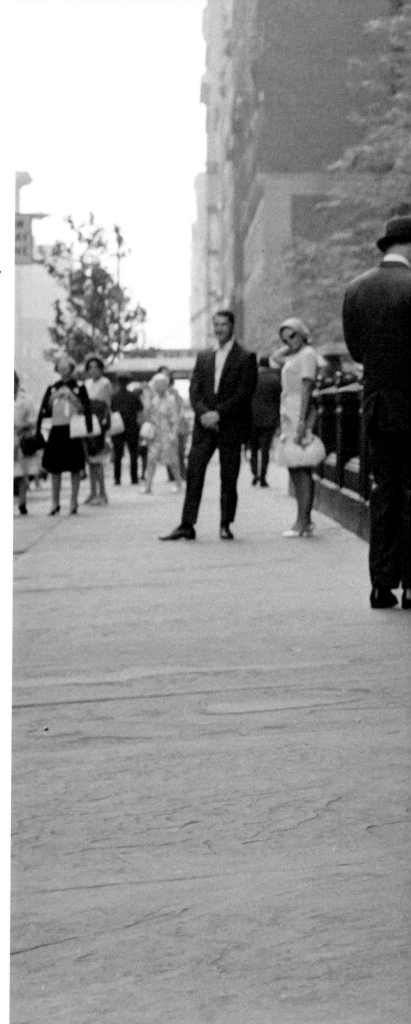

effects for the film industry. "Roman thought the pregnancy pads that were normally used in movies were stupid," Anthea recounted. "His biggest objection was they weren't hard as a pregnant woman's stomach is. So we sculpted four stomachs: three months, six months, nine months high and nine months low after the baby drops. They were made out of plastic wood, had a belly button and were painted Mia's skin color. And if you poked it, it was hard. Roman said 'I want to be able to photograph her stomach if I feel like it.'"

For the Castevets and Laura-Louise, Anthea ran wild, dressing them in purple, pink, orange, bright green, flowered prints, offbeat hats, gold sandals and jangling junk jewelry—all coming together in mismatched outfits that "shrieked to high heaven of idiosyncrasy." Wild hair and too much rouge completed the loud look, which, to the designer's credit, strikes an authentic chord. "Ruth Gordon is the only actress I can think of who could wear the costumes I designed for her and make them look like clothing," Anthea said.

For the rape sequence, Polanski requested that the coven, consisting of mostly older actors, appear naked (as they did in the novel). "I thought no friend of Helen Keller should go bare-ass, but is that the way an actress should think?" Gordon wondered. "They gave me a muumuu, but was that what Minnie Castevet would have worn at the witch's meeting?" Though audiences only get a glimpse of the devil, his costume was fairly complex and carefully conceived. "I researched devil worship extensively," Anthea said, "and the image that kept reappearing was one of a reptilian creature with scales, a form of dragon."

In the novel, Levin writes of the Bramford apartment manager: "Mr. Micklas was small and dapper but had fingers missing from both hands, which made shaking hands an embarrassment, though not apparently for him." Faithfulness to the book thus dictated that Elisha Cook's Mr. *Nicklas* have a few missing digits as well. To get the effect, makeup man Allan Snyder spent one hour each day turning Cook's fingers back, covering them with plaster-of-paris and wrapping them in flesh-colored gauze.

Mia Farrow's noteworthy hairstyle predates any involvement with famed stylist Vidal Sassoon, who is mentioned on page 149 of the novel and whose name is naturally dropped in the film. For the first part of the movie, Farrow sports a shoulder-length wig styled by MGM's chief hair stylist Sydney Guilaroff. The wig disappears from the film the moment Rosemary returns from Vidal Sassoon and shows a disapproving Guy her pixie cut. "I literally cut it myself with a pair of fingernail scissors while working on the *Peyton Place* TV series at Fox Studios," Farrow said. "This was long before I ever heard of Vidal Sassoon." Polanski had the idea of bringing Sassoon himself to Hollywood to cut Farrow's hair, a notion that William Castle turned into a public event on a Paramount soundstage complete with photographers and television crews, not to mention spectators sitting on bleachers erected just for the occasion. "I intend no disrespect to Mr. Sassoon," Farrow observed, "but he had nothing to do with my haircut."

William Castle's assistant Hawk Koch was brought on board to serve as dialogue coach and, quite possibly, the Happiest Person on the Set. "You know, I was 21 years old so, for me, everything was, 'Whoa ... how exciting is this?!'" Koch remarked. "I wasn't as stressed as everybody else was. I was just excited that everything was happening."

The cast rehearsed for two weeks on a soundstage equipped with little more than white tape on the floor to indicate walls and furniture. "I began badgering the studio to buy me a videotape deck," said Polanksi. "They were just coming onto the market. When [Paramount] balked at the

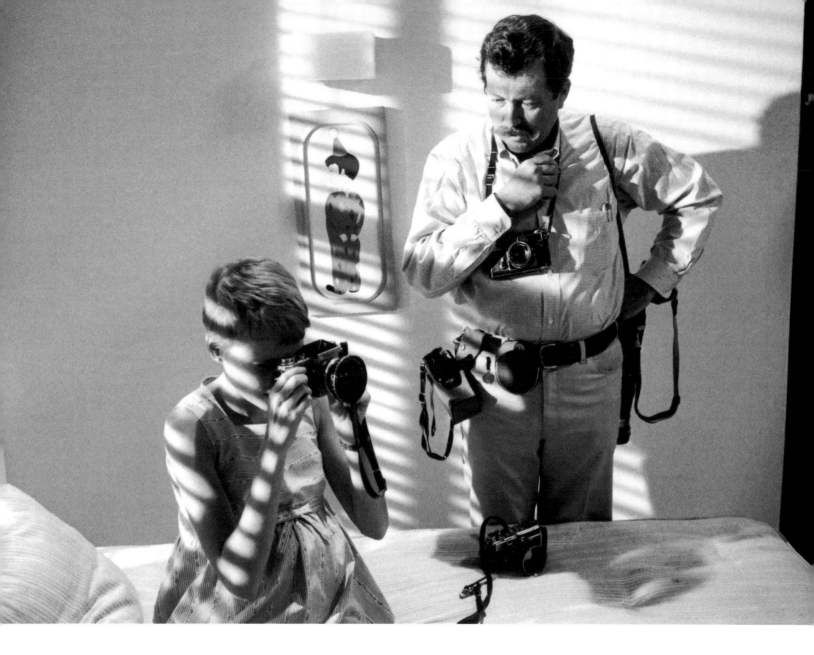

Above: Photographer Bob Willoughby with Mia Farrow.

Overleaf: Cinematographer William Fraker with Roman Polanski on the roof of the Dakota building.

expense, I agreed to buy the deck back at a discount when we were through. I wanted to record scenes, then play them back to Cassavetes and Mia for analysis and discussion. Both, at this stage, were highly enthusiastic about the film and my directing methods." While rehearsals were underway, Richard Sylbert's crew was finishing construction of the Bramford interiors on a nearby soundstage.

In the sixties, movies were becoming less and less shy about showing consumer products—one need look no further than William Castle's own *Strait-Jacket* (1964) to see a scene-stealing six-pack of Pepsi sharing the screen with Mrs. PepsiCo herself, Joan Crawford. Yet product placement reached new heights with *Rosemary's Baby*, as veteran television producer Sidney Balkin crafted a national movie tie-in with the studio where Yamaha motorcycles appear in Guy's television ad within the film. As a result, Polanski and Cassavetes were given bikes of their own for tooling around the Paramount lot and beyond. During this period, Polanski and Cassavetes were congenial with one another. That would change, and by the end of summer, cameras were ready to roll.

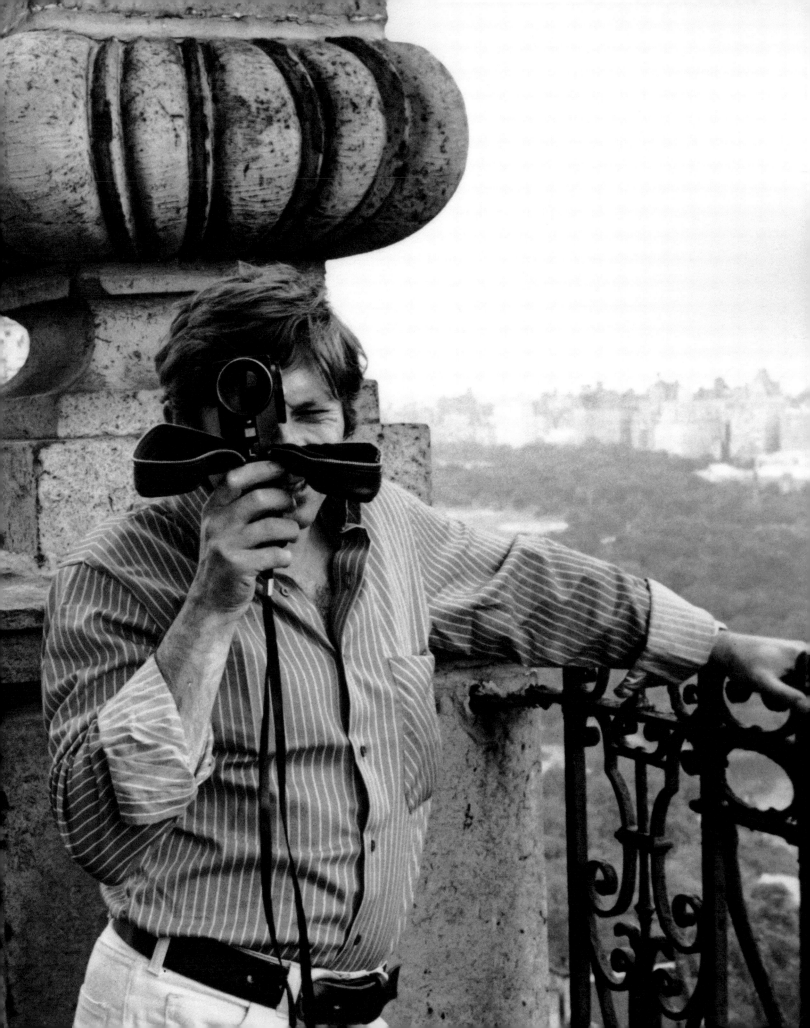

NEW YORK

Nobody will run down a pregnant woman.

Roman Polanski arrived in New York on Thursday, August 17—the day before his 34th birthday—to begin two weeks of filming at various locations, including the Sullivan Street Playhouse, a phone booth on Fifth Avenue and the place where most of the action takes place, the Dakota. On Monday, August 21, 1967, Polanski and Fraker prepared for the first shot—a panoramic view of New York that swept from the East Side to Central Park to the West Side, eventually landing at the famed apartment building. They began at 7:00 a.m.; by noon, to producer William Castle's chagrin, they were still at it.

On day two, the scene where Terry is found dead on the sidewalk after she had jumped from a seventh-floor window (or fallen, or had been pushed) was scheduled to begin shooting in front of the Dakota and wrap up the following night. The weather did not cooperate. "We had three rain delays," remembered Jack Knight, who played the cop who interrogates the Castevets. "Polanski was so nervous and tense about the delays and the weather and everything that he actually started acting out what he wanted. There's the part where the blanket is put over the body—he actually took the blanket and demonstrated how he wanted it. And when I was going to be taking notes on the report, he wanted me to stick the pencil up on my ear. So there were certain things he had visualized ahead of time and he didn't have time to rely on the natural instinct of whatever the actor had in mind."

The "suicide" scene was the one moment in the entire horror film where blood was spilled. "Roman was unhappy because there was not enough," recalled Rutanya Alda, who was Mia Farrow's stand-in for the New York shoot. "As I stood by, he seized the red bottle and kept screaming, 'More blood! More

blood!' as he [Jackson] Pollocked the sidewalk with it. The next day, Roman inquired, 'Why is Rutanya nervous around me?'"

"I did something that I cannot explain," said Knight, who was fully decked out as a New York policeman. "Some kid during a break walked under the police tape onto the set. I pulled my plastic gun on him. What the hell I was thinking? I have no idea. He must have shit his pants."

By the fourth night in front of the landmark apartment building, the scene was in the can. "Almost a century old, it had fallen into bad times during the twenties, and only recently had become the 'in' place to live," Castle said about the Dakota. The basement laundry room—recreated back at Paramount for a key scene later on—in real life acted as the production's green room, wardrobe and makeup areas. "Our family's apartment, conveniently, was right next door," Farrow said of her home located at 135 Central Park West. "Perhaps more ominously, the Gulf & Western Building was right around the corner."

It was therefore no surprise that Charles Bluhdorn would pay a visit to the set now and then—or even more often than that. "Charlie Bluhdorn was new enough in the top job to feel that a studio boss should know every single thing about every project in progress," Polanski stated. A few famous neighbors to the Dakota stopped by as well, namely Elia Kazan, who lived across the street, and Lee Strasberg, who lived further down on Central Park West. At the time, Strasberg was seeing Rutanya Alda, Mia Farrow's stand-in for the New York shoot. "I introduced him to Roman Polanski," Alda recalled, "to whom I remember Lee being more curt and aloof than I had expected. But Lee was also

The Dakota, New York City.

50

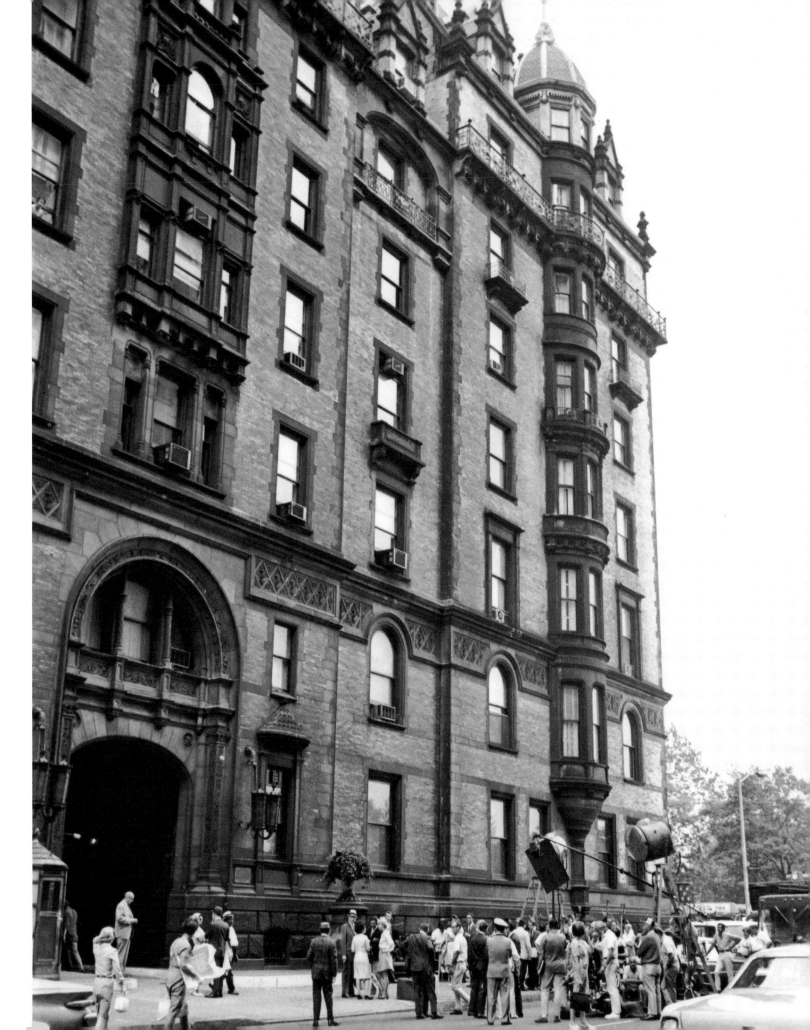

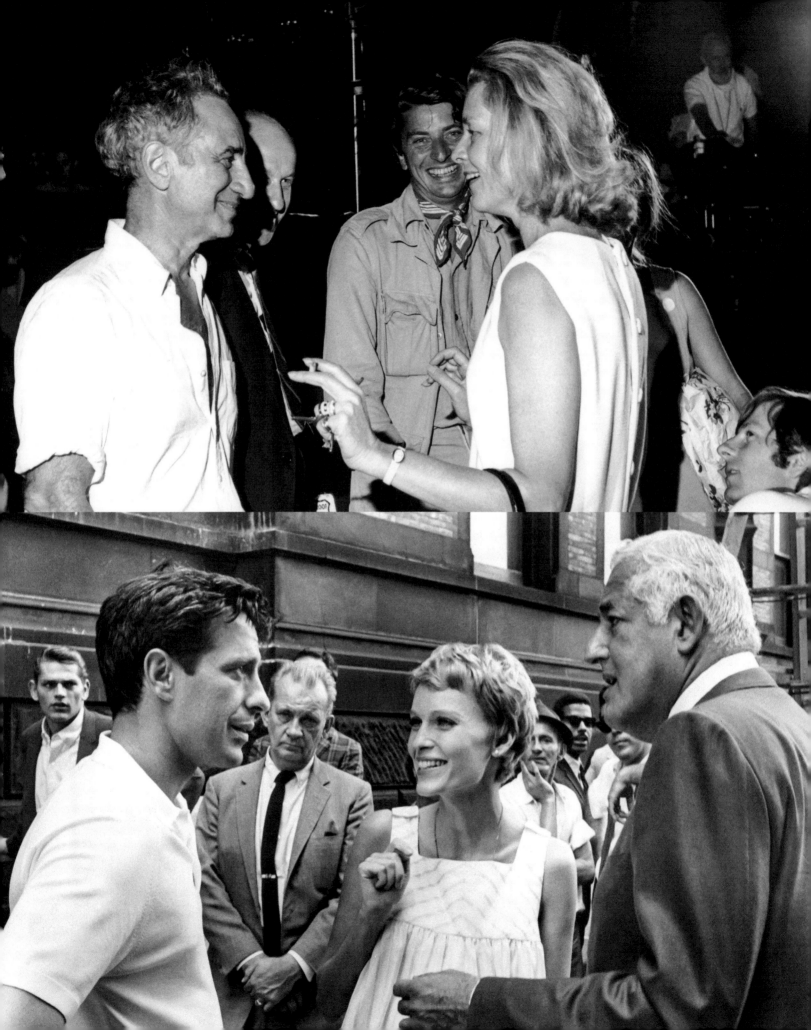

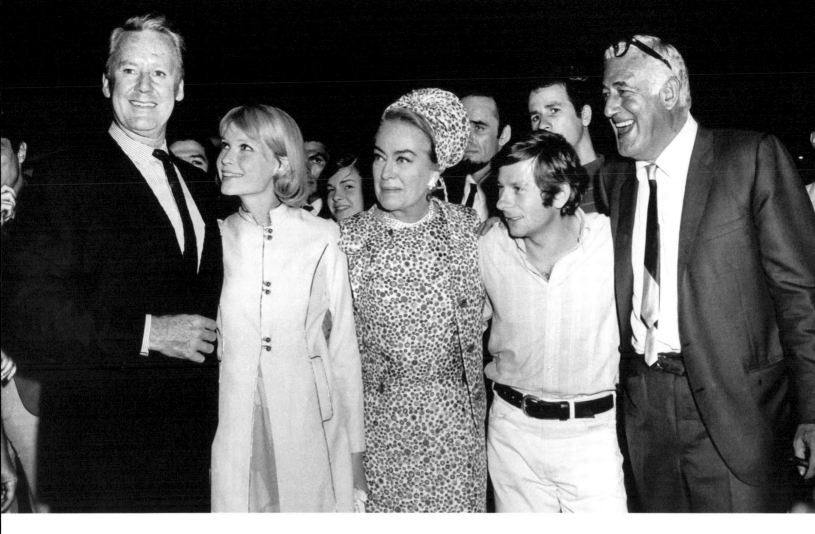

Opposite top: Elia Kazan, production designer Richard Sylbert and Lauren Bacall.
Opposite bottom: John Cassavetes, Mia Farrow and William Castle. Above: Van Johnson, Mia Farrow, Joan Crawford, Roman Polanski and William Castle.

very aloof and cool to most people he met." Dakota resident Lauren Bacall came down to watch the shoot and, during a lull in the action, invited Castle up to her apartment for a drink. The actress tried to reassure the impatient producer, who was used to shooting entire movies in a matter of days. "You're going to have a great picture," she told him. "That's all that matters, isn't it? ... The film can't miss."

"You worry too much," Polanski said to Castle, adding, for good measure, "You smoke too much." William Castle, a man whose cigar smoking was slightly more habitual than that of Groucho Marx, was, by Polanski's count, on stogie number eight that morning. "He *always* had a cigar, *always*–morning, noon and night," said his daughter Terry. "Whether it was lit or not, there was a cigar in his hand and sort of hanging out of his mouth, and ashes on his jacket."

What was to be a week of shooting in Manhattan quickly doubled in length and grew in cost. "Bluhdorn would call my dad in, and that was scarier than hell," Terry said, "because you know it was a lot of money for a horror movie." Robert Evans, ever protective of his Polish discovery, had tried to get Polanski to pick up the pace. "The Paramount management promptly recommended throwing me off the picture," the director recalled, "but Bob Evans, who was fascinated by the rushes, backed me to the hilt. If I went, he told headquarters, he would go, too."

"Roman knew what he wanted and there was no question about it," said Hawk Koch, "and it just sometimes took longer than some people hoped. And Billy Fraker was not the fastest cameraman in the world. Roman had specific ways he wanted things to look, and if Billy lit it a different way, Roman would

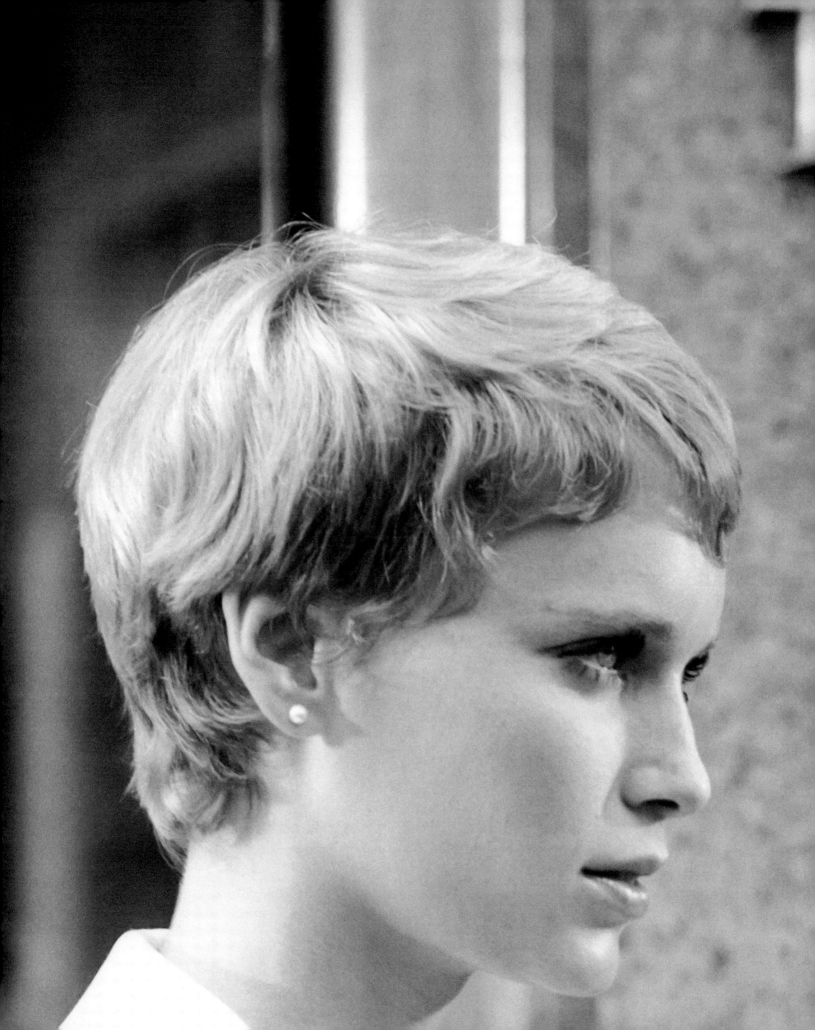

work with Billy to try and fit more in the vision of what Roman wanted. And sometimes that took a long time." To Polanski, there was no democracy on a film set, a feeling echoed by his cinematographer. "I work for the director," Fraker asserted. "He's the god. His 'yes' or 'no' is what I follow ... I watch for every nod, every blink."

Production moved to Lutheran All Faiths Cemetery in Queens to shoot Hutch's funeral, which offered a neat example of the dynamic between Bluhdorn and Polanski. "He learned that I was using a Yellow Checker cab for the cemetery scene," the director said. "To my annoyance, props produced a red one instead, so I told them to go away and come back with the real thing. Charlie seized on this incident as an example of the 'crazy Polack's' maniacal perfectionism. It became a ritual joke: 'Zat grazy Polack didn't like ze color of ze cab.' I told him he shouldn't even know about such trivia, much less worry about them."

Polanski described how he directs: "I never tell [actors] where should they go or what should they do in the scene. I let them do it first and usually what they do instinctively is the right thing ... I let them go through the scene and then I try to follow what they do with the camera. I think that doing the reverse is like having a ready suit and trying to find a man that fits it."

In his technical approach to *Rosemary's Baby*, Polanski wanted to enhance "the subjective immediacy" of the story by using short focal lenses that would require greater precision in where the camera was located and where the actors were placed. It was a time-consuming approach, but, according to the director, it would make the shots more vivid and, ultimately, convincing.

The company next relocated to Greenwich Village to shoot the scene where Rosemary and her friend Elise attend the long-running play *The Fantasticks*, at the time enjoying its seventh year at the Sullivan Street Playhouse. The street was packed with onlookers. Though not in the script, Castle arranged that the scene feature cameos by a couple of golden-age movie stars, Van Johnson and Castle's good friend Joan Crawford. Farrow hadn't shown up yet, so they used Alda to set up the shot where Rosemary exits the cab. "Hello, I'm Joan Crawford," came a voice. "So pleased to meet you." Face to face with the Hollywood

legend, a startled Alda managed to eek out a "Thank you, Miss Crawford" and wondered if Crawford had mistaken her for Farrow. By the time Farrow showed up, an offhand insult by Johnson toward Polanski–"Who's that, Pinocchio?"–infuriated the director, who cleared the set and decided that the scene was not worth shooting. Crawford delivered the exit line to the whole misfire, telling Polanski, "You should learn to have the manners of a William Castle."

The phone booth scene was remarkable for a couple of reasons. For one, it was a single, four-and-a-half-minute take. For another, it was a two-character scene shot with three actors. In the story, Rosemary is waiting to see Dr. Sapirstein when she suddenly realizes that he may be a member of the coven of witches out to somehow harm her baby. She excuses herself and runs to a nearby phone booth to call Dr. Hill and tell him everything she thinks is going on. While she is on the line, a man appears just outside the booth, ostensibly waiting to use the phone. Seen only from the back, the gentleman bears a solid resemblance to Dr. Sapirstein. Rosemary's moment of fear passes when the man turns around to reveal that he is not actually Sapirstein.

Castle told him, "Roman, trying to shoot on Fifth Avenue during the lunch hour is absolutely crazy." Polanski told him it could be done, and told Castle to go back to the hotel and put on his brown suit. When Castle returned to the set, he noticed Ralph Bellamy, playing Dr. Sapirstein, wearing a similar brown suit and standing outside the phone booth with his back to Farrow. (Bellamy sported a fake beard that day; he would grow a real one in time for his scenes back in Hollywood.)

Said Castle: "As Bellamy walked the few steps out of camera range, I walked in, timing my movements exactly with his. Wearing the brown suit, I stood with my back to the phone booth for several seconds. Then I turned and Rosemary, with relief, exited the phone booth. It was only me–nice, gentle, gray-haired, and chomping on my perennial cigar. I said my one line– 'Excuse me'–and, entering the telephone booth, inserted a dime and began dialing. Polanski had the last word. I played part of

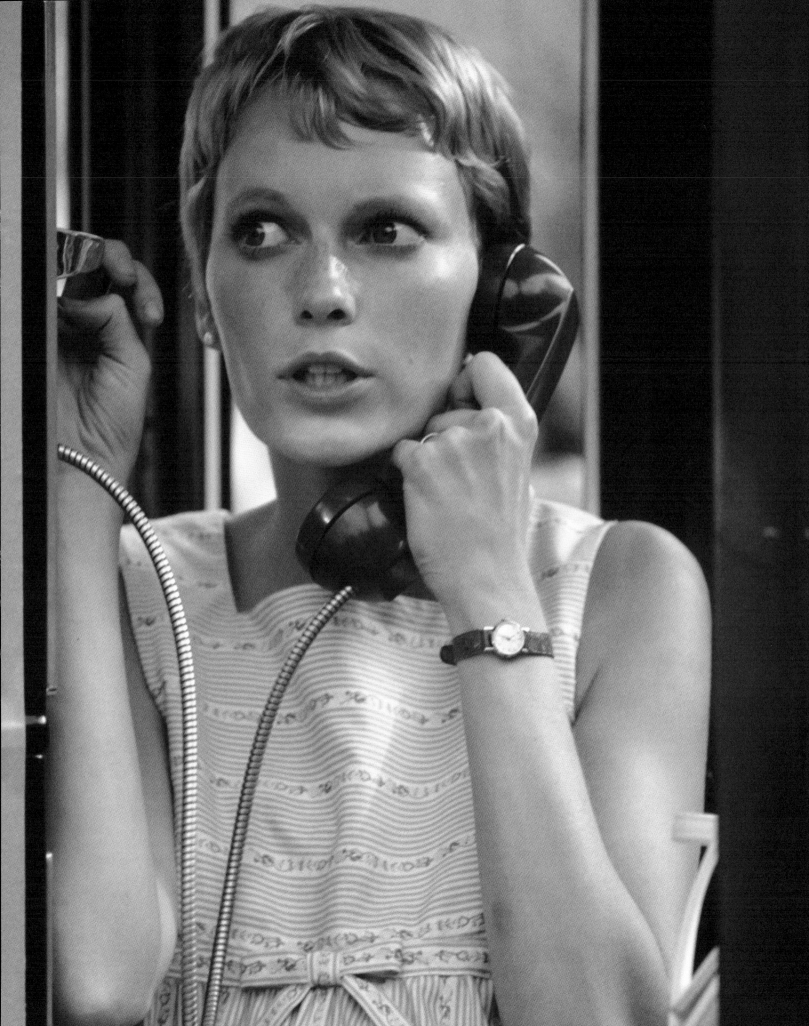

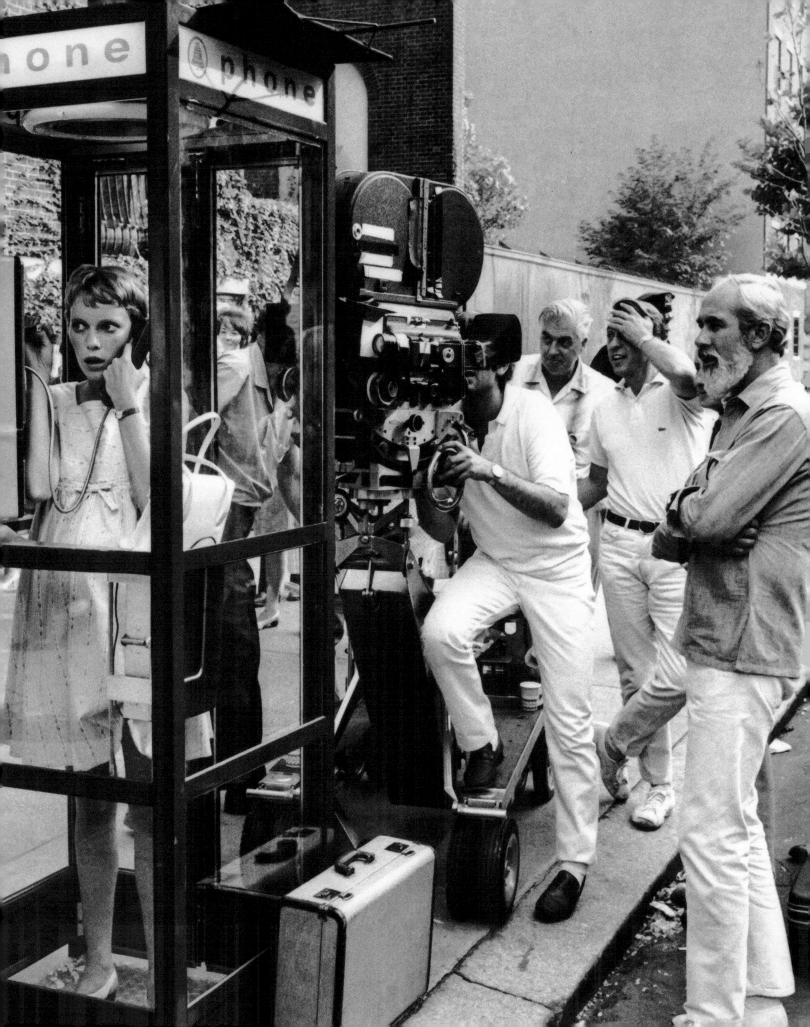

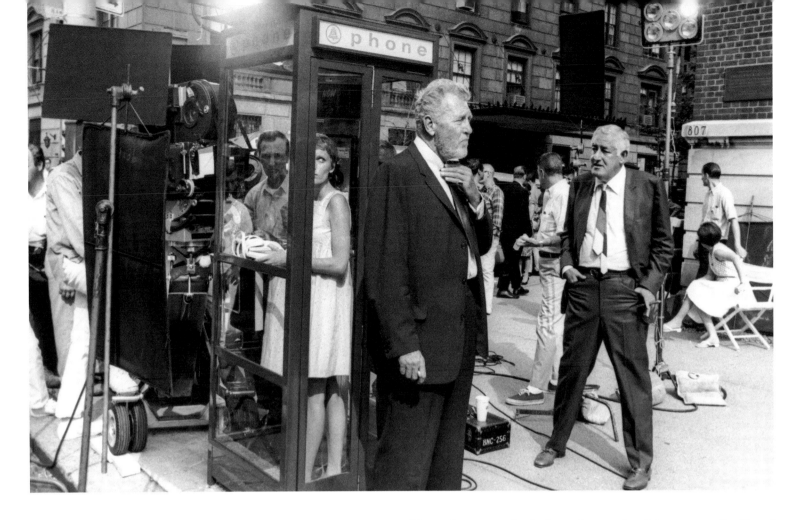

Sapirstein—a very *small* part."

Late in the film, a very pregnant Rosemary walks absent-mindedly across a busy Mahattan street and, as she reaches the other side, throws the charm necklace that Minnie gave her down into a sewer grate. The location was Fifth Avenue near 57th Street at peak daytime traffic. Only one thing about it was staged: Farrow would walk across traffic as a cameraman walked alongside her filming the scene. No street closure was involved, no drivers were in the know, and certainly no cameraman wanted to do it. Farrow asked Polanski if he was out of his mind. "I may be," he replied, "but please do it. Nobody will run down a pregnant woman." With no cameraman willing to do the scene, the director operated the hand-held camera himself as Farrow stepped into the street. "I took a deep breath—an almost giddy, euphoric feeling came over me," recounted the actress. "Together Roman and I marched right in front of the oncoming cars—with Roman on the far side, so I would have been hit first."

Only one more scene was to be shot in New York, slated for November 27 and 28, but, due to the delays, actually filmed December 16 and 17. A New York City all gussied up for the holidays served the scene nicely, as did the weight loss Polanski wanted the 98-pound Farrow to undergo towards the end of the shoot for the moments where Rosemary appears sickly.

In the scene, Rosemary agrees to meet Hutch at the Time & Life Building at 50th Street and Sixth Avenue. He doesn't show up, she calls him and learns that he has slipped into a coma, and, stunned by the news, runs into Minnie, who insists they taxi back to the Bramford. Once again, Rutanya Alda was employed as Farrow's stand-in, but this time she got to appear on screen: Rosemary believes she sees Hutch waving at her as he approaches, but it is someone else, and the woman he greets is Alda wearing a raccoon fur hat and a brown coat. "I froze that day," Alda recalled.

Sandwiched between these two stretches of filming in New York was the drama, real and otherwise, that was to unfold on Paramount soundstages.

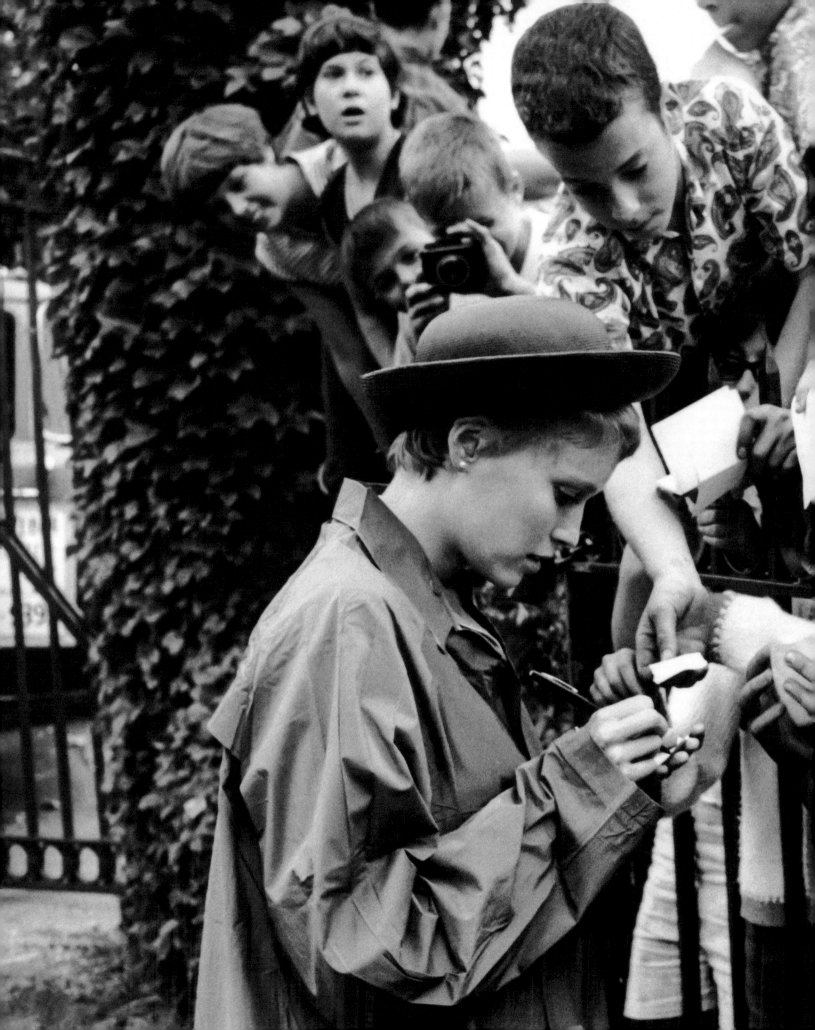

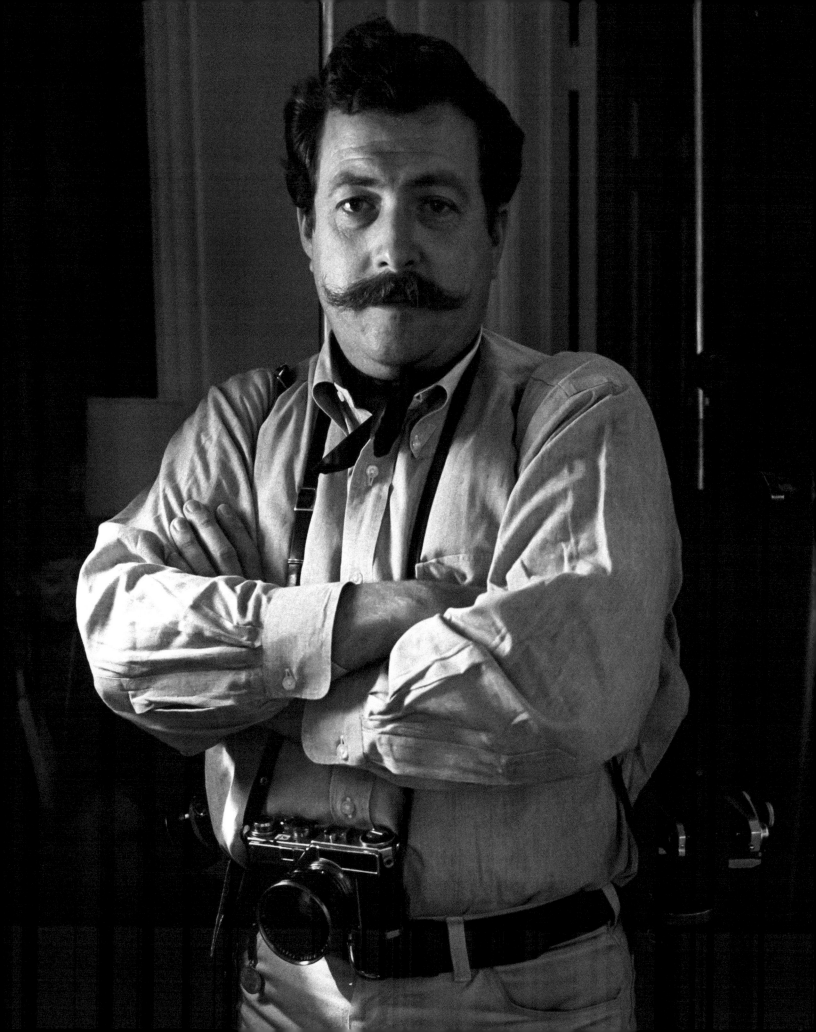

BOB WILLOUGHBY

There was never ever a dull moment.

Set photographer Bob Willoughby's talent was for capturing actors being themselves. His genius was to know exactly how to get those images into the public eye.

Early on, he realized that every magazine had its own distinctive look. "Being familiar with these individual styles was the key to my success when I started working for the studios," Willoughby said. "They never could figure out how I sold my pictures to the magazines, when they couldn't give theirs away ... and I never told them my secret."

His career began in 1954 with *A Star is Born*, which allowed him key exposure in a major magazine. "*Life* ran my photographs," Willoughby said, "and most exciting of all, I had my first *Life* cover. This was the dream of every young photographer. This was not lost on the other studios, who were always looking to get their films featured in *Life*. Whether I liked it or not, from this moment on, the direction of my journey became much clearer."

In 1967, Paramount arranged an introduction between Willoughby and Roman Polanski and sent the photographer home with the script to *Rosemary's Baby*. When Willoughby had finished reading it, he placed it on the floor next to his bed and turned out the light. In short order, the tale's satanic imagery flooded his brain. Willoughby turned the light back on, picked the script up off the floor, placed it in the hallway—safely away from where he and his wife, pregnant with their fourth child, were sleeping—and closed the bedroom door.

Despite of the disturbing subject matter, the photographer gladly accepted the assignment and began preparing for his shoot by breaking down the screenplay and identifying which scenes and situations would be most exciting to capture with his various Nikon cameras. From there he would consult the production shooting schedule, keeping in mind that it was a moving target, always subject to last-minute changes. He would then tell the studio how many days he would need during filming.

To Bob Willoughby, the commandment of all movie sets was "Don't hold up the production!" Becoming invisible, knowing the chain of command and a sense of timing were key, all lessons Willoughby learned from his stint on *A Star is Born*. "I watched rehearsals carefully, saw where I felt the best shot would be and was cautious not to get into the eye line of anyone who was watching the shot," Willoughby explained. "That meant the director, the choreographer, the script girl, the grip moving the camera, sound, etc. I found their rhythm and that was the clue. I moved when they moved, and I became part of the team."

"Roman knew exactly what he wanted, and I find actors respond very well to this in a director, so this was a great film to document," Willoughby said of his experience on the *Rosemary's Baby* set. "There was never ever a dull moment."

PARAMOUNT STUDIOS: photographs by Bob Willoughby

There are 127 varieties of nuts. Mia's 116 of them.

"I felt none of the expected thrill as my rented Mustang convertible swept through the famous Cecil B. DeMille gate," Polanski recalled. "I had 60 technicians at my beck and call and bore responsibility for a huge budget—at least by my previous standards—but all I could think of was the sleepless night I spent in Krakow, years before, on the eve of making my first short, *The Bicycle* (1955)."

The Dakota apartments had been faithfully reproduced and assembled by Richard Sylbert. The Woodhouse apartment was on Stage 8; the Castevet apartment, plus the Bramford lobby, was on Stage 18. Stage 5 was set up for the basement laundry room scene between Rosemary and Terry. Stage 12 was Dr. Hill's office and Stage 2 was used for scenes set in the interiors of cars and taxis. William Fraker's lighting was all worked out and Bob Willoughby was standing at the ready to capture the proceedings on celluloid. It was the first day of shooting on the Paramount soundstages.

In the first scene to be shot, Elisha Cook, Jr. walks down a hallway with Mia Farrow and John Cassavetes, unlocks the door to apartment 7E and enters it. In the second scene to be shot, Cook gives the couple a tour of the various rooms. "It was a real apartment," said Farrow. "It had a wood-burning fireplace, and I fell asleep in a real bed, and it was a real kitchen and I had a real blender and a real stove. It was just an authentic apartment." Before the cameras rolled, Sylbert practiced disassembling and reassembling the set's walls, which were attached by catches and came apart easily. "Sylbert actually thought for the cinematographer," said Fraker, who could now move his camera more freely throughout the apartments. "He didn't think of himself as an architect or contractor—he was a filmmaker."

One of Fraker's challenges was the 18-to-20-foot walls of the Bramford apartments. It was faithful to the Dakota, yes, but the height pushed the overhead lights so high that they created black circles under the actors' eyes. To solve the problem, Sylbert worked with Paramount's electrical department to make a "trombone" device that would allow lights to slide up and down to different heights along the wall. To achieve certain moods, Fraker would light only half the set, with actors moving in and out of the shadows. "Bill Fraker had told me that he wished he had the option of shooting in black and white," Willoughby recalled, "as color tends to distract from the drama, making everything often too pretty."

Polanski found John Cassavetes to be chummy and agreeable during rehearsals. "As soon as shooting began, however, he started living up to his reputation as a difficult subject, questioning every aspect of my direction and constantly arguing about delivery," the director said. "I quickly discovered that he had no gift for characterization, could play only himself, and was lost if he had to act without his beloved sneakers."

Polanski and Cassavetes were simply a terrible match. The director liked multiple takes; the actor preferred one. The director expected precision; the actor enjoyed improvising. "Every scene seemed pivotal to him," Willoughby said of Cassavetes. "He was a director himself, and he went to great pains to understand everything that was going on, sometimes I felt to the extreme." Polanski's exactness and Cassavetes's method acting drove each other nuts. "In everyday life we aren't constantly making gestures," the director said in critique of his leading man. "Just once we might say something without putting a finger in our ear or scratching ourselves ... I assure you he

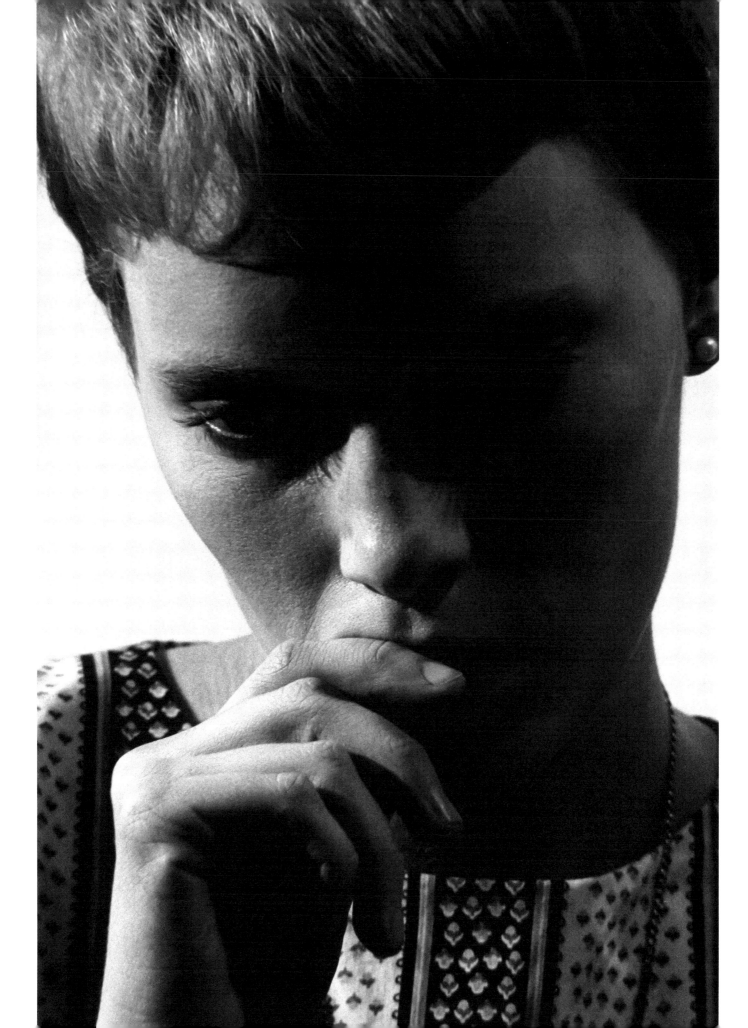

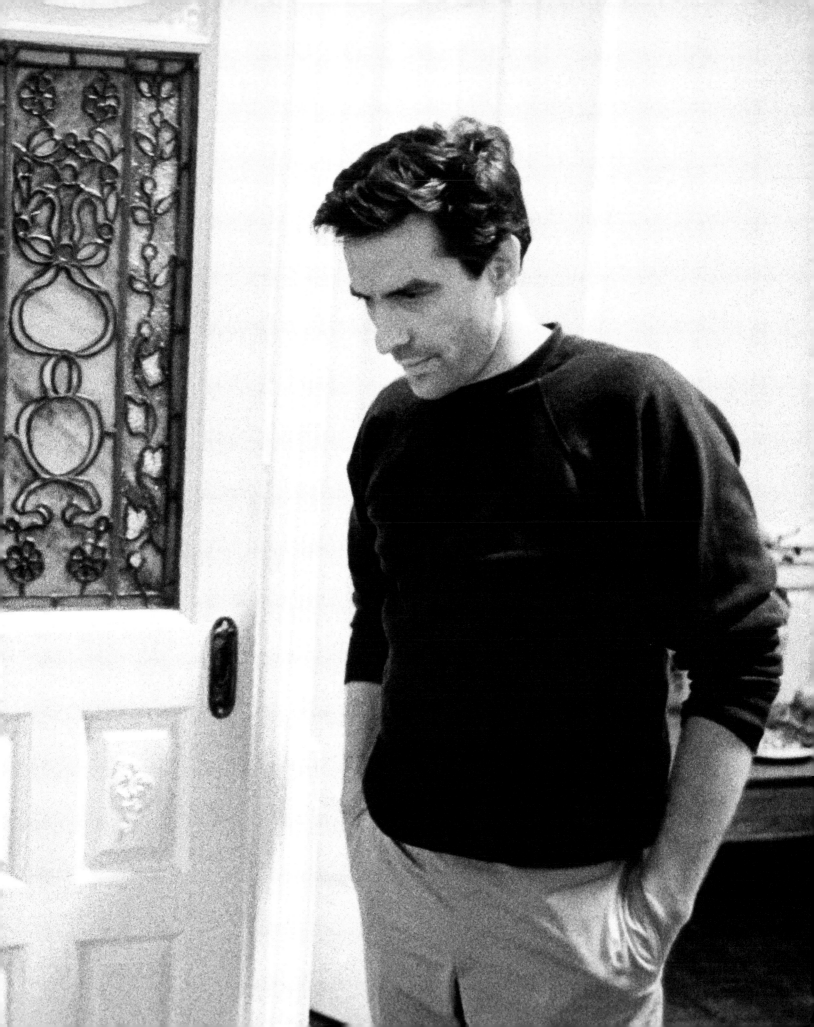

scratches himself far too much.”

Farrow said that 40 takes here and there were not uncommon, but the record seemed to be held by the laundry room scene. It is where Rosemary meets Terry, the young woman who has been taken in by the Castavets and, one later assumes, was being groomed to carry the devil's child. Rosemary and Terry become acquainted, united by their uneasiness about being in the basement laundry room. Terry shows Rosemary the tannis-root necklace that the Castevets gave her to wear “for luck.” It is the same amulet that Minnie will later give Rosemary after Terry has died.

It's unclear if Polanski intended the entire five-page scene to be all one shot, and accounts vary over the most number of takes. Editor Sam O'Steen remembered the scene for having the most and put the number at “about 35.” Joel Schiller recalled 52 takes while William Castle remembered at least 55. In the final film, the scene is comprised of three shots: Rosemary and Terry's introduction and chit-chat—1 minute and 39 seconds; close-up of the amulet—4 seconds; Rosemary and Terry continue their talk—47 seconds.

Farrow's closest friends on the set were Ruth Gordon, whom she had known for years, and Malcolm, whom she had known since he was a kitten. “I always took him to work with me, even when I was doing plays in New York,” Farrow said of her feline ally. “I used to put him in my galoshes and take him to work and leave him in my snow boots.”

For the all-important relationship between star and director, it was an easy road to travel. “Off the set Roman was shy with me, but when we were working he communicated clearly,” Farrow observed. “He had an infectious enthusiasm that few could resist, and a real knowledge of what would work professionally.”

“She's very conscientious, hard-working and receptive, like blotting paper,” Polanski stated. “She's wonderfully natural, which at the start was the cause of a misunderstanding. I didn't say anything to her for several days while I was directing the other actors, so she thought that maybe it wasn't working out. But on the contrary, it was going so well there really was nothing more to tell her. I said, 'Wait until there are some more dramatic scenes, then we'll need to do some work together.' When it came to the more gut-wrenching moments, I had to push her a little bit, but generally she was wonderful.”

“When Roman wanted me to eat raw liver, I ate it, take after take, even though, at the time, I was a committed vegetarian,” Farrow said. “I trusted him all the way. And he was never wrong.”

One thing photographer Bob Willoughby—and, later on, editor Sam O'Steen—had to adjust to was Polanski's disdain for master shots. Typically, a director will shoot a master—a shot that involves all the actors in a scene—then shoot individual actors in close-up or medium close-up and edit everything together in such a way as to emphasize key elements of the scene. Polanski told Willoughby his strategy: It prevented the studio from re-editing his film. Said the photographer of these new limitations, “Unless I staged it afterwards, which was something I always tried to avoid, I had to convey the idea of the plot in one photograph, where Roman had used five or six individual camera set-ups.” Eventually Willoughby understood what needed to be done and adopted Polanski's method. “After Roman had made his shot, I did mine.”

An important element of the film is Rosemary's dream state. Though the dream sequences in the film are remarkably faithful to the ones described in the novel, Polanski added his own sensibilities to the equation. “I wanted the dreams in the film to look as close as possible to my own,” he said. “Nothing is ever static—everything moves and changes. I might be talking to you when suddenly you become the President, even if he still looks like you. So we understand dreams in more than one way. They aren't only about what we see but also what we know for sure …

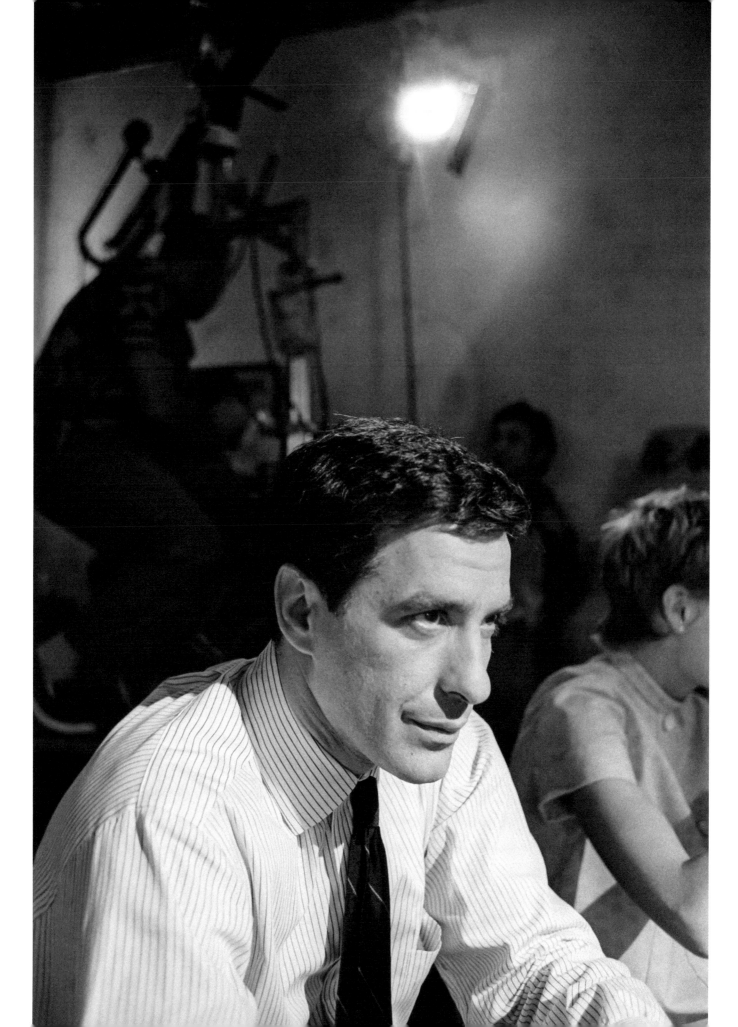

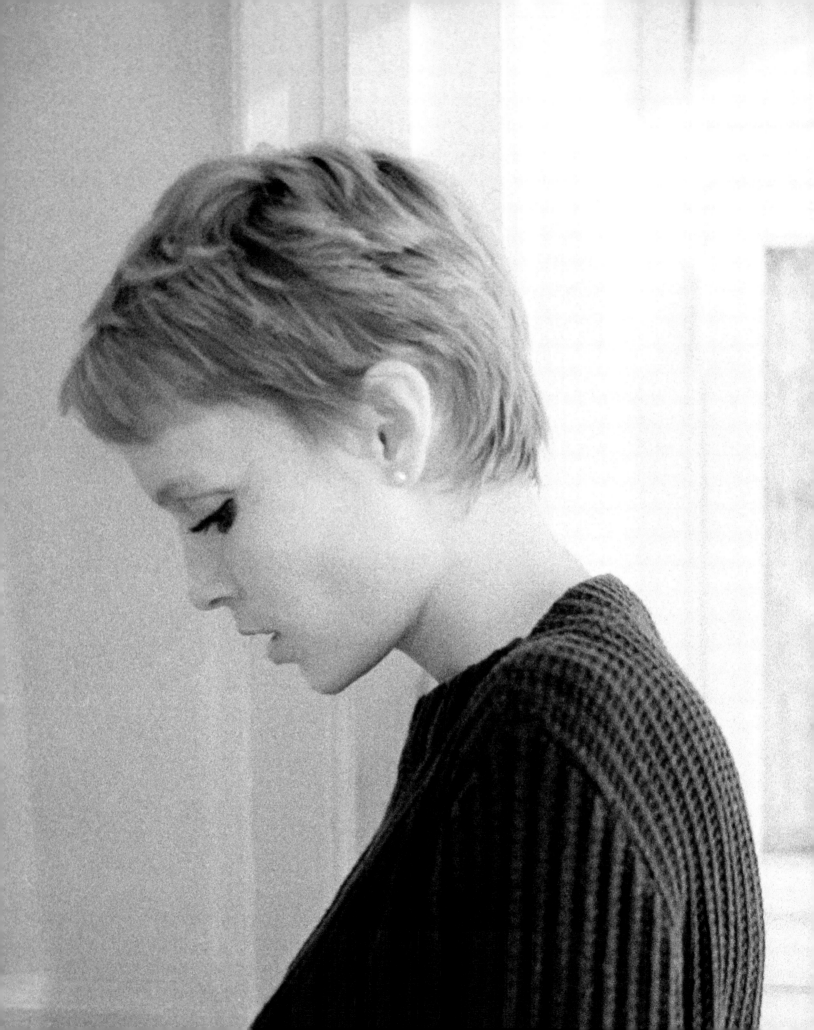

obviously this kind of thing isn't easy to show on screen."

As it was in New York, Paramount heavyweights continued to pressure Castle about Polanski's pokiness, and Castle in return pressured Polanski until, one day, the director made the producer a promise: He would speed things up and get the studio execs to leave Castle alone. "Polanski kept his word," said Castle. "The eight-page sequence in which Guy and Rosemary have dinner for the first time with the Castevets—a tough sequence to shoot—was completed in one day. Paramount relaxed—at least for the time being."

"Studio executives conferred, agonized, wrote memos to Bill Castle, and started to harass me," Polanski said. "Though pleased with the rushes, they simply wanted me to deliver within my 50-day shooting schedule. When I wouldn't—in the interest of quality—the hassles began."

"He was brilliant," Castle said of his director, "but to watch him work had become exquisite pain."

Castle and Evans were as happy about the dailies as they were unhappy about the pace and rising cost. Ruth Gordon recalled that "one morning [Castle] rushed onto the set just as the camera was going to roll, [exclaiming,] 'Roman, I saw the dailies and I don't care if we *are* 29 days behind schedule, just keep on directing, this picture is *great!*'" Evans was equally impressed: "Roman's dailies were weird, he touched off an ominous sense of fright ... one I had never seen on film before." It took a visit to the set by Otto Preminger to shift Polanki's thinking and relieve his stress. "Are they happy with the rushes?" Preminger asked the director. "More than happy ... delighted," Polanski replied. "Roman, remember this," Preminger said. "You can go over budget as much as you like, provided the rushes are good. They only replace a director when the dailies are lousy."

At one point, Donnenfield asked the director to try fewer takes, just for a trial period. Polanski exploded. "Look, I've had it up to here. You want me to shoot fast? No problem. I'll shoot 20 pages of script a day from now on and bring in the picture by the end of the week. I hope you'll like it." Evans the Diplomat stepped in to talk to his Polish genius. "Roman," said Evans, "just go back on the set and do it your way. I'll take responsibility." And with that, a grateful Polanski went back on the set and did it his way. "There were no more major hassles after that, and I completed the picture about four weeks behind schedule," Polanski said. "When everything was in the can, we'd gone some $400,000 over a $1.9 million budget—a trifle compared to what the film ultimately earned."

In 1967, four-letter words were still fairly rare in mainstream movies, yet *Rosemary's Baby* contained one that made Castle and the Production Code office uneasy. Cassavetes utters it— "Ah, shit!"—right after the doorbell rings and interrupts the romantic dinner between him and Rosemary. It is easy to miss and, one might argue, wholly unnecessary. Yet Polanski left it in and tried to get Castle to see the writing on the wall, telling him, "There's a 'new wave' coming in. Pictures are growing up—and words more verbal than 'shit' will soon be acceptable ... if the camera records truth, then sound must record *everything* people say."

As luck would have it, Polanski and Cassavetes were each on the edge of the set having a cigarette when Willoughby realized that their smoke was just what his next shot needed. It was of Rosemary at the kitchen sink, just beginning to feel the effects of the drugged dessert. To give the shot a dizzying effect, Willoughby distorted the image using an extreme wide-angle lens and kindly asked the two men if they wouldn't mind standing closer to where Farrow was standing. The result was a hazy, dreamlike quality "supplied by probably the two most expensive special effects men in the business."

For the critical rape sequence to be filmed on Stage 12, art director Joel Schiller began to assemble scenery that was used in other films as a way to cut costs, which did not interest Richard

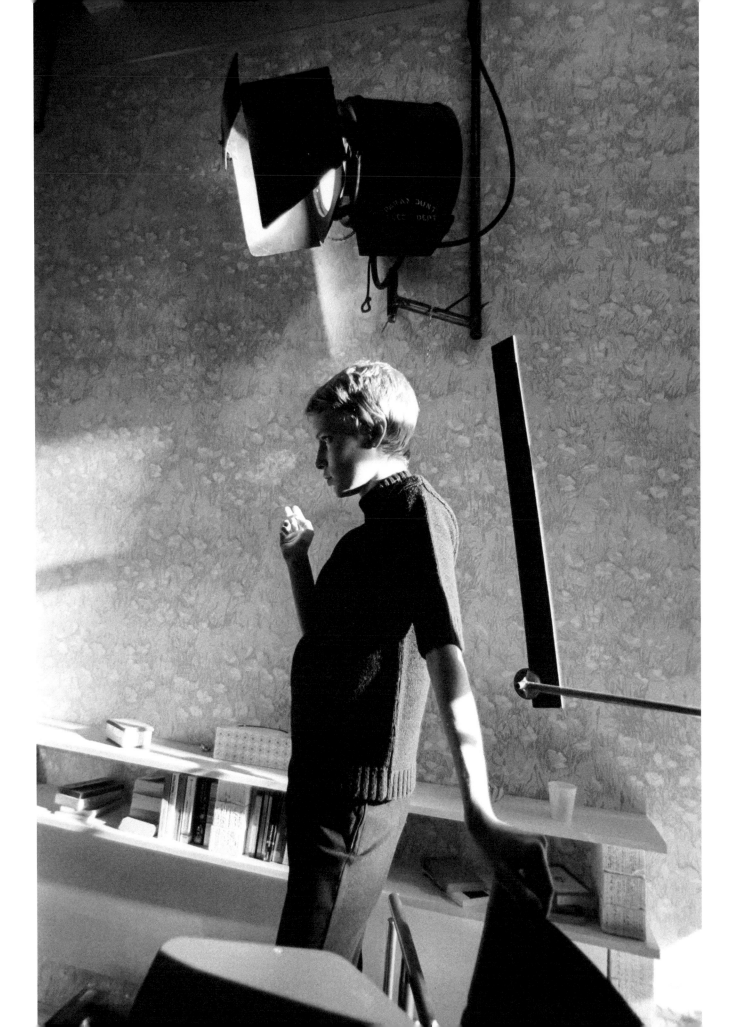

Sylbert in the least. "Throw that junk away," was his directive for Schiller. Sylbert's ideas were expensive–the Sistine Chapel set alone cost around $200,000–and to get his way, the production designer bluffed. "I told the studio heads that if they didn't build the sets," Sylbert said, "Bill Castle would pull the show from Paramount and finish it at Fox." According to Schiller, that was enough to green-light the expenditure.

The sequence's off-kilter set pieces career from Rosemary on a floating mattress to a Catholics-only yacht, views of the Michelangelo's famous fresco, a typhoon warning, a burning church, naked witches, Roman Castevet painting Rosemary's naked body, a Jackie Kennedy-esque cameo, rape by the devil and absolute forgiveness by the Pope. Scenes set onboard a yacht were later filmed on the Alterego, a former Navy search-and-rescue vessel moored in Marina Del Rey, located about 15 miles southwest of the studio.

Scenic designer Clem Hall and staff spent six weeks duplicating the size, texture, brush strokes and cracks of the Sistine Chapel's artwork. The burning church effect was achieved by a simple combination of cellophane streamers, a fan and colored lighting.

In a 1967 letter to Katharine Hepburn, Ruth Gordon writes, "Decided to take my life in my hands and get two moles off my back since I may appear nekked in *Rosemary's Baby*." Flesh colored muumuus for Gordon and Patsy Kelly gave the desired effect, whereas the male coven members wore skimpy, flesh-colored briefs. Cassavetes had resisted taking his clothes of for the scene early in the picture where the couple make love in their new, empty apartment. When it came time for the rape scene, where Polanski asked 20 people, including Cassavetes, to strip, the actor responded, "Hey Roman, don't you know Mia is married to Sinatra? Do you want the ceiling to fall in on us?" Blackmer was one of the few actors in the scene with clothes on; his discomfort mainly lay in having to paint on Farrow's nude body double.

"But I didn't entirely miss out on the scene," said Farrow. "One day I found myself–me from convent school, who prayed with outstretched arms in the predawn light–tied to the four corners of a bed, ringed by elderly, chanting witches. The Pope brought over his big ring for me to kiss, while a perfect stranger with bad skin and vertical pupils was grinding away on top of me. I didn't dare think. After finishing that scene the actor climbed off me and said politely, in all seriousness, 'Miss Farrow, I just want to say, it's a real pleasure to have worked with you.'"

Back on Stage 8, the Castevets pay a visit to the Woodhouses after hearing that Rosemary is pregnant. Minnie knows of a Dr. Sapirstein who would be just right for Rosemary and asks to use her telephone, which is in the bedroom. It was in the framing of the shot of Gordon–sitting on the bed while on the telephone–that William Fraker gained insight into Polanski's specific way of involving the audience. As the cinematographer recounted in the 1992 documentary *Visions of Light*, Fraker had framed Gordon perfectly in the doorway–you could see her face, you could see the telephone. "And [Roman] comes over and he looks, he says, 'No, no, no, Billy, no, no, no, Billy, move, move, move, move to the left, move to the left.'" And so Fraker reframed the actress to where mostly just her back was showing through the doorway–with at best a narrow view of her face, a small glimpse of the telephone. "But you can't see her," Fraker told Polanski. "Exactly," the director said. When the shot appeared in front of movie audiences, Fraker reported, 800 people leaned to the right to see around the door jam.

Tony Curtis began his movie career in 1949, a year that saw him in no less than five feature films. One of those was a crime drama called *Johnny Stool Pigeon*, directed by William Castle. They would collaborate again for *Rosemary's Baby*, though this time the actor received no billing and did not even appear onscreen. "One day [Polanski] called me up and said, 'Tony, I need somebody to play the actor on the telephone who loses the

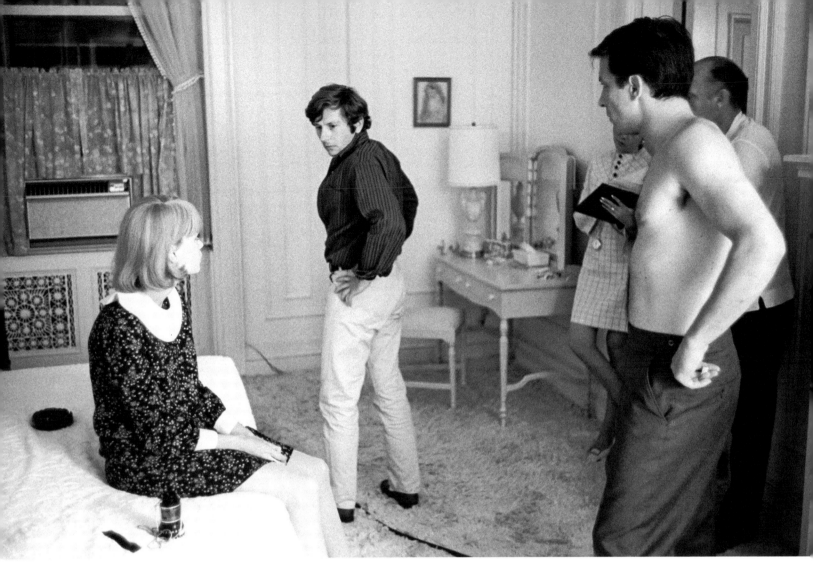

job because John Cassavetes casts a spell and takes the job away from him. I want to sneak you into the studio and I'll put you on the phone with Mia Farrow.' So that's what we did. Not until it was over did Mia Farrow realize it was me."

Two sequences took place in the office of Dr. Hill, a young obstetrician played by Charles Grodin. In the first, Rosemary undergoes medical tests to see if she is pregnant. In the second, Rosemary, whose paranoia is now burning at full incandescence, finds a sympathetic ear in Dr. Hill (with Grodin now sporting a fake moustache to make his character look older). Dr. Hill's nurse was played by Janet Garland, a real-life, 20-year registered nurse that Castle yanked out of Paramount's first aid station to appear before the camera. Minutes after her moment of celluloid glory, Garland gave up acting, returned to nursing and never looked back.

Grodin shares his most vivid memory of the shoot:

When Mia comes to me in the movie as her doctor, and tells me about her interaction with the devil, I look at her for a moment, and then say, "You may be right."

Roman directed me to take out the pause before my line. I told him my reaction to her would not be believable if I took out the pause. His response to me, "They pay me a lot of money to do this!"

I said, "Well, they don't pay me a lot of money, but I have a pretty good reputation."

As I recall, in the final version of the movie there is a small pause before I say the line. Years later when I ran into Roman at some function, I took a long pause, then said to him, "I've been thinking about what you said about that pause, and I think you were right."

"Good, good!" he said.

"Did you just believe me?" I asked.

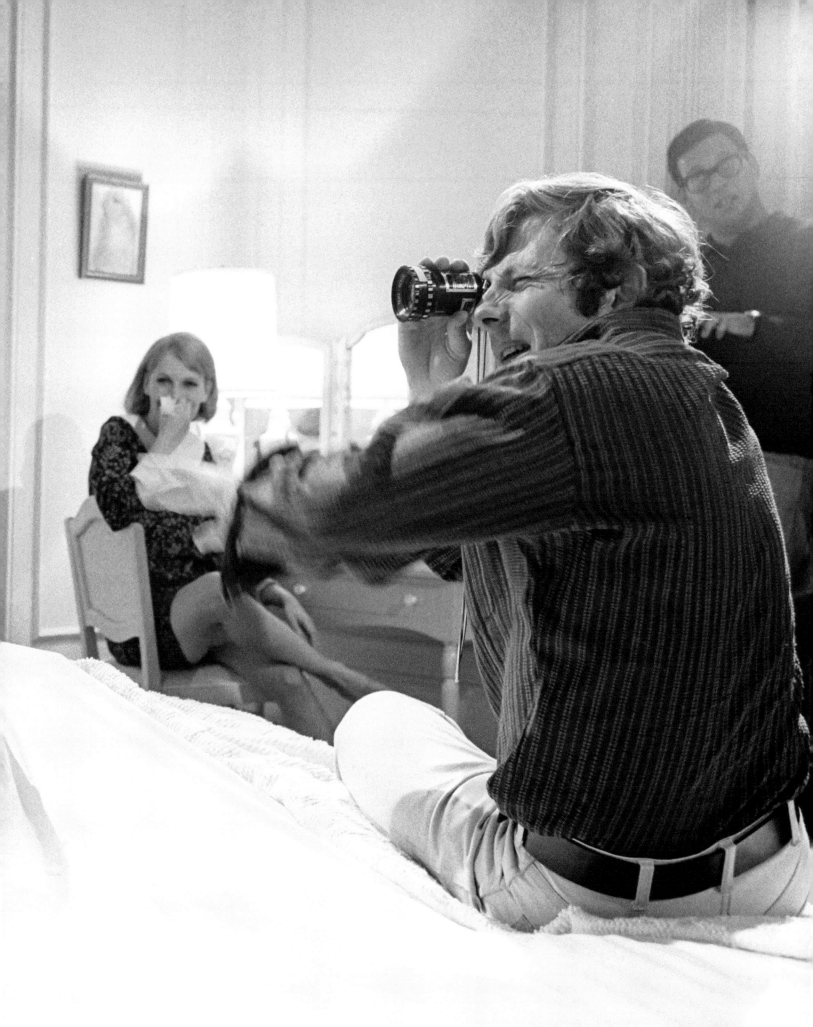

"Yes,"said he.

"Well, I didn't agree with you at all," I replied. "I just wanted to show you how a pause can sell a line."

For the scene where Rosemary's friend Hutch has the Woodhouses over for dinner, Maurice Evans was called upon to figuratively pat his head and rub his stomach at the same time. "Talking incessantly," Evans said, "I was required to dish up a leg of lamb in the kitchen, carry it into the dining room, return to the kitchen for the vegetables, then back to the table with them—still talking." With pinpoint precision, Evans married action and dialogue to Polanski's satisfaction, but did so at a gastronomic cost. "A whole morning on camera, and six legs of lamb later, our whimsical director got the picture he wanted," said Evans. "But at the same time he ruined my appetite for that particular joint of meat for the foreseeable future."

Bob Willoughby remembered a day during filming when Farrow was particularly happy: "Mia was seeing Frank Sinatra during the filming ... He had taken her to lunch this day, and had wined and dined her and Mia returned to the set full of the joys. She was like a giggling school girl, tipping over the assistant director's chair, climbing on top of the wardrobe. She was a panic, and of course I was clicking away. As she was being bundled off to her dressing room, she leaned in to me, giving me a most memorable parting line: 'Older men always try to spoil me!'"

"There are 127 varieties of nuts," Polanski once said in an interview. "Mia's 116 of them." Farrow, by Polanski's view, was "heavily into the whole range of crackpot folklore that flourished in the 1960s, from UFOs through astrology to extrasensory perception." Said Farrow, "The sixties were in full bloom. Roman was humming, 'If you're going to San Francisco, be sure to wear some flowers in your hair,' and I painted the walls of my dressing room with rainbows, flowers and butterflies." Added to that were dragonflies, birds, a sunburst, a large heart, the words "peace," "love," "live" and a color scheme of purples, reds, yellows and greens. Farrow quipped about entering it for competition at the Los Angeles Museum of Art, if only she could move it.

"They gave me a ping pong table because I was a kid, and I was getting no exercise," Farrow said. "I wouldn't even see the light of day. One night I even slept on the set." Countless and sometimes fiercely competitive games ensued involving Farrow, Polanski, the Sylberts Anthea and Richard, various crew members and even Cassavetes's *Dirty Dozen* co-star Jim Brown, who was visiting the set. But it was Cassavetes who dominated many of the matches. Only Hawk Koch could best him. "I beat John Cassavetes for a lot of money," recalled Koch.

During lulls in the filming, the energetic director practiced quick draws with a prop six-shooter and, at the end of the shoot, the crew bestowed upon him a real one with his name inscribed on the ivory handle. "He'd have his six guns out and he had a cowboy there that was a six gun draw expert who was one of the best in Hollywood," said actor Craig Littler. "So he's teaching, and Roman would be sitting there—he's a little bitty guy—and I'm sitting there, as a young actor looking at all of this, going, 'So this is moviemaking, huh? This is, this is the big time?'"

On Monday, October 23, 1967, members of the cast and crew who had watched a production of *Johnny Belinda* on television the night before came by to congratulate its star on her performance. The broadcast was directed by Paul Bogart and starred Ian Bannon, David Carradine, Barry Sullivan and, playing the deaf/mute girl at the center of the story, Mia Farrow.

One scene on Stage 8 gave Farrow a series of bruises all over. Guy and Dr. Sapirstein pick Rosemary up from Dr. Hill's office and take her home, she bolts and locks herself in the apartment, but she is found, forcefully subdued and injected with a sedative by Dr. Sapirstein. "I had a bedside scene with poor little Miss Farrow," recalled Patsy Kelly. "She was black and blue after the witches' coven had pushed her, shoved her, kicked her, shook

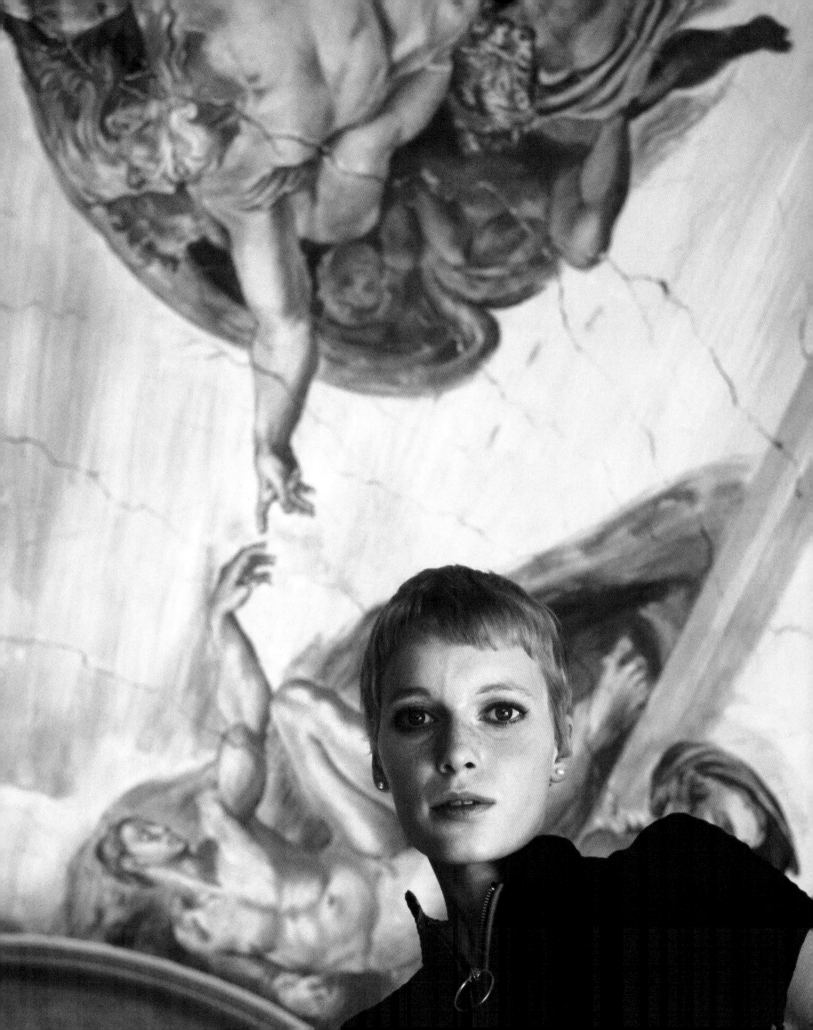

her, pinned her onto the bed at least twenty times. No nonsense, either. She never used a double. I touched her forehead and felt a high fever. I said to them, 'You better get this girl to a doctor,' but she kept right on working."

Polanski wanted Dr. Sapirstein to give Rosemary a real injection, so he dressed nurse Maryann Ward from the Paramount medical station in Bellamy's shirt and coat, had the syringe filled with energy-boosting vitamin B12 and shot the injection in close-up, with Bellamy's left hand holding Farrow's arm while Ward's right hand administers the shot.

In that scene, Rosemary is about to give birth. Showing the results of that birth became a matter of debate.

"We see far less than we think we see because of past impressions already stored in our minds," explained Polanski, referencing a book by which he was heavily influenced, *Eye and Brain: The Psychology of Seeing* by Professor R. L. Gregory. "This goes some way toward explaining what happened when the movie was finally released. Many people emerged from theaters convinced that they'd seen the baby, cloven hooves and all."

The novel describes the baby in detail, an element Polanski did not wish to carry over to the film. He discussed the final scene with Castle, who thought audiences would feel cheated if they didn't see the infant. The director insisted on leaving it to the audience's imagination, telling Castle, "Everyone will have his own personal image. If we show our version—no matter what we do—it'll spoil that illusion ... If I do my job right, people will actually believe they've seen the baby."

Ernest Harada played Young Japanese Man in the final scene and made quick friends with Ruth Gordon, Sidney Blackmer, and Patsy Kelly. "I was hired for a week, but I think we went over," said the actor. "Actually, we were close to ten days doing just that one scene. Cinematically, it was really kind of difficult. It was all hand-held going through doorways ... it was just like

nothing I had ever seen filmed ... How painstaking it was for them to get everything timed just right, and it was the beginning of my love affair with Roman Polanski."

"The biggest moment was when Roman wanted [Cassavetes] in the final scene, kind of, you know, *there*, as that meek kind of guy," explained Hawk Koch. "And John didn't want to play it like that—he didn't want to be in the scene ... one of the biggest fights I had ever seen on a movie set was between Roman and John that day on Stage 18."

Fraker recounted his take on the matter: "One day we were working and all of a sudden we heard this screaming and hollering, and John came out from behind the set and started walking away to the stage door. He was screaming, 'There are no stars in this goddamn picture! *You're* the star!' And Roman stuck his head out from behind the set and said, 'You better believe it!'"

"Relations between John and Roman ... had broken down," Farrow said. "While mapping out the final sequence of the movie, John became openly critical of Roman, who yelled, 'John, shut up!' and they moved toward each other ... It was Ruth Gordon, with consummate professionalism, who said, 'Now, come on, let's get back to work,' and saved the day."

Koch chalked it up to "two great filmmakers wanting their way. There are a lot of egos in making movies and those two just didn't match up very well ... John's playing the biggest shit in the world, he's giving his wife to the devil. I mean, that's a tough role to play."

Cast and crew left the gates of Paramount for a day to film at various Los Angeles locations, including a Paul Williams-designed house on the southwest corner of South Las Palmas and West 4th Street. Played out on the front lawn was the brief dream Rosemary has—showing the baby to a group of people—while resting in Dr. Hill's office. Also part of the day-long field trip was a shopping sequence, a section of the movie only

partially shot. A montage where Rosemary and her friend Joan (Marianne Gordon) shop for apartment items was scheduled to include the exterior of a carpet store, a fabric department, a bedding department and a shot of the women riding up a department store escalator. The escalator scene was filmed before it was decided to scrap the entire sequence.

"Frank was baffled and outraged by the pace of our filming," Farrow said. Angry phone conversations between Sinatra, Robert Evans and William Castle ensued, with Sinatra threatening to pull Farrow off the film if she wasn't finished by November 14. "She's starting on my picture on the 17th," Sinatra told Evans. "Got it straight?"

As her start date for *The Detective* was drawing near, Farrow had serious options to weigh. Sinatra rightfully expected her to join him in *The Detective* when *Rosemary's Baby* was over. But because *Rosemary* was behind schedule, she was convinced that he expected her to walk away from it and report to work on his movie. She believed her marriage hung in the balance. Farrow thought Sinatra would eventually understand that she could not abandon as important an opportunity as *Rosemary's Baby*. And she knew that walking off the film would profoundly damage, if not outright kill, her career, not to mention negate months of great work by cast and crew. She felt confident that Sinatra would not leave her.

"The problem with Mia was with her marriage to Frank Sinatra," Richard Sylbert said. As he understood it, Frank wanted a homebound wife and Farrow was anything but, especially as female lead in a much-anticipated film. Sinatra's efforts to get Farrow to walk away failed because "Frank underestimated Mia's great inner strength—she wasn't about to be bullied."

On Stage 18, Farrow, Cassavetes, Marianne Gordon,

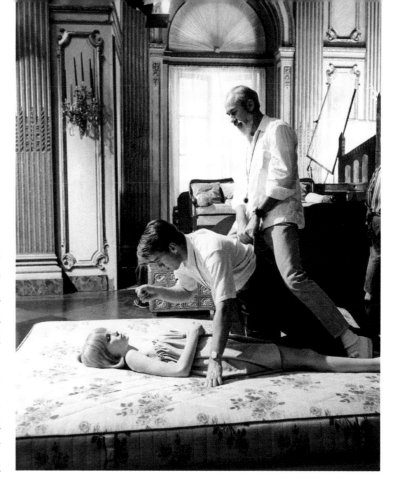

Emmaline Henry and 14 bit players assembled on Stage 8 to shoot the party scene. Marianne Gordon was given a red wig to set her apart because "Mia Farrow and I were both skinny and blonde." Also in the scene was actor Ken Luber, who said, "The most vivid thing I remember is the ping pong business and everybody saying at the time, 'Well, he's going to do a lot of takes, he's going to do a lot of takes.' And some people were happy about it and some people thought he was just being a dilettante."

Cassavetes charmed Georgia native Marianne Gordon, who observed, "He was so sweet, and so nice, and so ... not like a person who sold his soul to the devil, for sure! And not like he was, you know, a Hollywood actor type. He was just like 'I'm here, I happen to be an actor, but first of all I'm a husband, I'm a father, I'm a friend, I'm a human being.'" Luber liked the actor, too: "I talked with Cassavetes because we were playing ping pong. He was nice! I mean, he was like one of the guys— *that* kind of attitude."

Polanski gave very little explicit direction for the party sequence, basically telling the actors to just walk in, be real,

mingle, talk low unless the principles have dialogue. A couple of actors were given specific descriptions of who they were playing. George Robertson was told that he was to be a novelist and a friend of Guy's, "but that never went anywhere. Just another tale of the cutting room floor." Craig Littler played Jimmy, an actor friend of Mia's, and observed that that "was strictly something to give us for nothing, because there wasn't any way you could project that."

For this scene, a technical challenge presented itself. In the final script, the party scene ends with Rosemary's friend Jimmy (Craig Littler) exclaiming, "Hey, snow!" A description follows: "Guests crowd the windows; fat wet snowflakes shear down, now and then striking one of the panes, sliding and melting." Rosemary delivers the scene's final line: "This is why I wanted this apartment; to sit here and watch the snow with the fire going."

Polanski asked Paramount special effects man Harry Stewart to make it as wet and fat as described, something Stewart had never done before. It was an effect far removed from old days of using potato flakes, chopped chicken feathers or (gasp) shredded asbestos for onscreen snowfall. Stewart asked other special effects people at other studios; no one knew how to do it. After much trial and error, Stewart found the recipe: A tub was filled with dry ice, a metal bucket was placed in the middle of the tub, and the ensuing frost was scraped off the bucket and hurled at the window. To his and Polanski's delight, it hit the glass and dutifully melted as it slid downward.

The perception of Cassavetes as a man who did not like a lot of takes was challenged by Littler, who observed about 30 of them involving a scene in the kitchen. Finally Polanski said to the actor, "John, John, it's good, it's good ... We got it. I promise you we got it." It was about eight o'clock in the evening and, according to Littler, Cassavetes was *still* not ready to leave. "The guy made me nuts," Littler said of the actor. "I just couldn't believe it."

"John Cassavetes was known as an armpit actor," Littler said. "The guy was just constantly always looking for motivation, and he's one of those guys that a lot of directors say, 'Your motivation is that check you get at the end of the week for a half a million bucks. Just say the lines.' John was good, but he was very introspective in his acting. He was very overly dramatic. He really worked hard at the method, that sort of Stanislavski method."

Farrow's role in *The Detective* was reduced and recast with Jacqueline Bisset while Farrow plugged away at *Rosemary's Baby* and hoped Sinatra would come to terms with her decision. It was not to be, and while Rosemary's party was being captured on film, Sinatra's lawyer Mickey Rudin showed up with a brown envelope for Rosemary herself. Farrow and Rudin went into her dressing room; inside the envelope was an official application for divorce. Surprise and shock took over. "I held myself together and signed all the papers without reading them," Farrow said. "If Frank wanted a divorce, then the marriage was over."

A short time passed, then Rudin left quietly, leaving her inside with the door closed. She was needed on the set, but didn't come out. As Littler recalled, "Roman's waiting for Mia, William Castle comes walking in with Bob Evans ... and they're talking, 'Where's Roman, where's Roman?' Well, Roman is over there playing ping pong 'cause he didn't give two shits. He just goes, 'Well, okay, tell me whenever she's ready.'" Polanski knocked on her door. There was no answer. Finally,

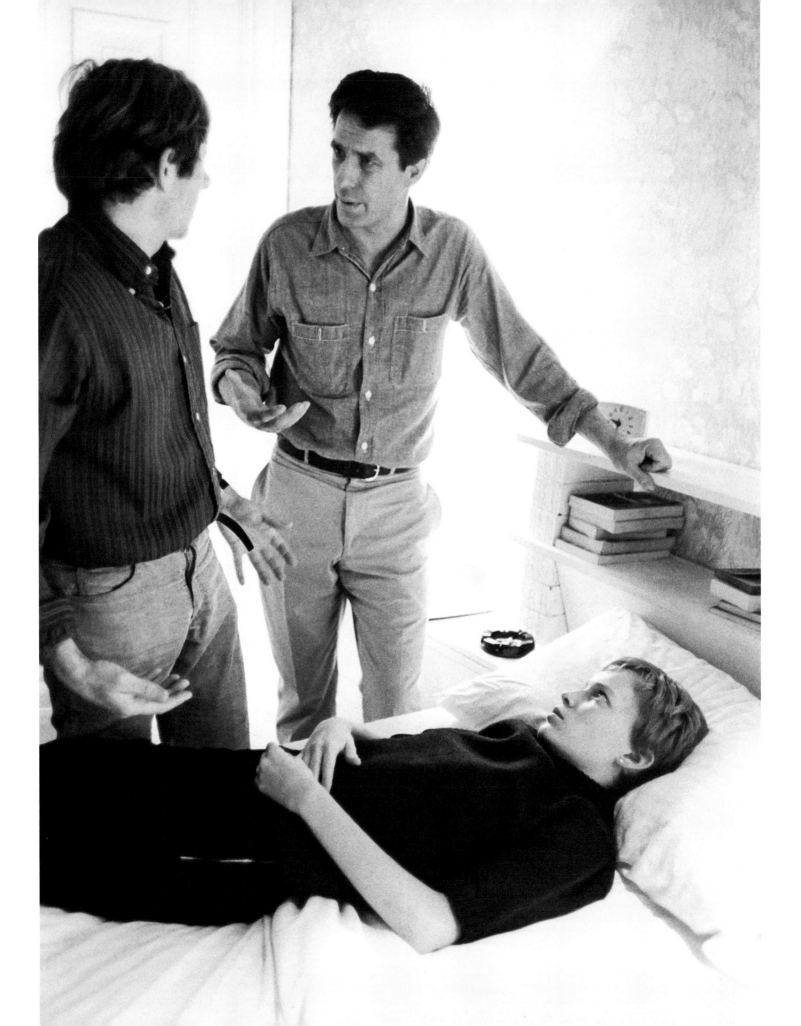

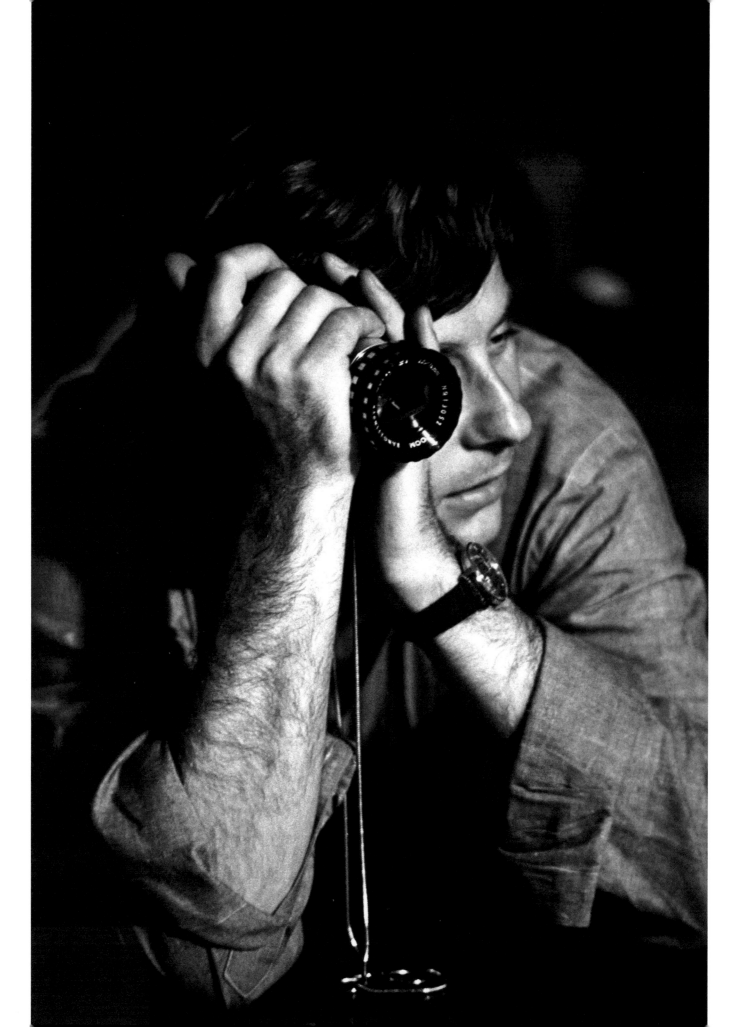

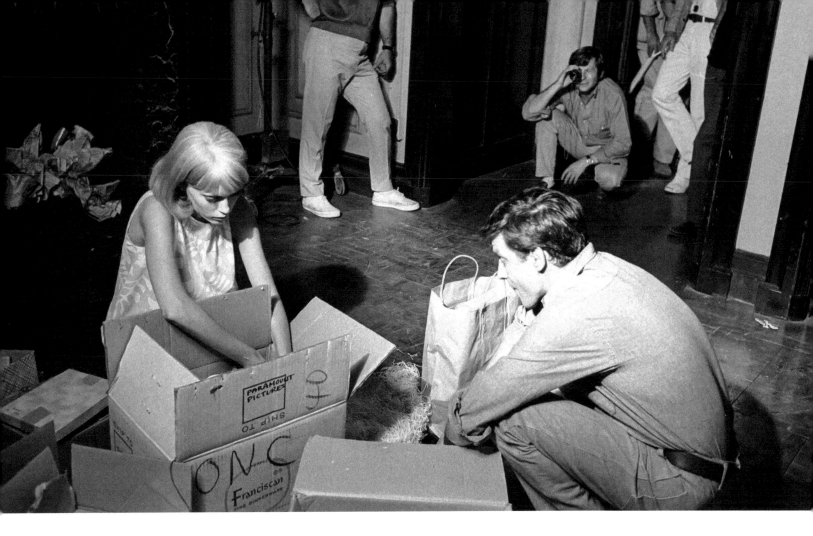

he opened the door and went in.

"There she was, sobbing her heart out like a two-year-old," said the director. "At first she was completely inarticulate. Then she managed, haltingly, to tell me that Rudin had come to inform her that Sinatra was starting divorce proceedings. What hurt her most was that Sinatra hadn't deigned to tell her himself, simply sent one of his flunkies—a callous move that didn't endear him to me ... sending Rudin was like firing a servant. She simply couldn't understand her husband's contemptuous, calculated act of cruelty, and it shattered her."

Farrow was in no condition to work, and the party scene had to resume filming the following day.

To calm her down, Robert Evans showed Farrow an hour-long rough cut of the movie and effusely praised her portrayal, telling her "It's as good, no, even *better* than Audrey Hepburn's performance in *Wait Until Dark*. You're a shoo-in for an Academy Award." Evans said, after that, Farrow's only interest was to see *Rosemary's Baby* outgross *The Detective*.

The news of the divorce hit the public around Thanksgiving. Though Farrow would go on to spend Christmas with Sinatra in Palm Springs, she spent much of her free time with Polanski and Sharon Tate for the remainder of the shoot. "Like the princess in a fairy tale, Sharon was as sweet and good as she was beautiful," Farrow said. "Generously they invited me into their lives, and since I now had none of my own, I gratefully spent my weekends with them."

The film finally wrapped just before Christmas. "I don't think the picture was scheduled properly," said Hawk Koch on what he thought was the movie's core problem. "I think to say it was behind schedule was because the people who scheduled it didn't really communicate with Roman about *how* he liked to work and the *way* he worked. I think we ended up going 85 or 90 days, and the original schedule was 55 days ... had I been scheduling, I probably would have scheduled something around 70 days." Ultimately, *Rosemary's Baby* went $400,000 over budget and cost Paramount $2.3 million.

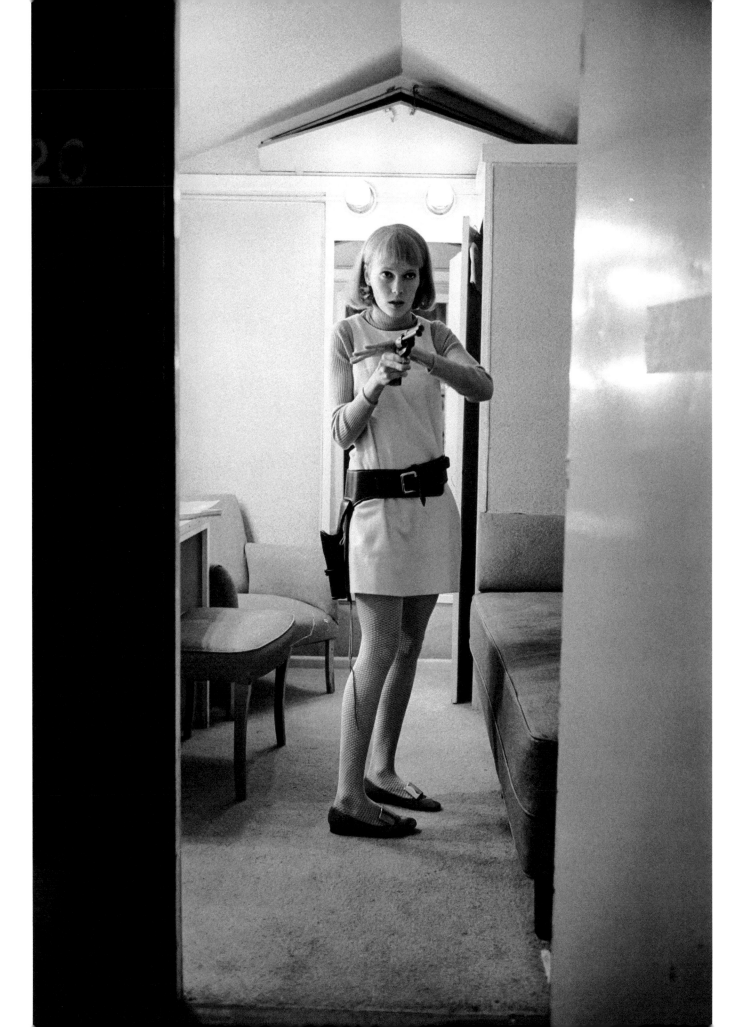

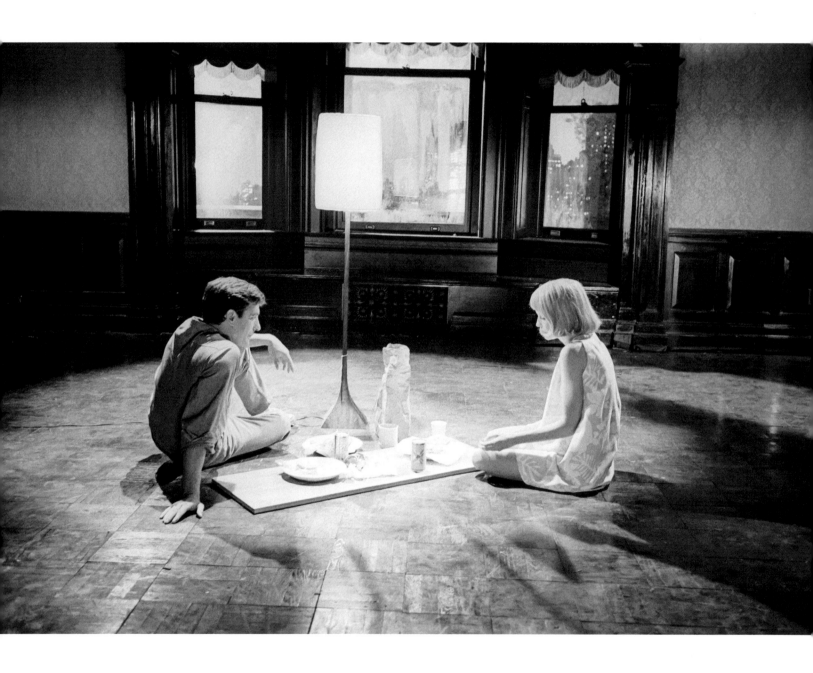

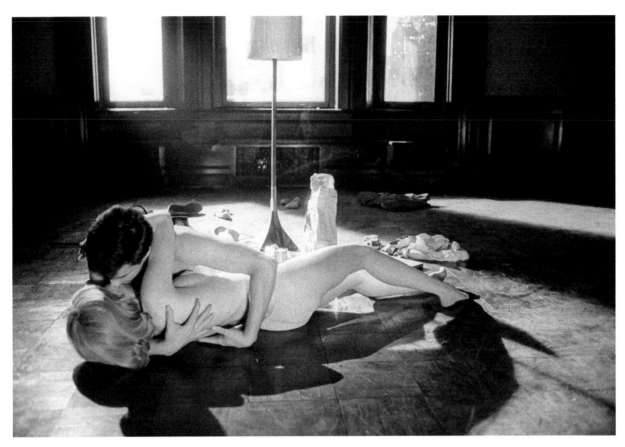

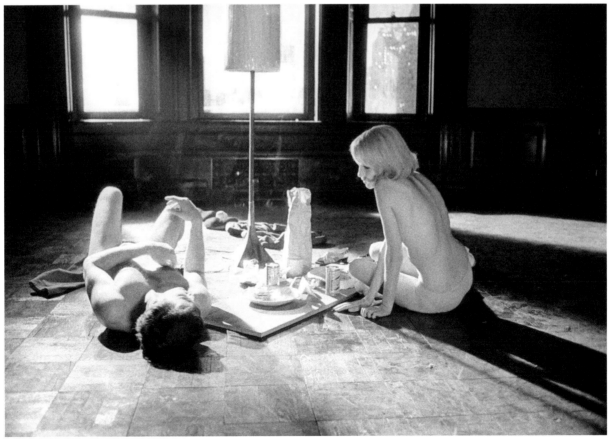

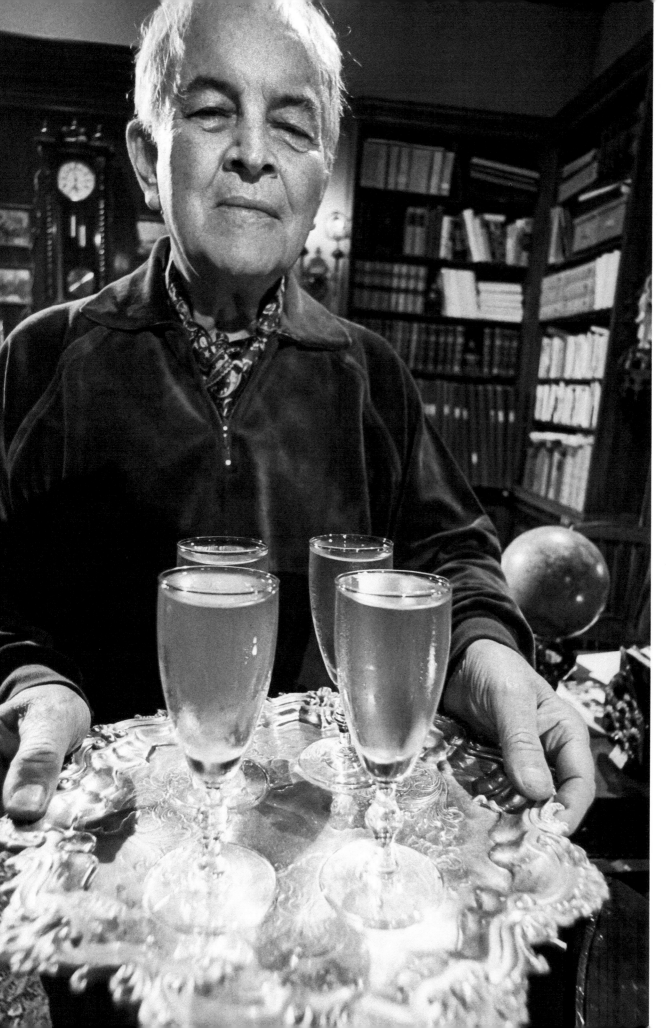

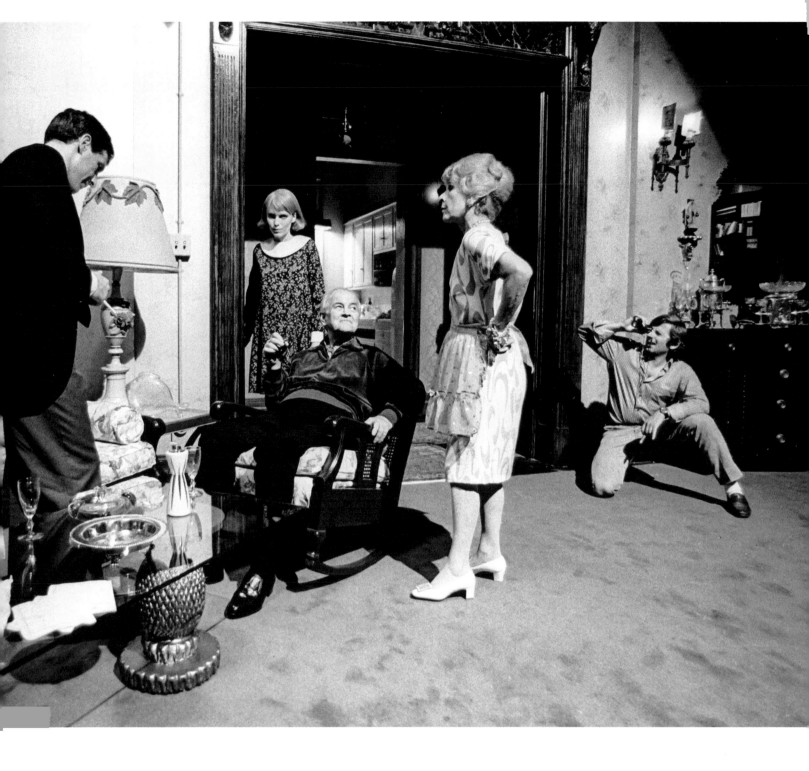

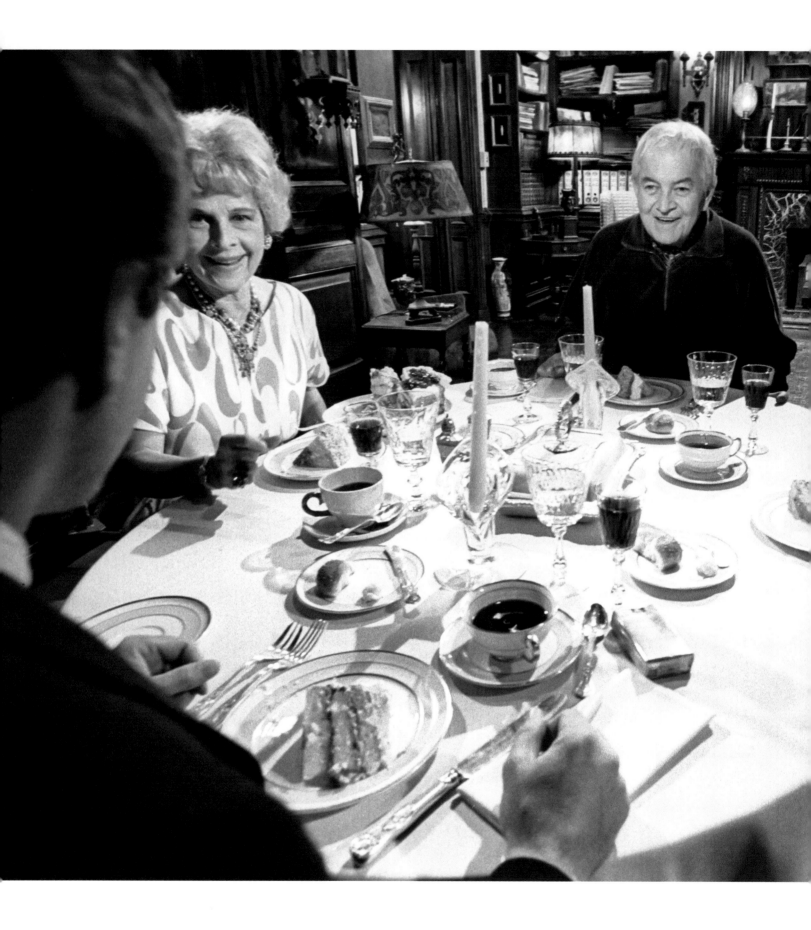

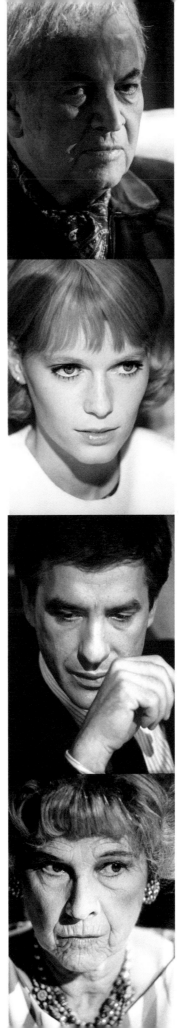

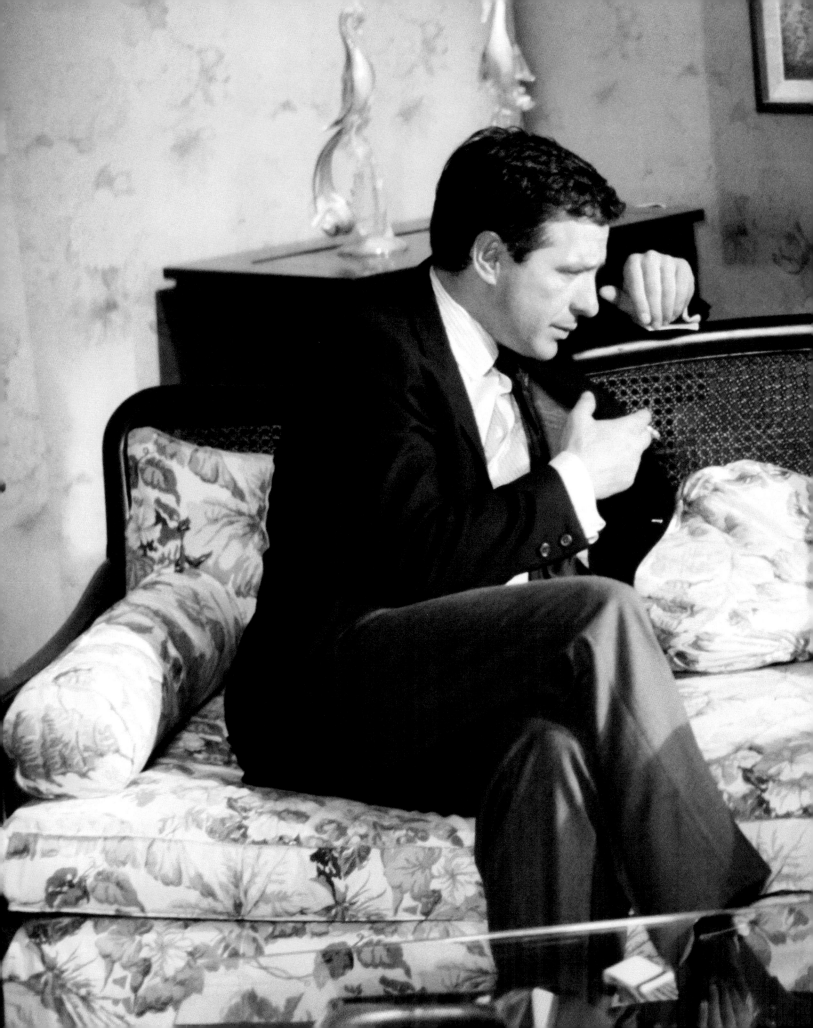

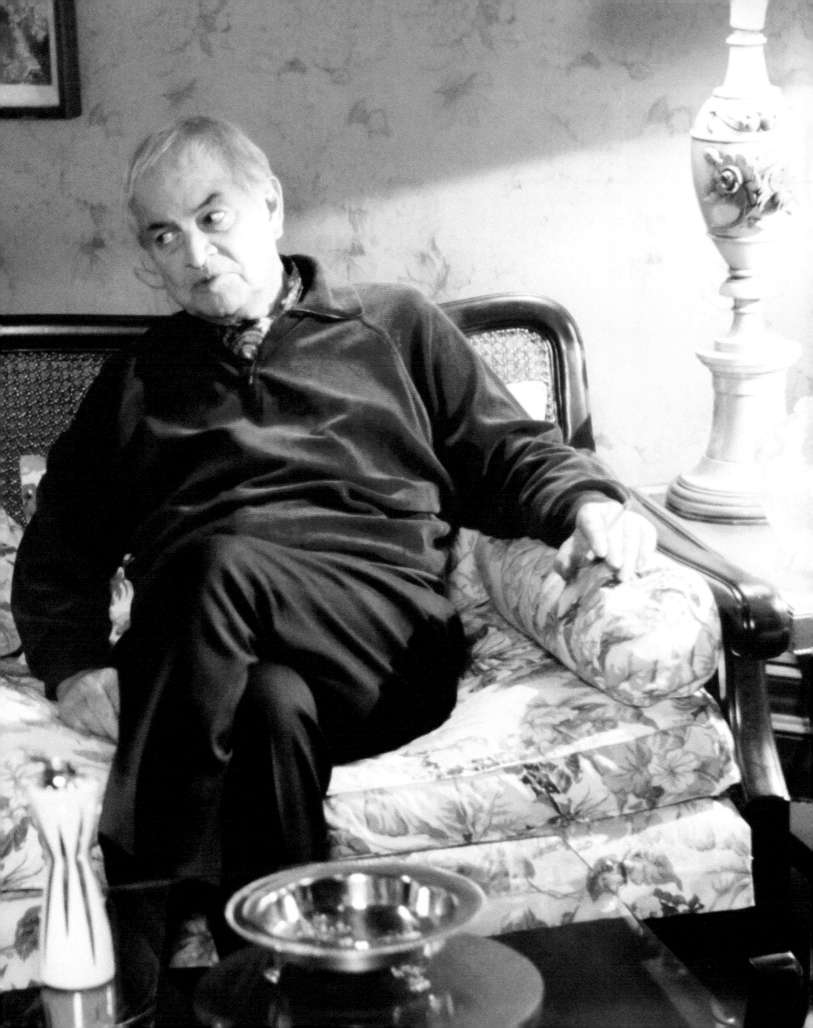

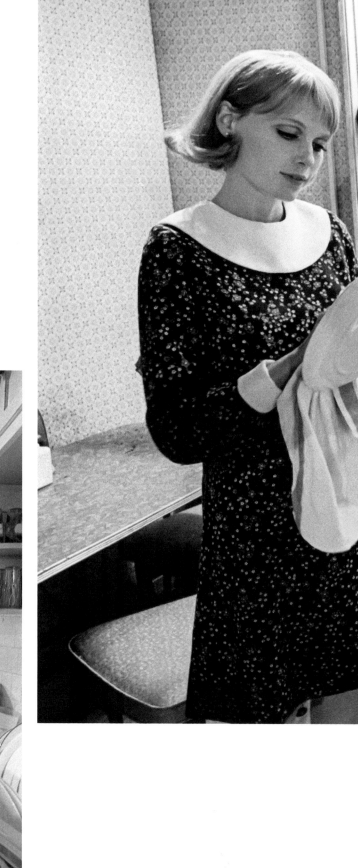
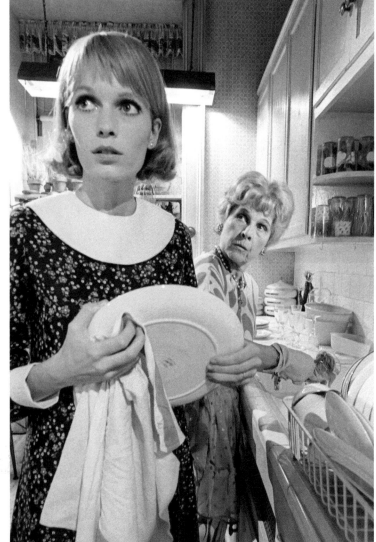

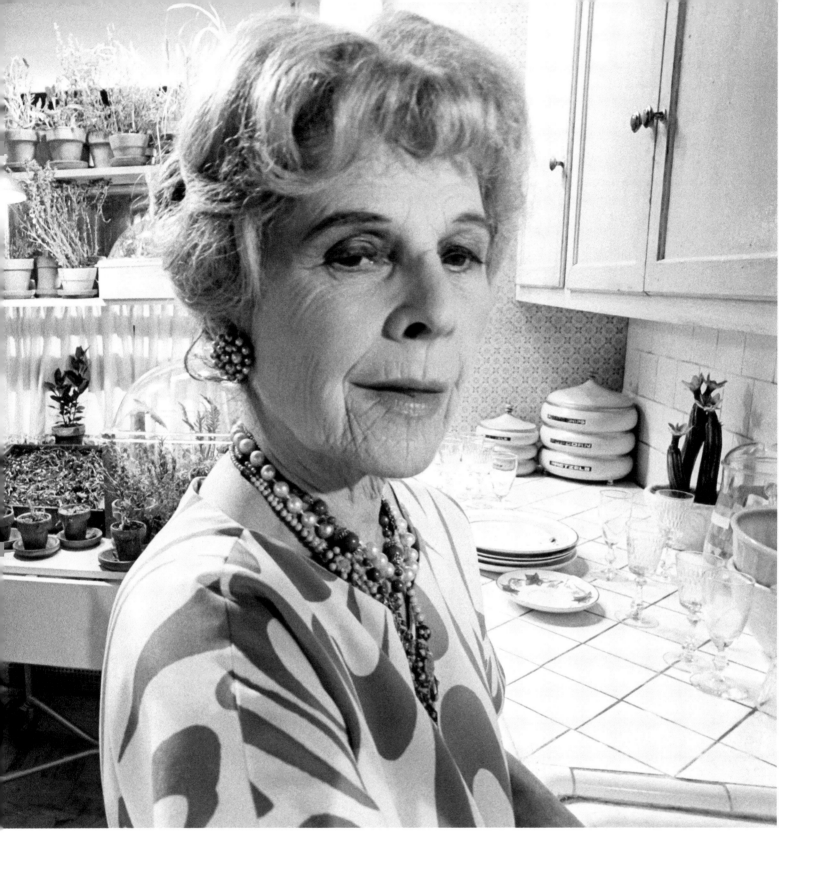

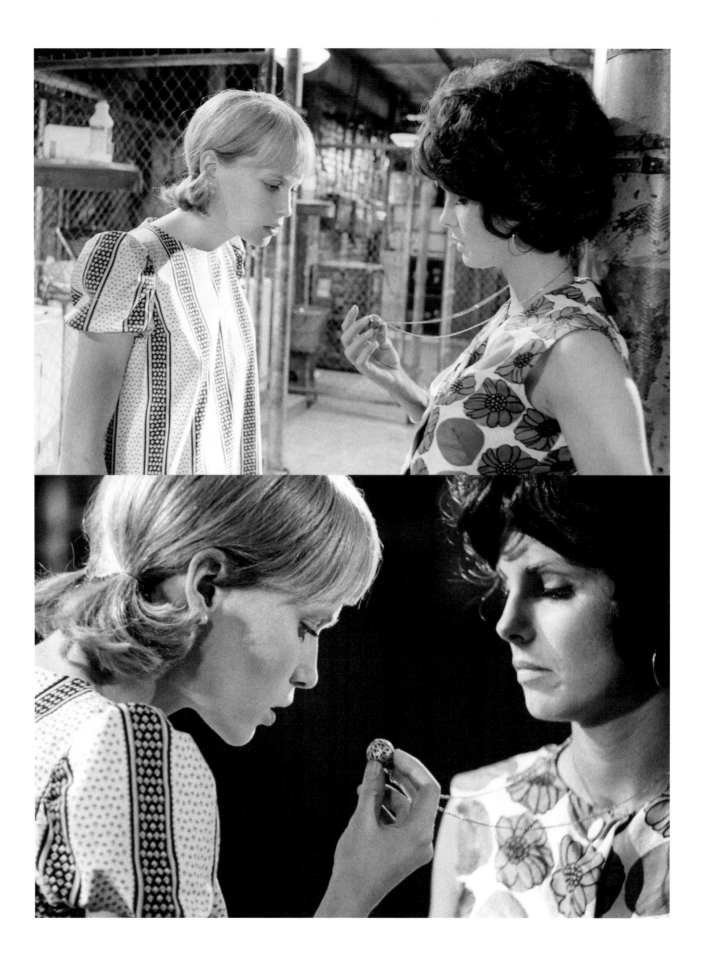

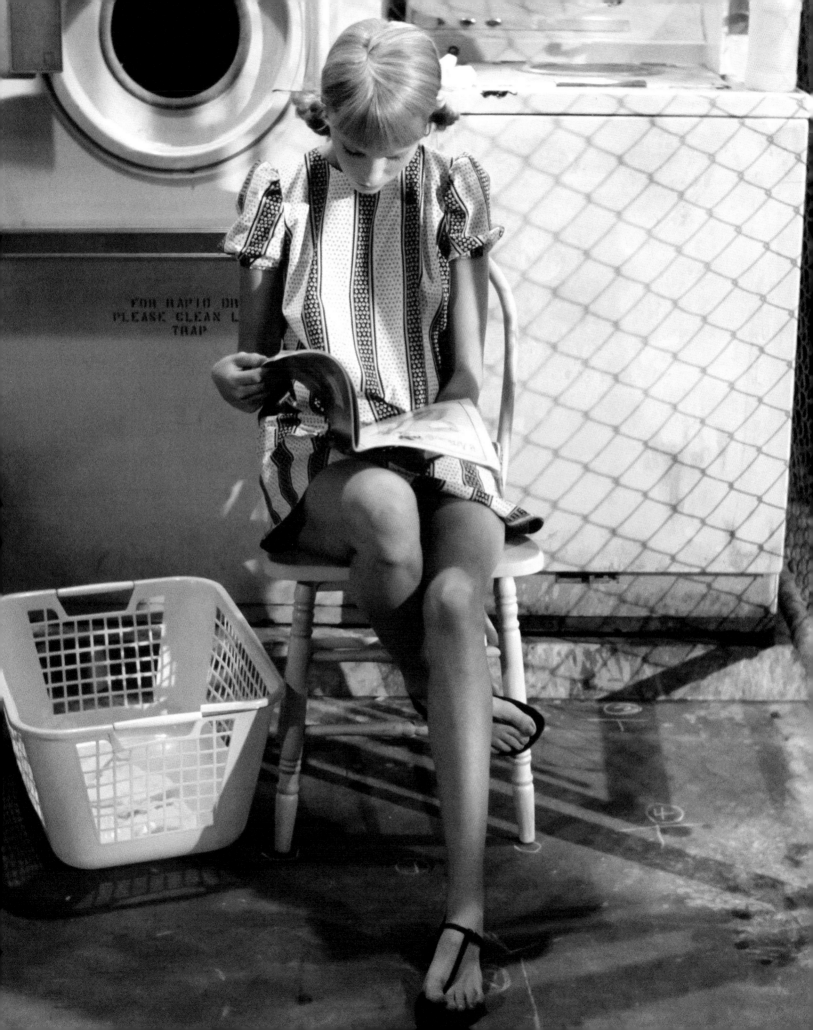

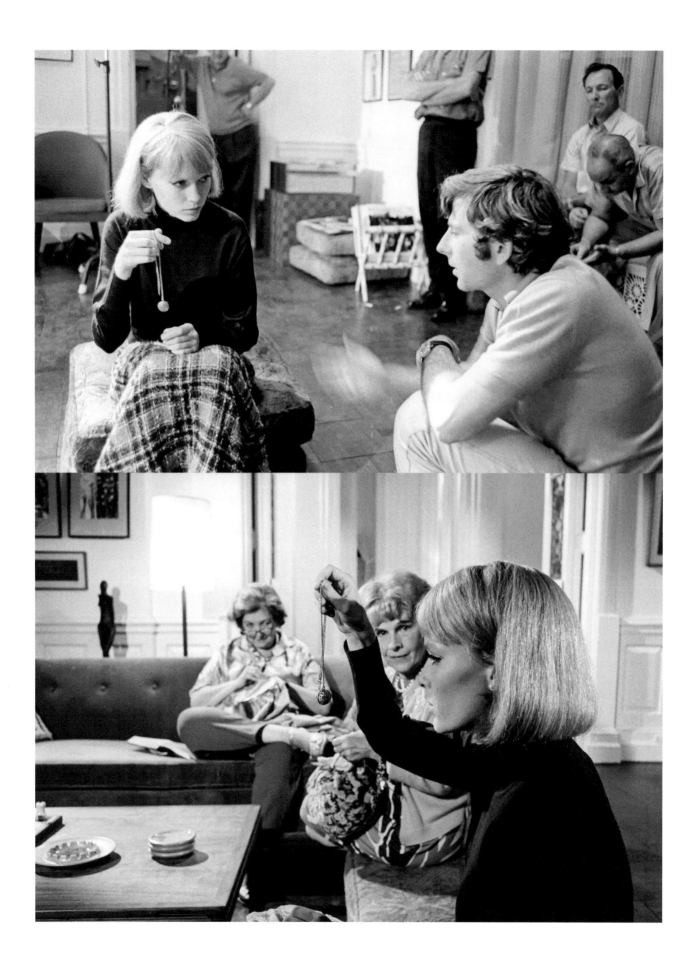

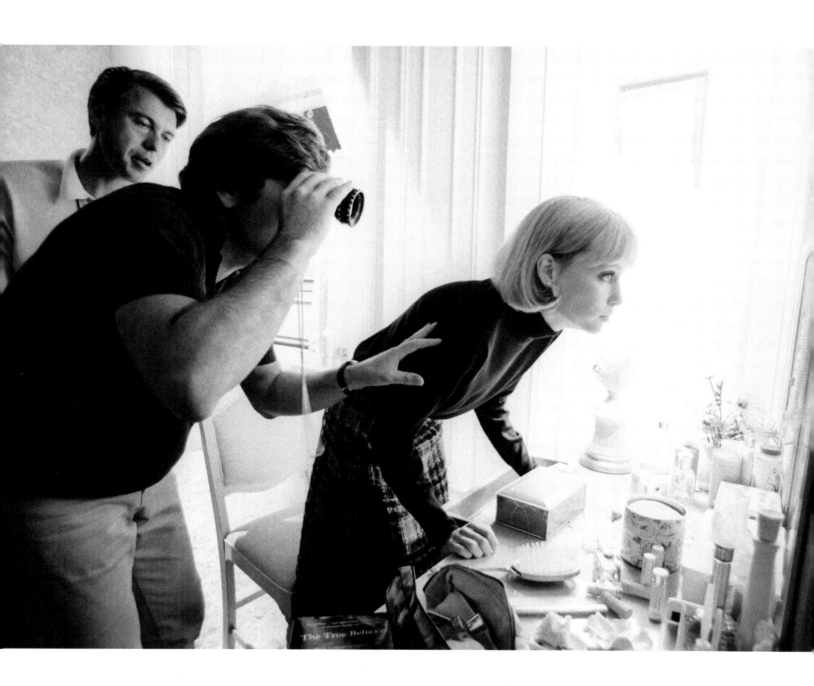

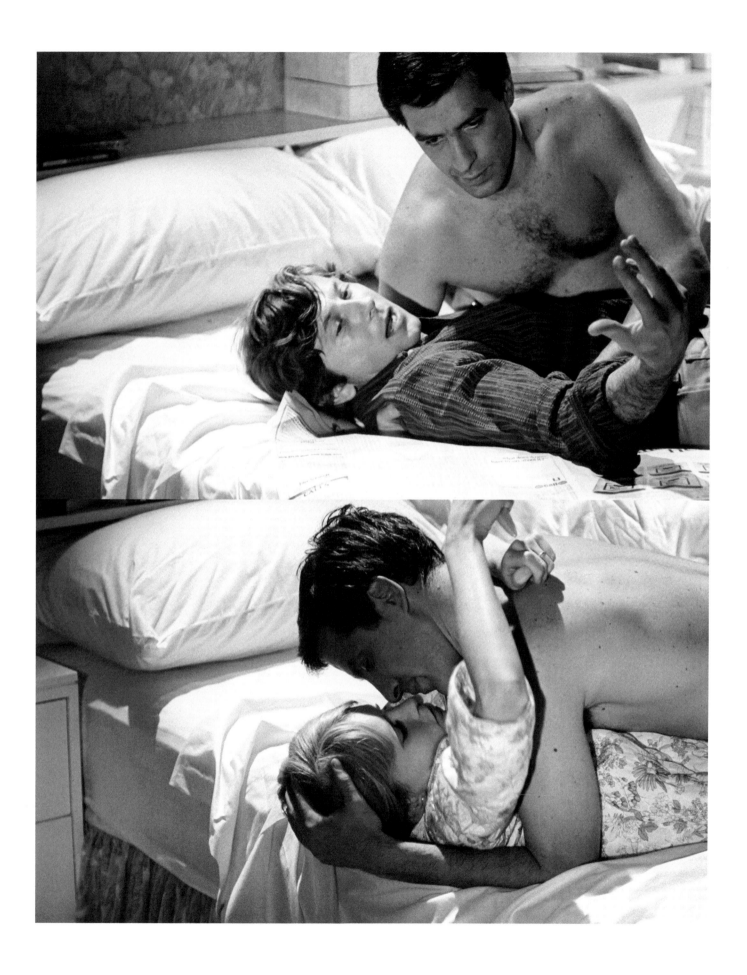

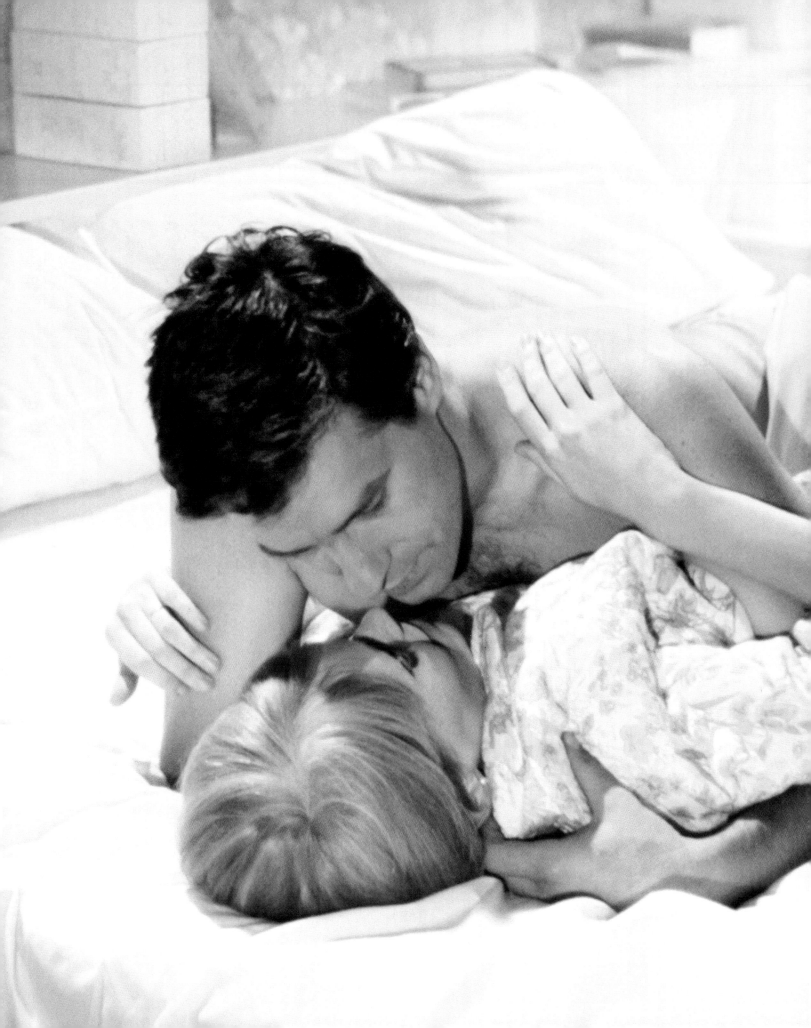

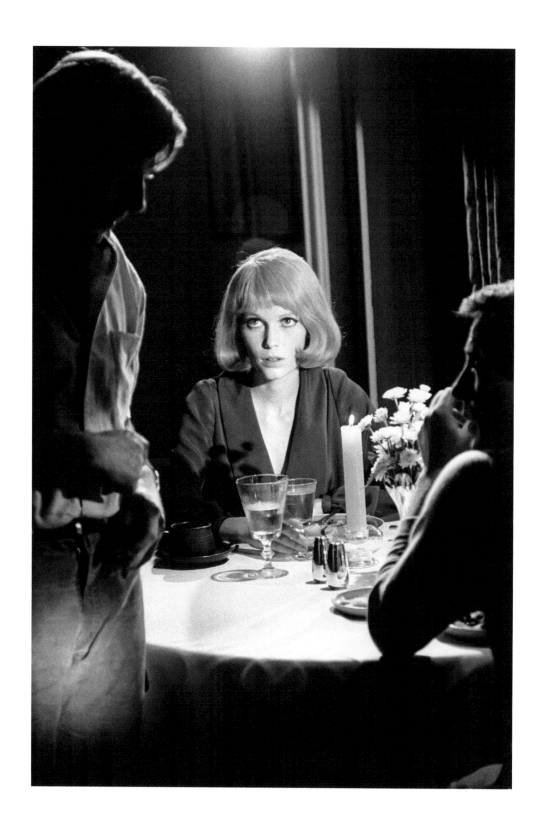

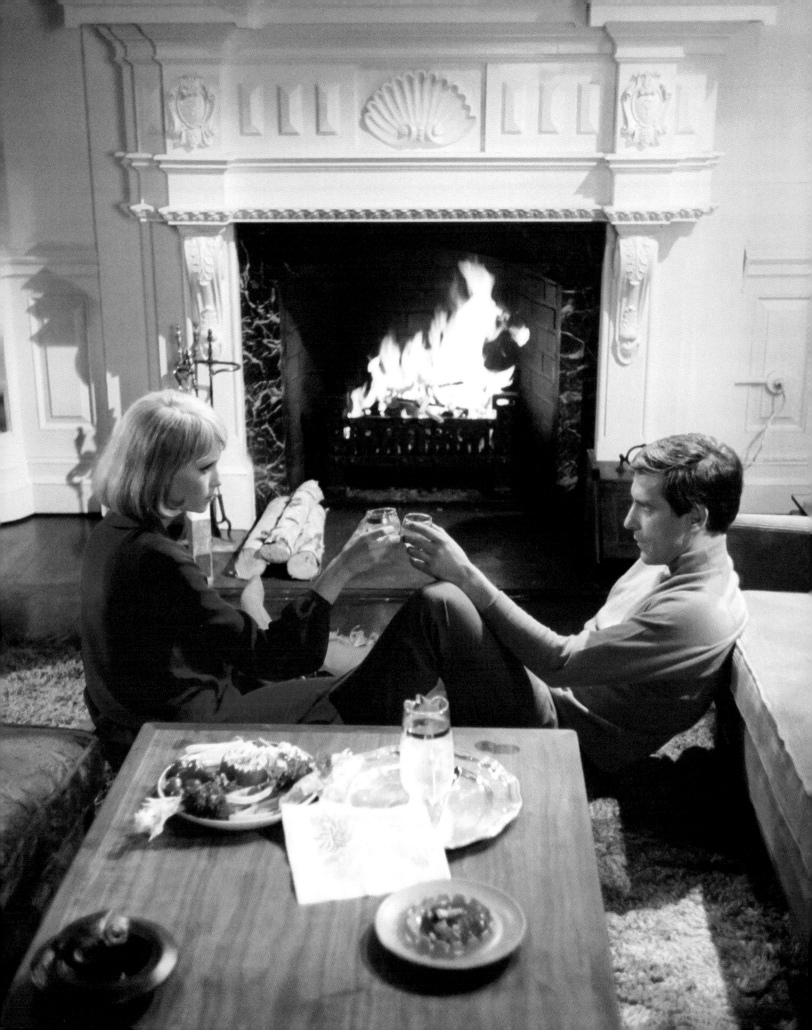

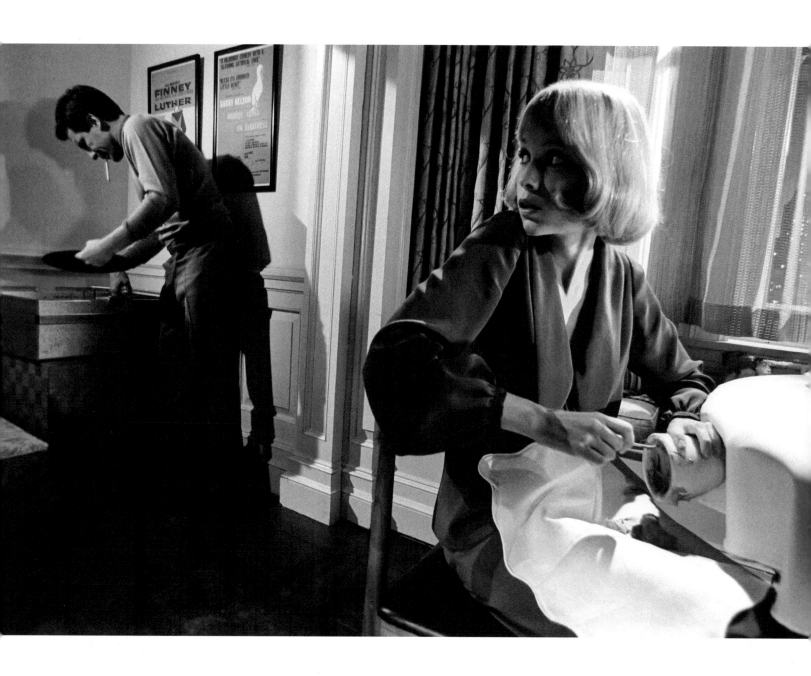

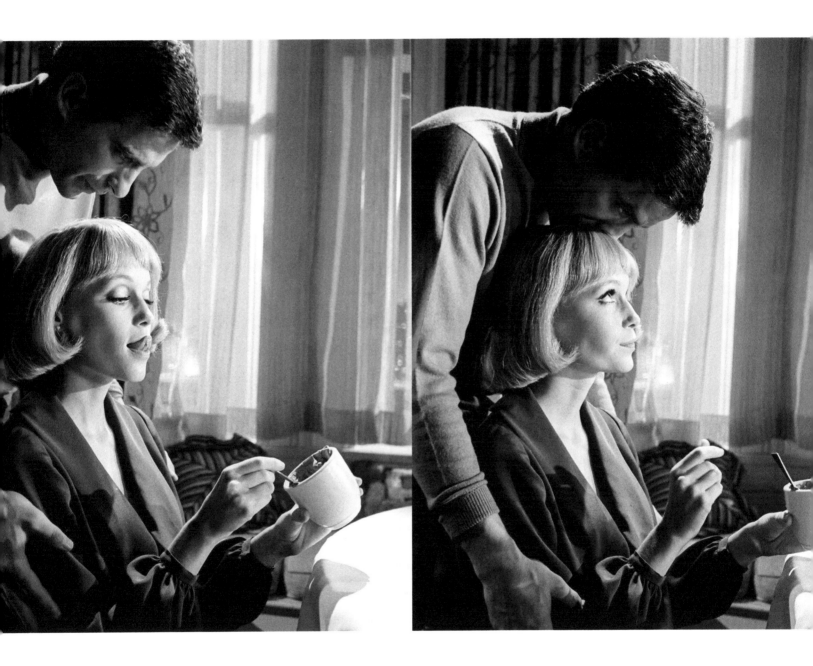

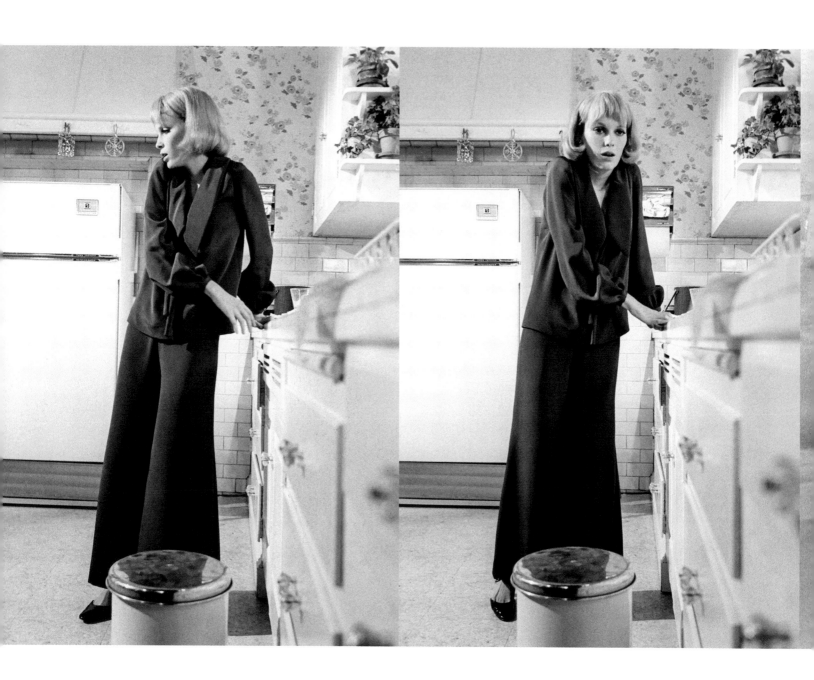

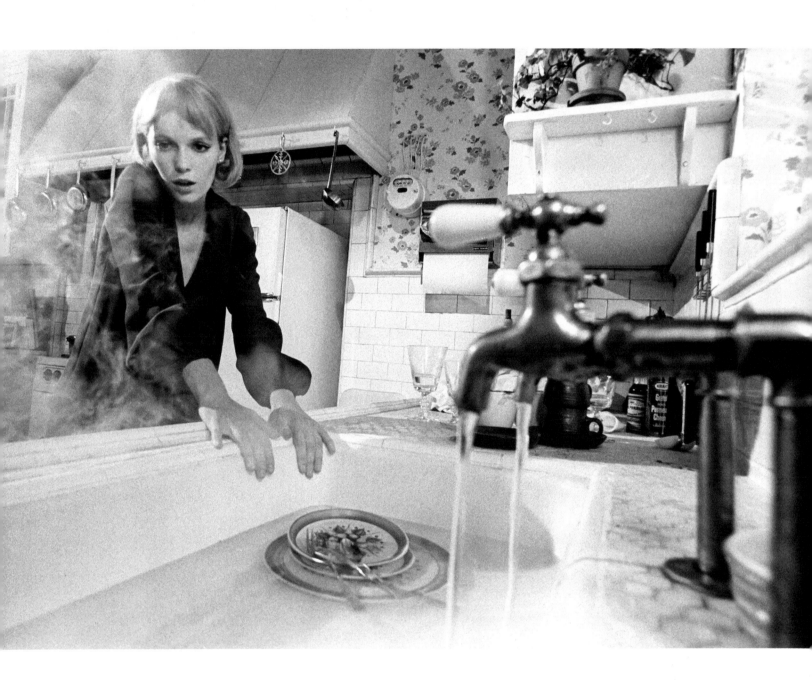

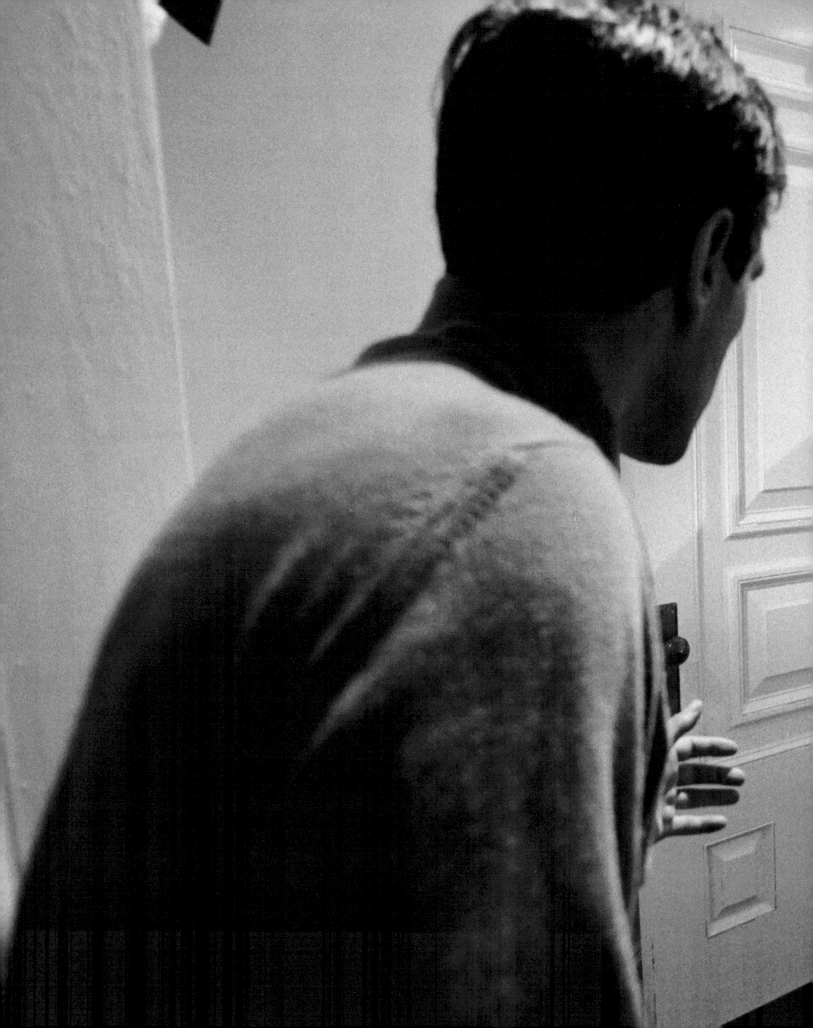

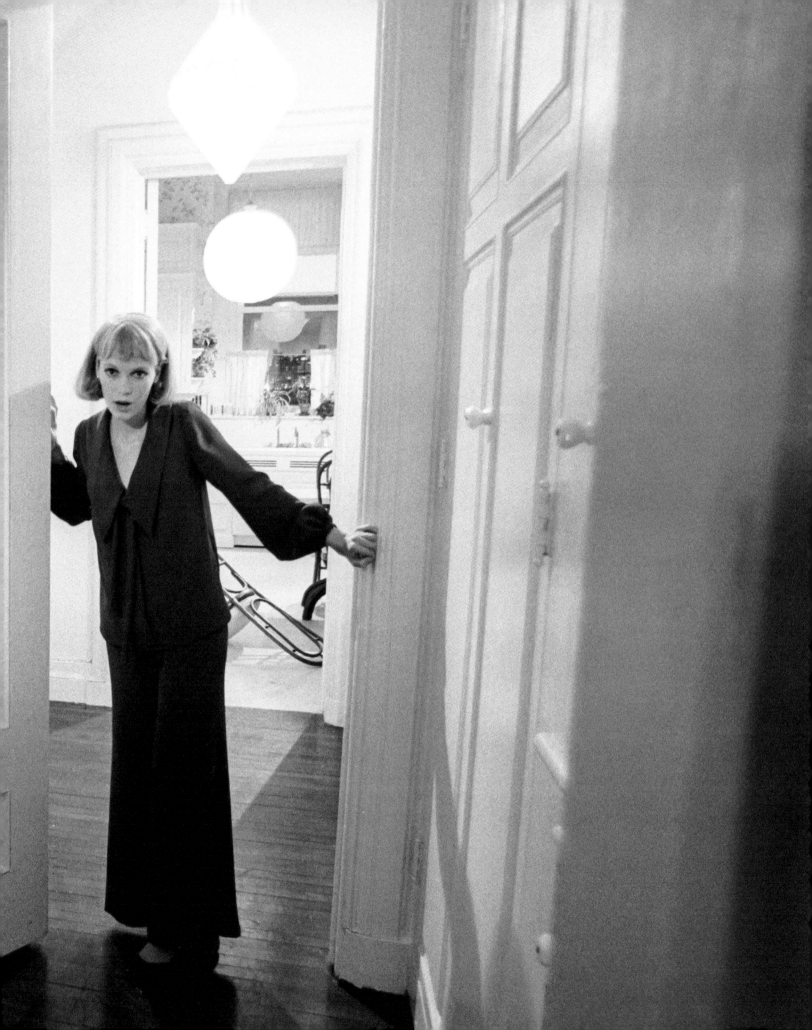

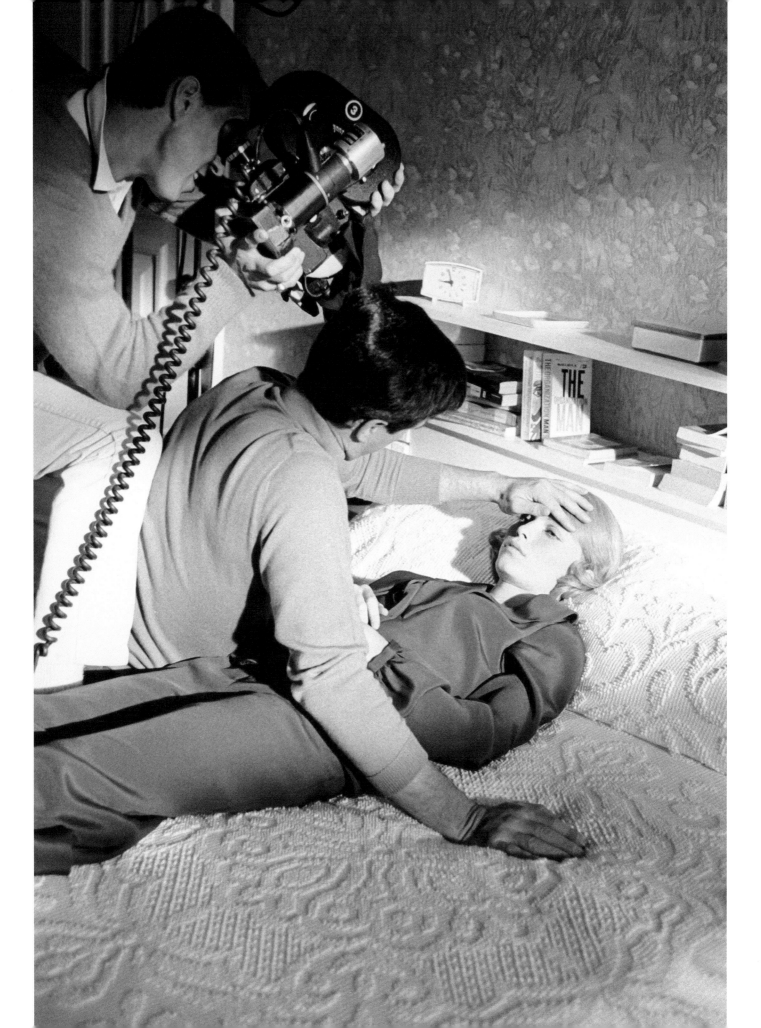

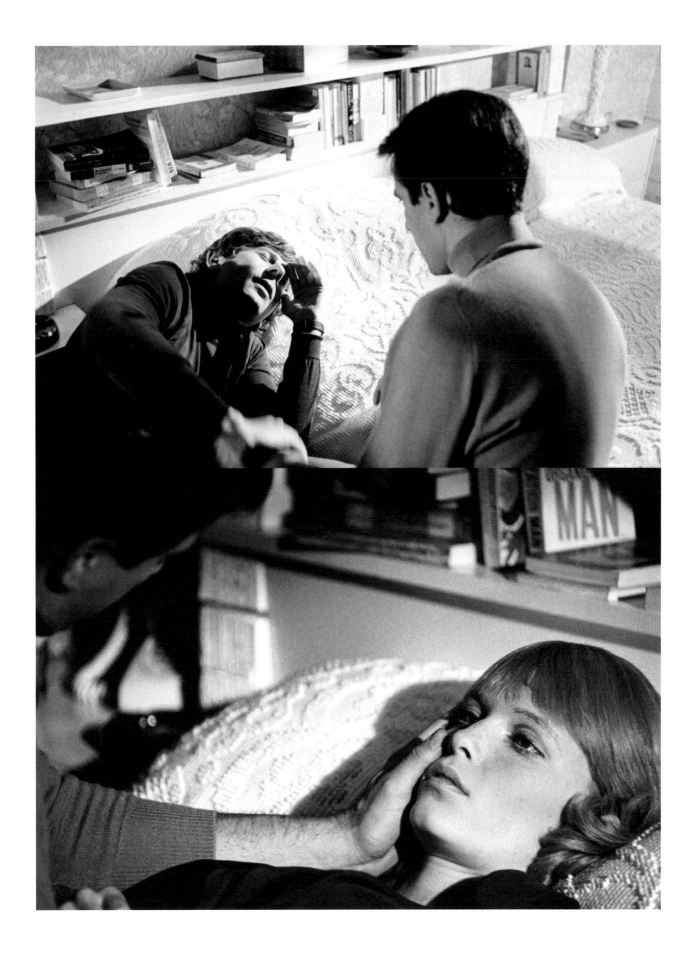

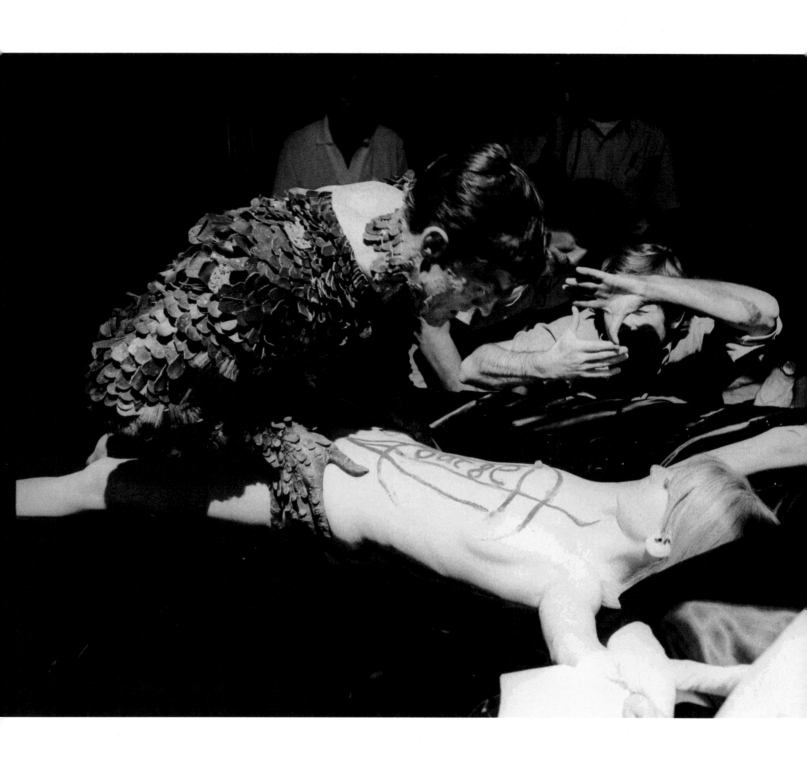

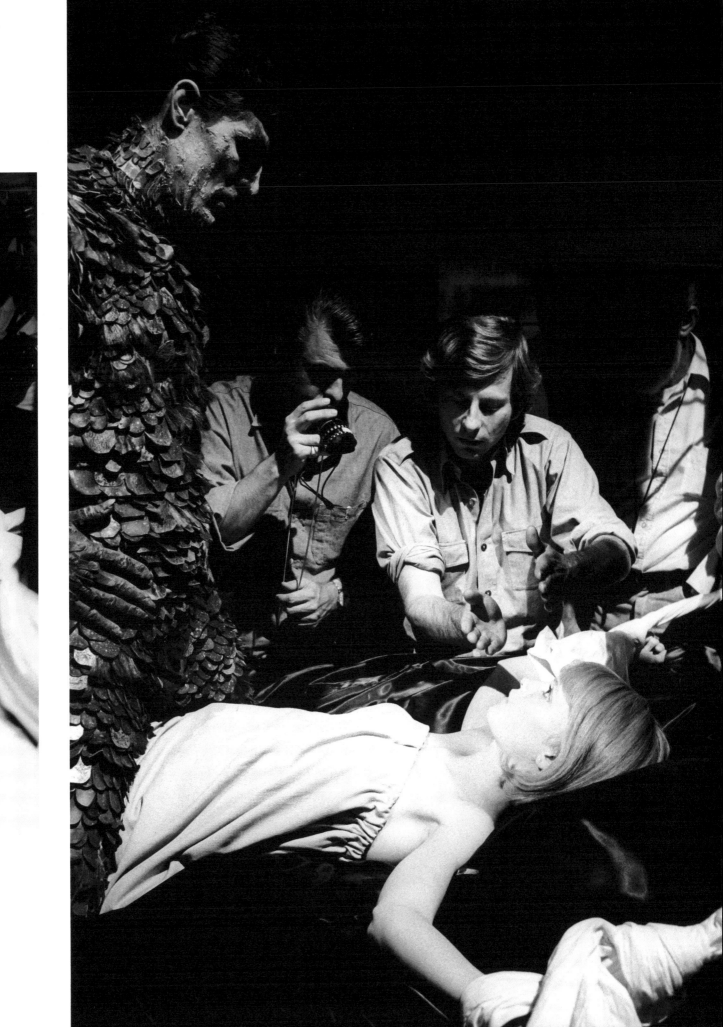

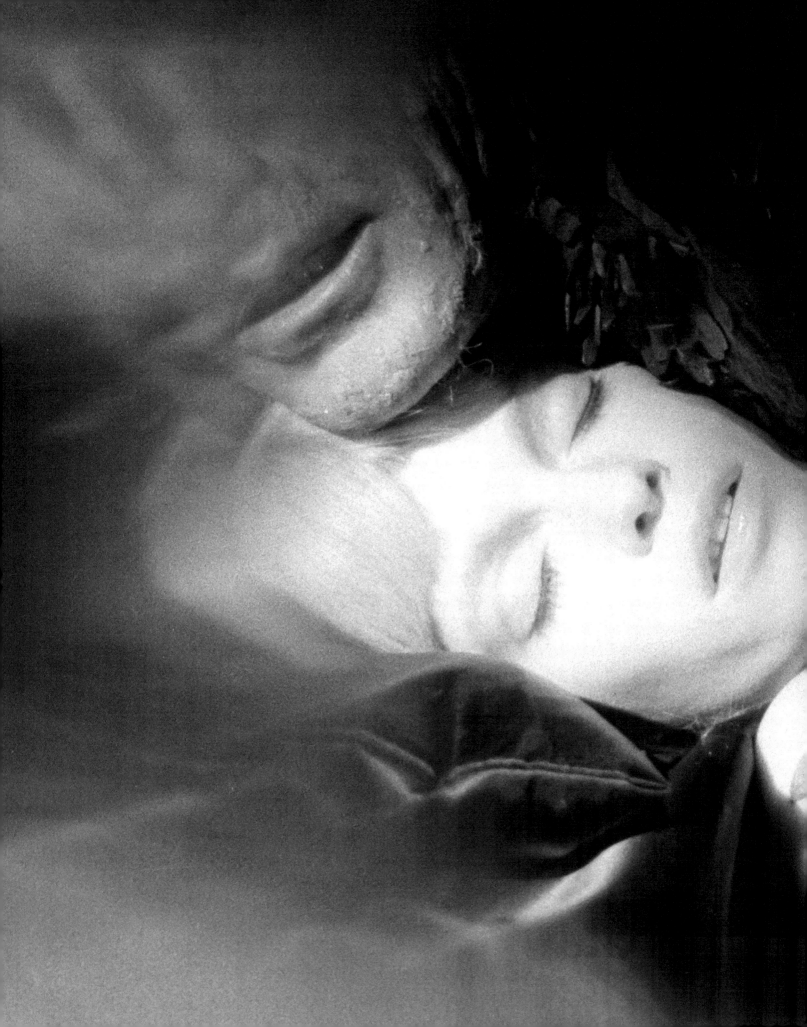

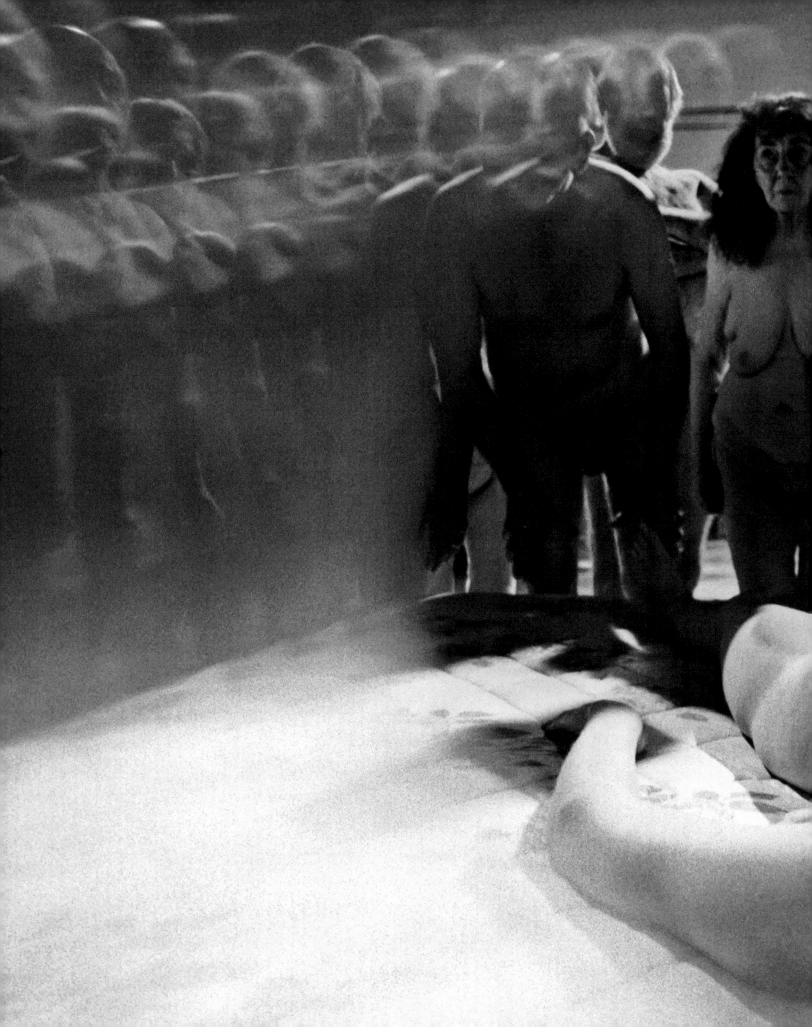

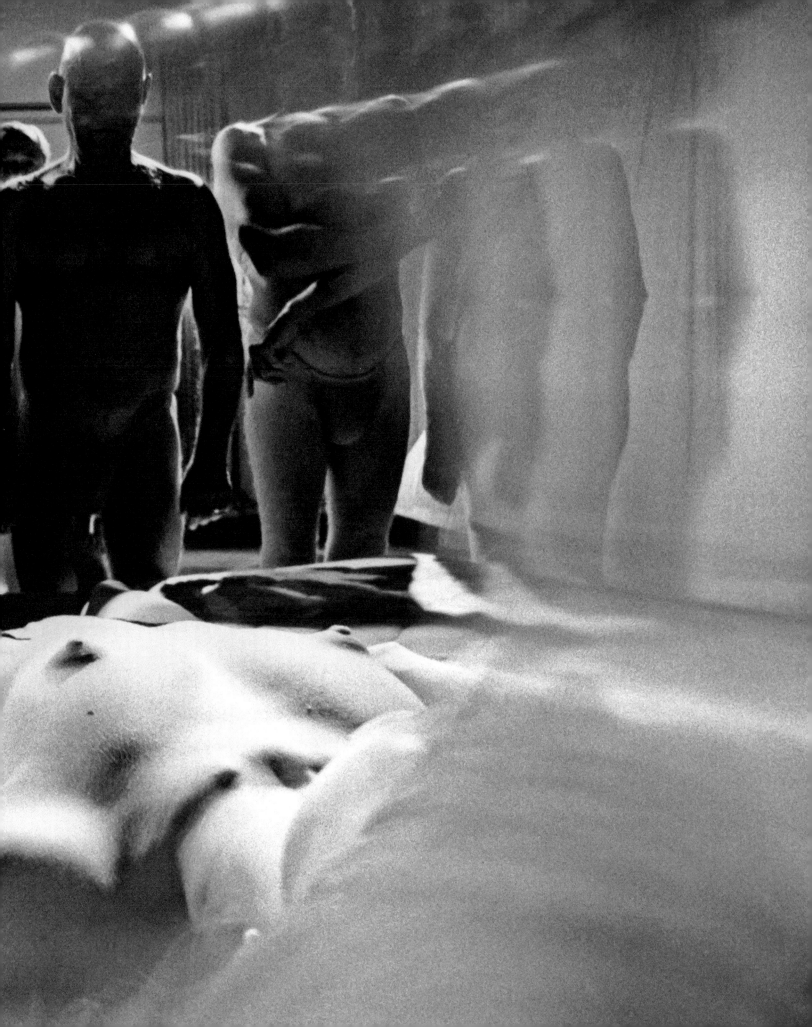

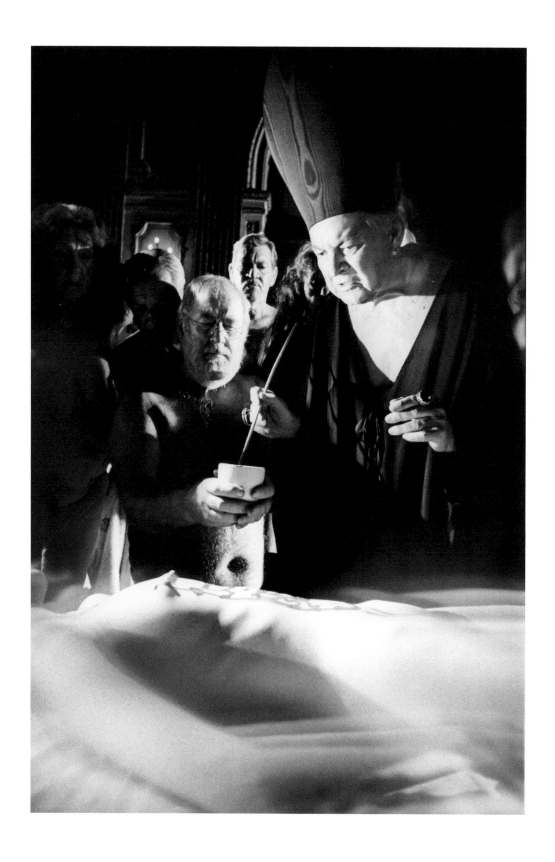

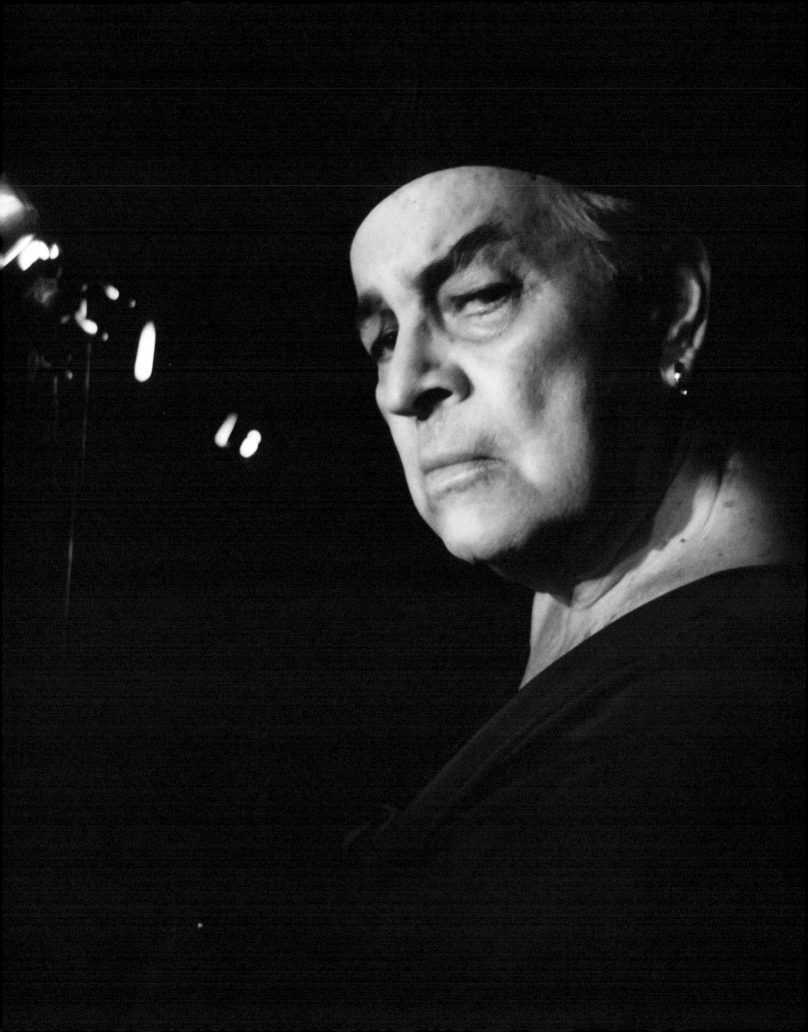

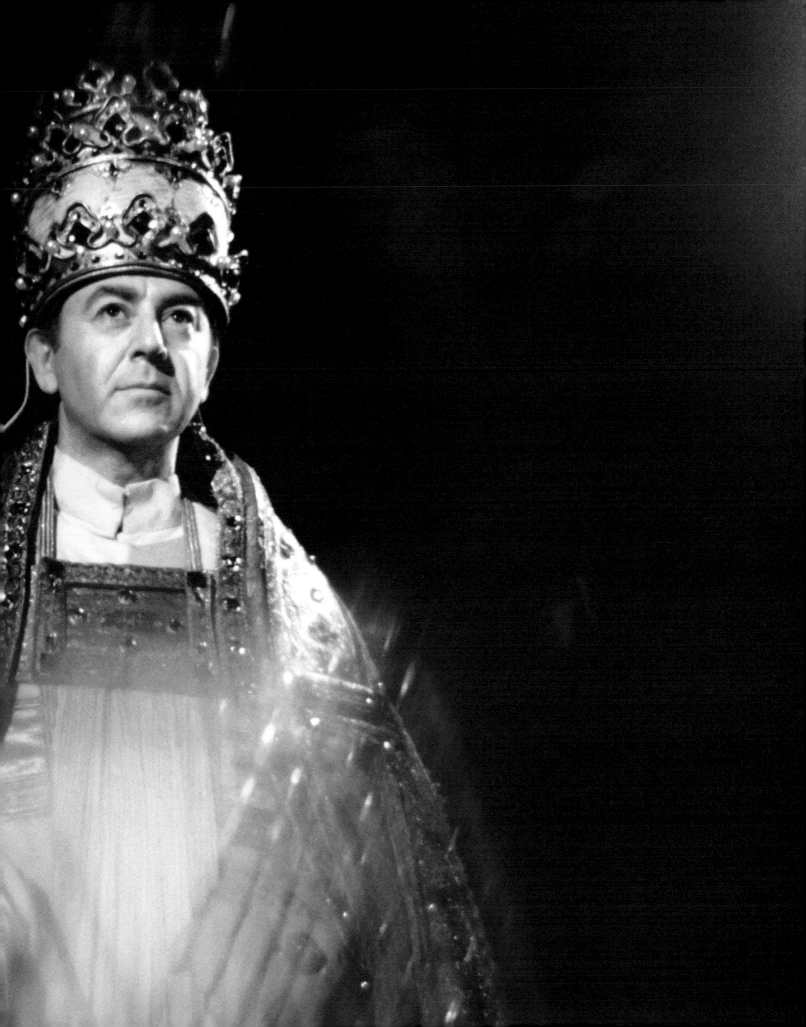

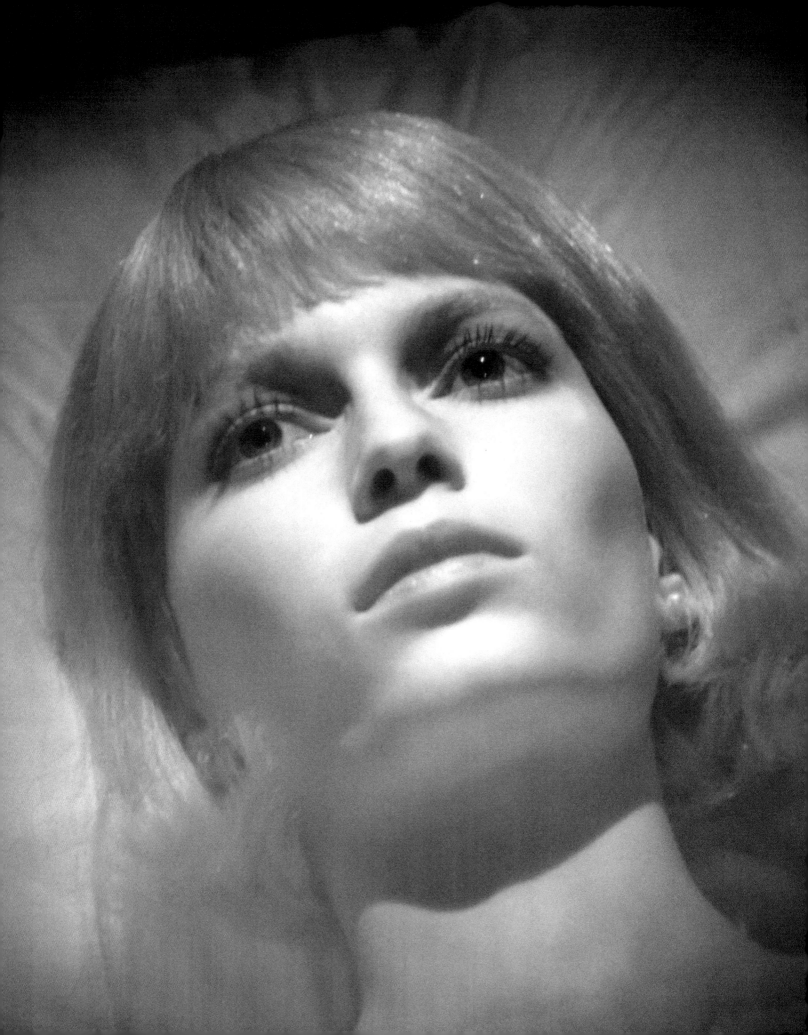

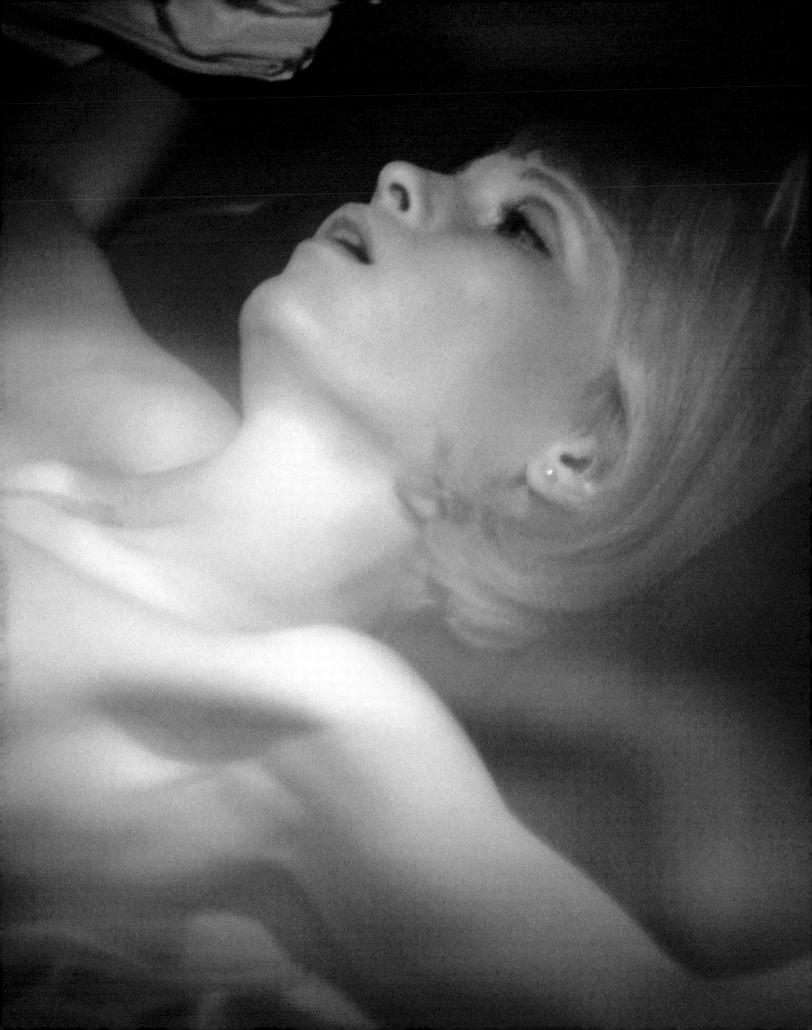

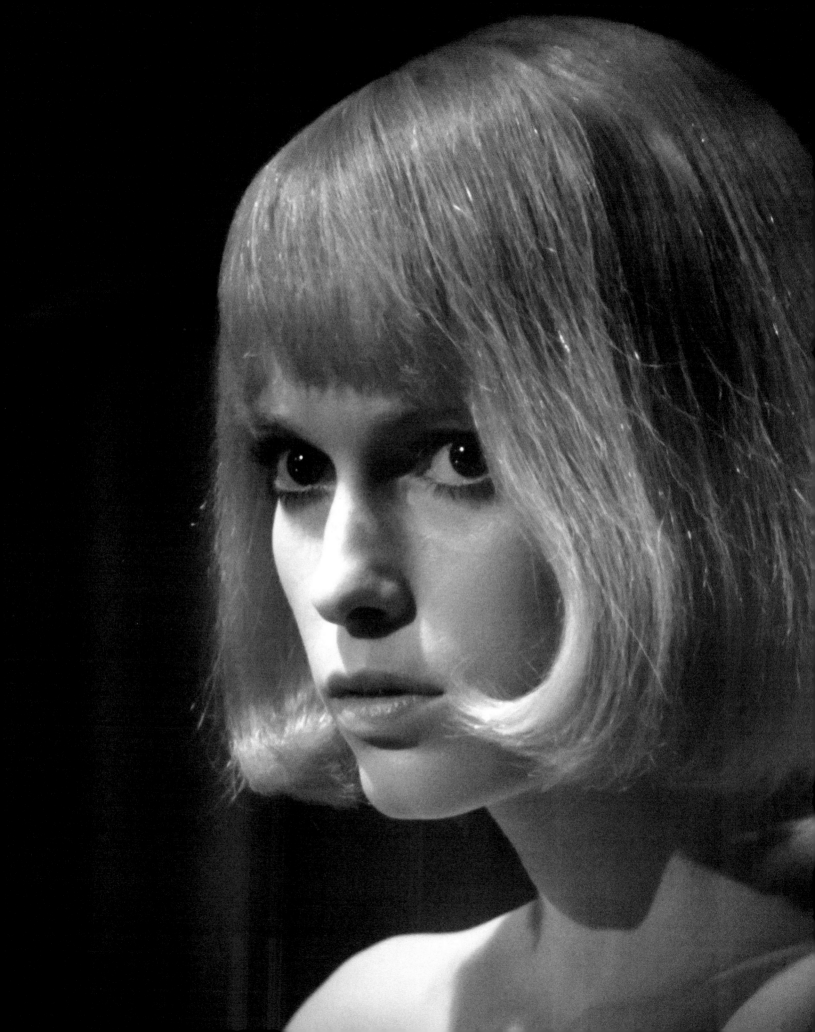

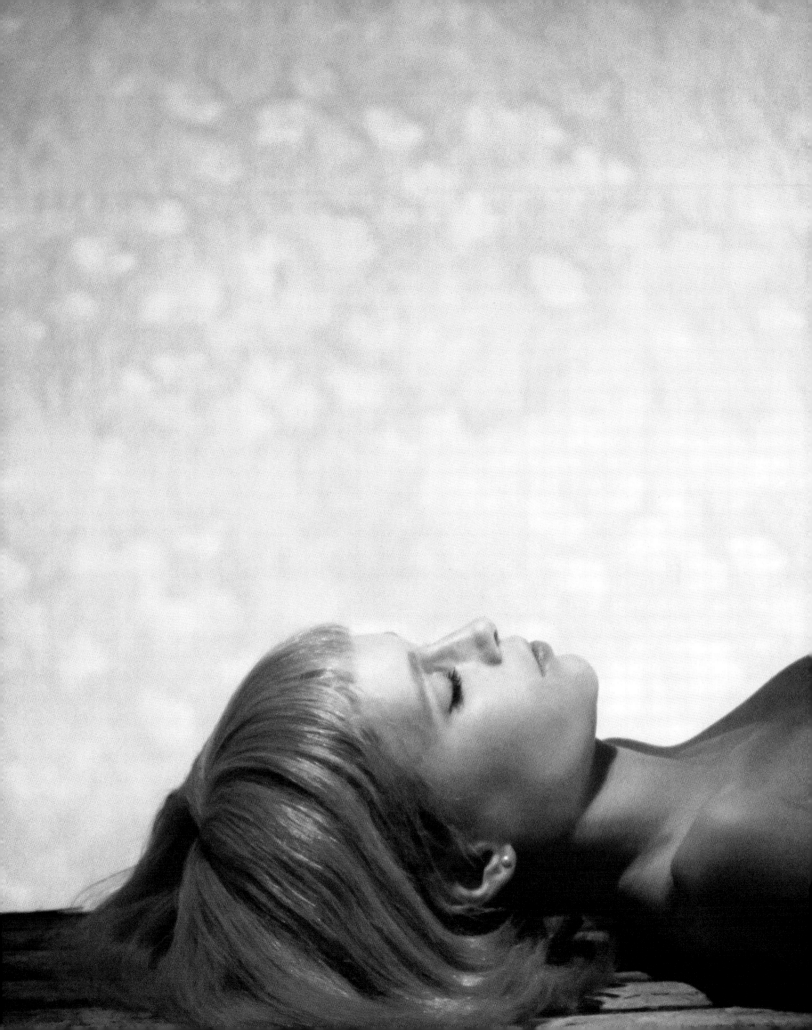

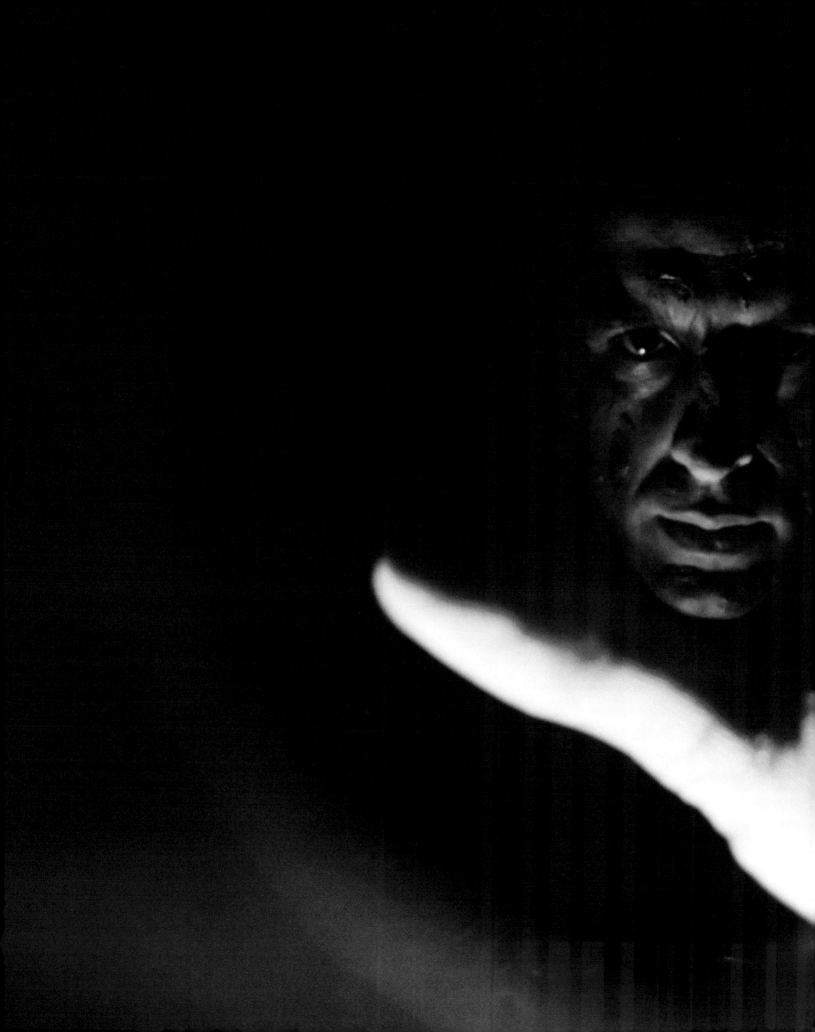

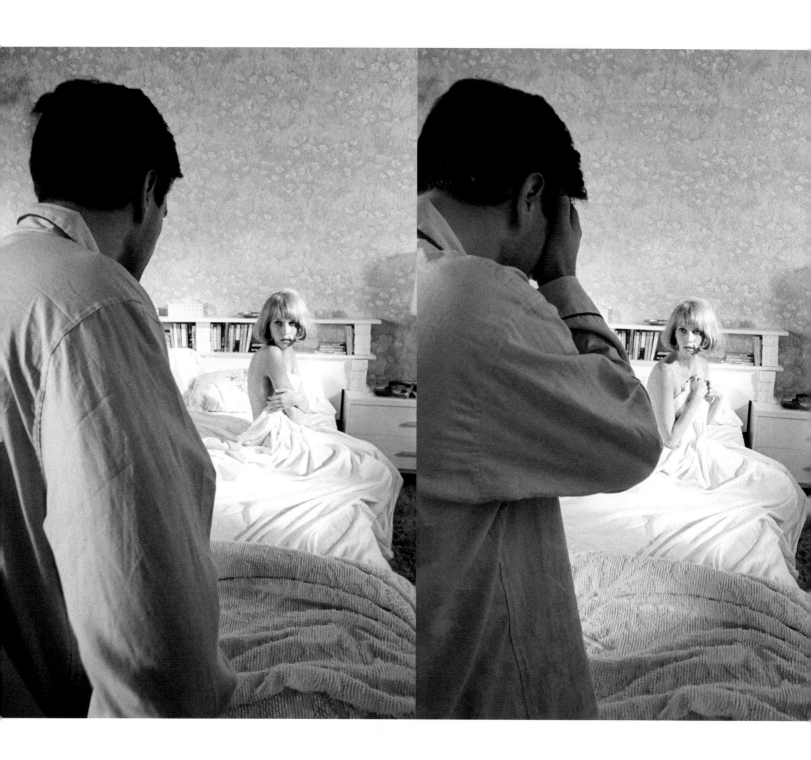

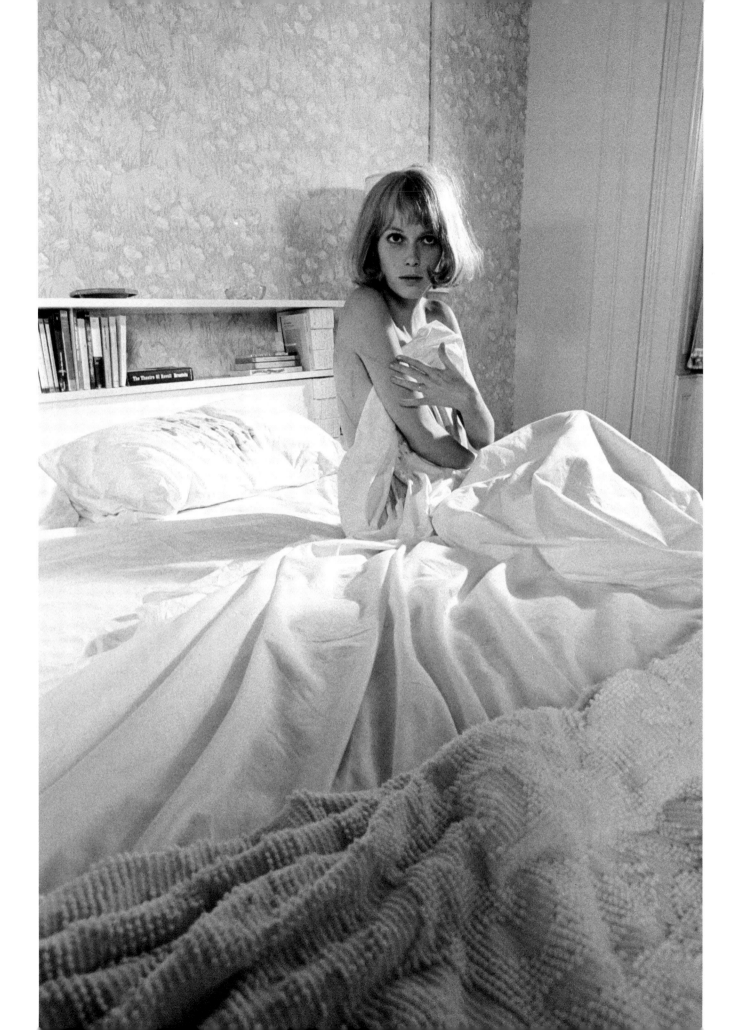

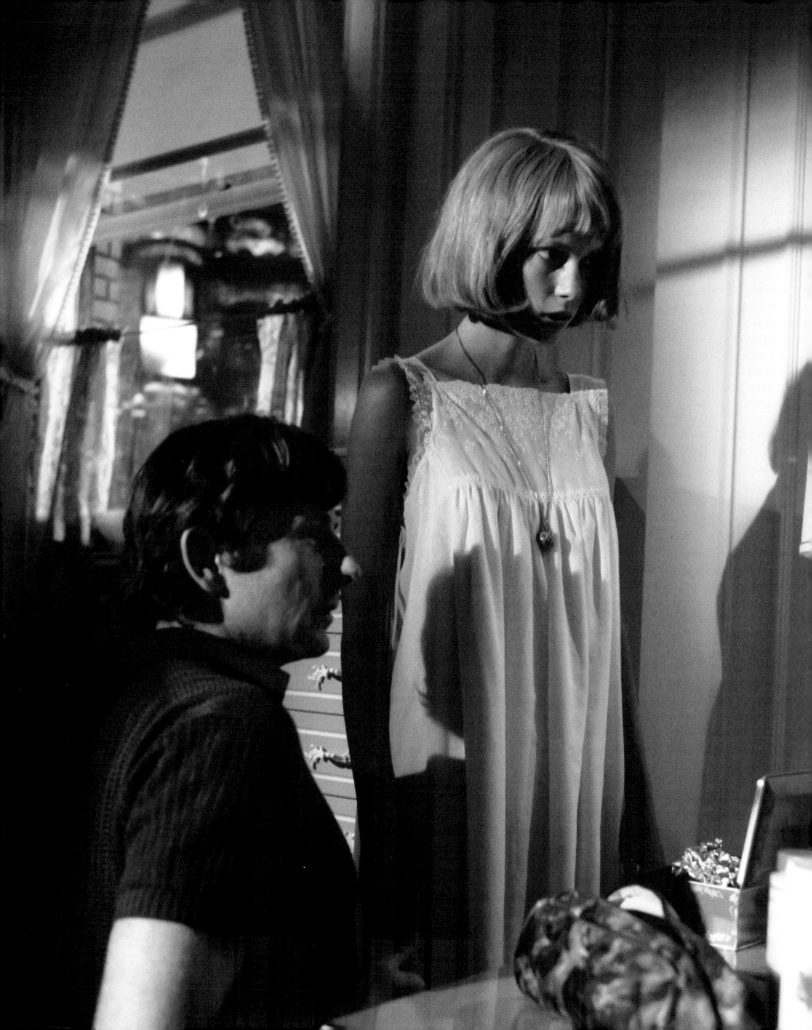

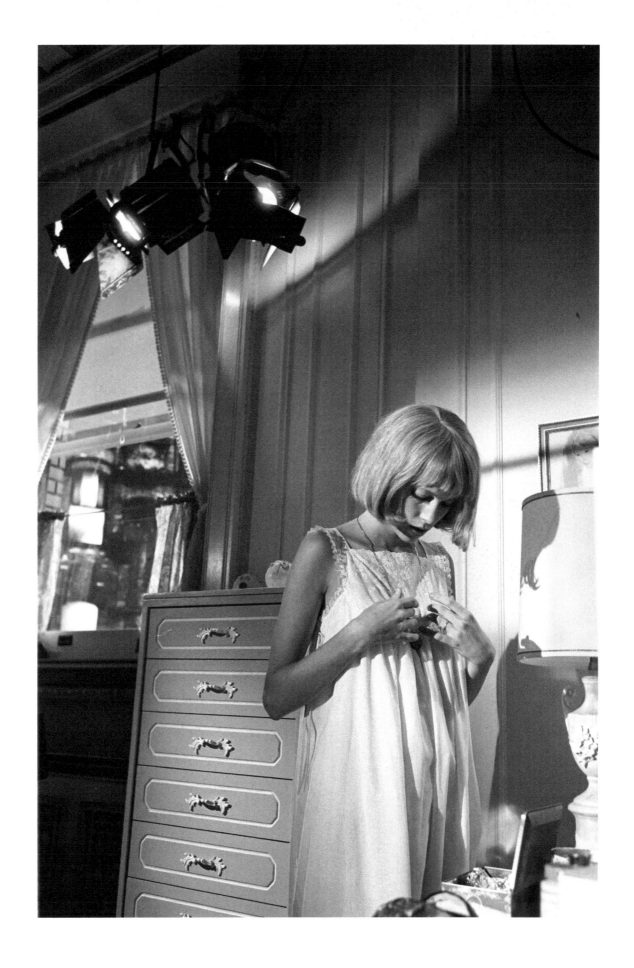

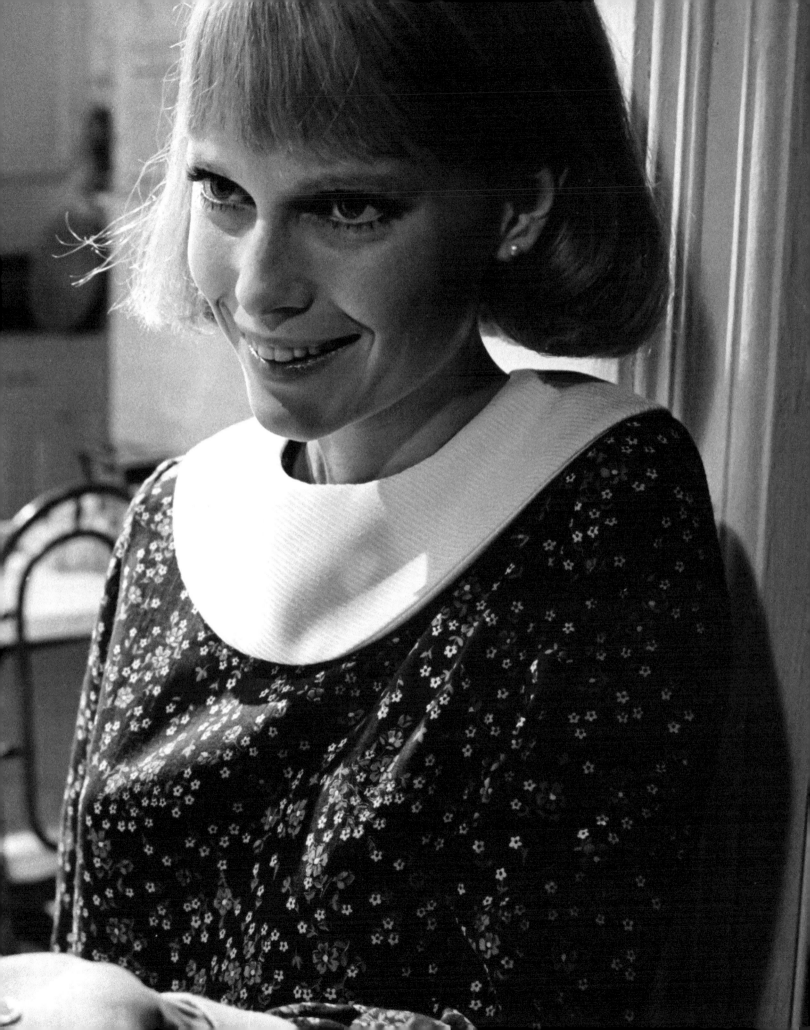

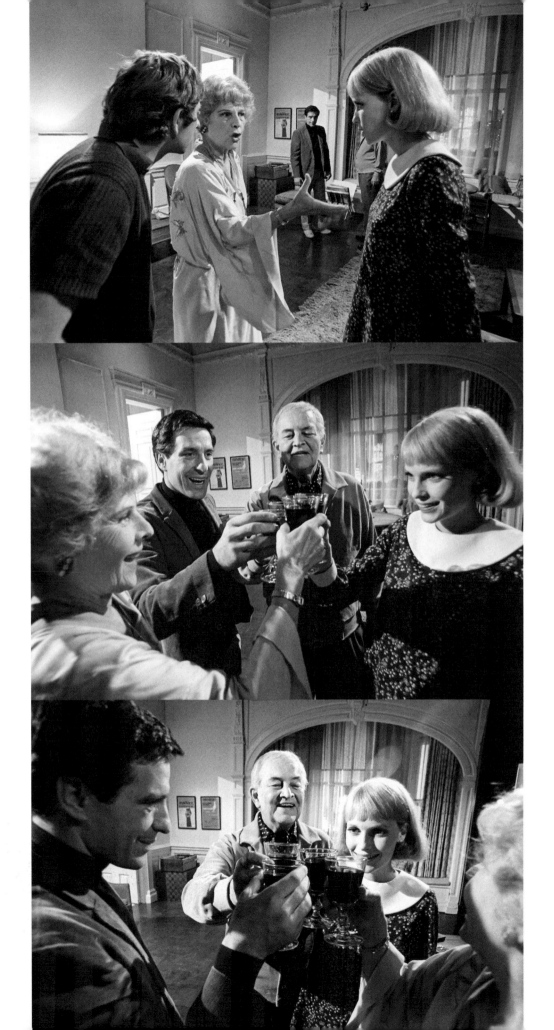

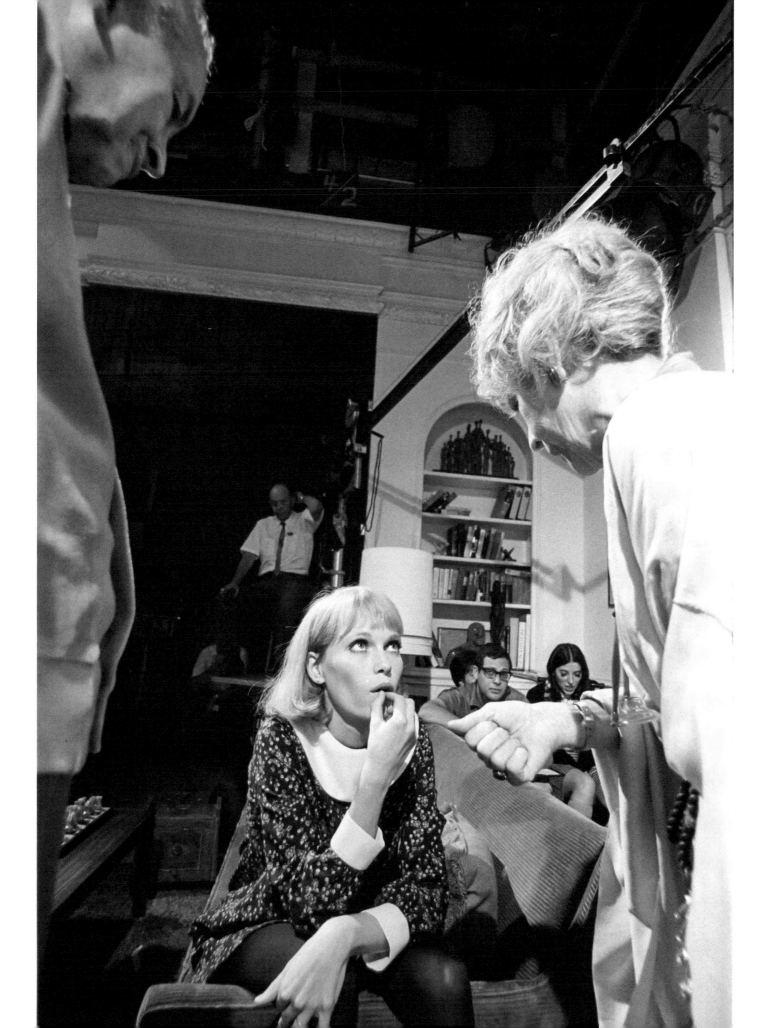

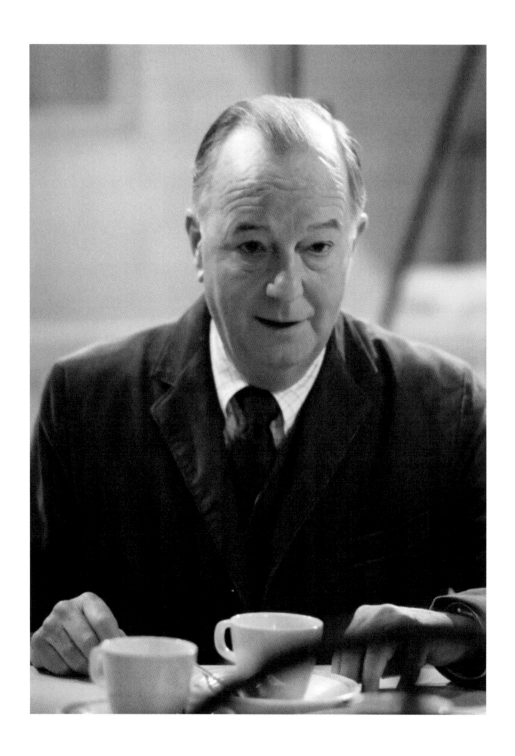

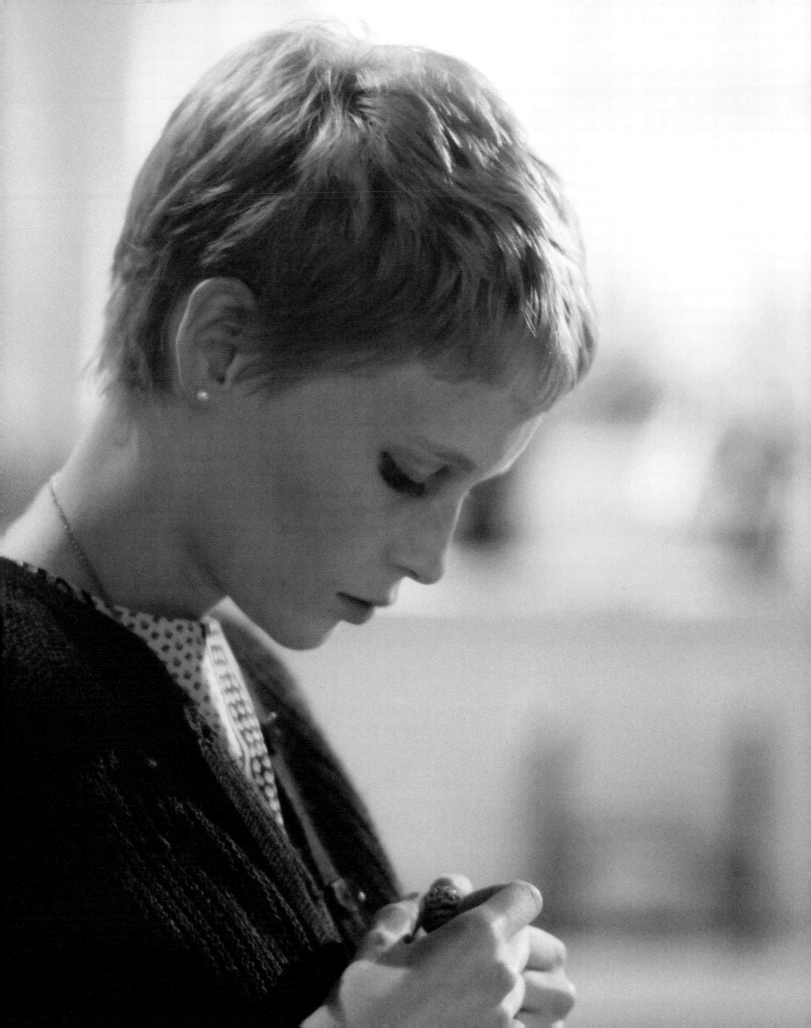

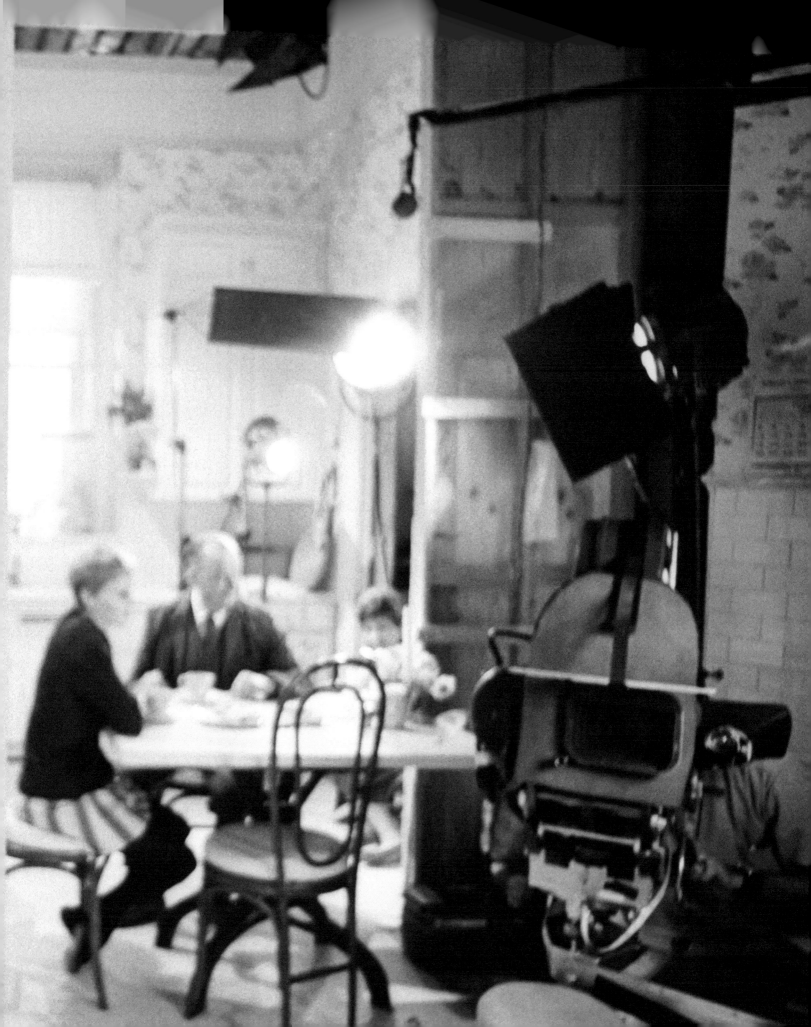

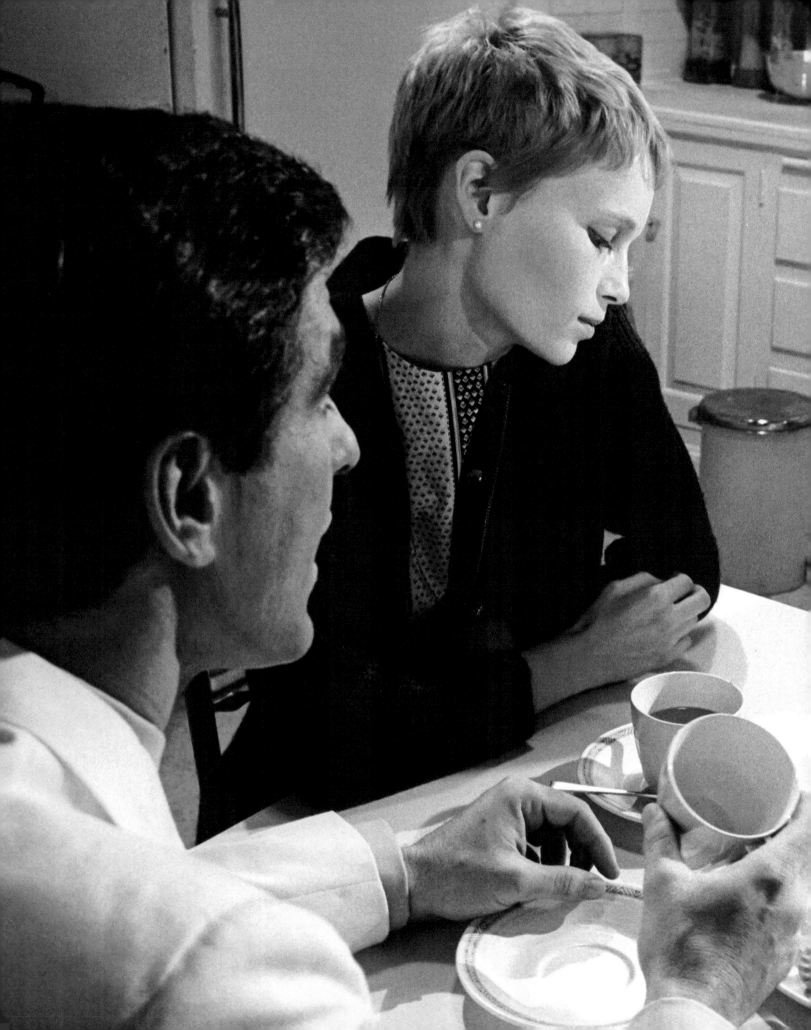

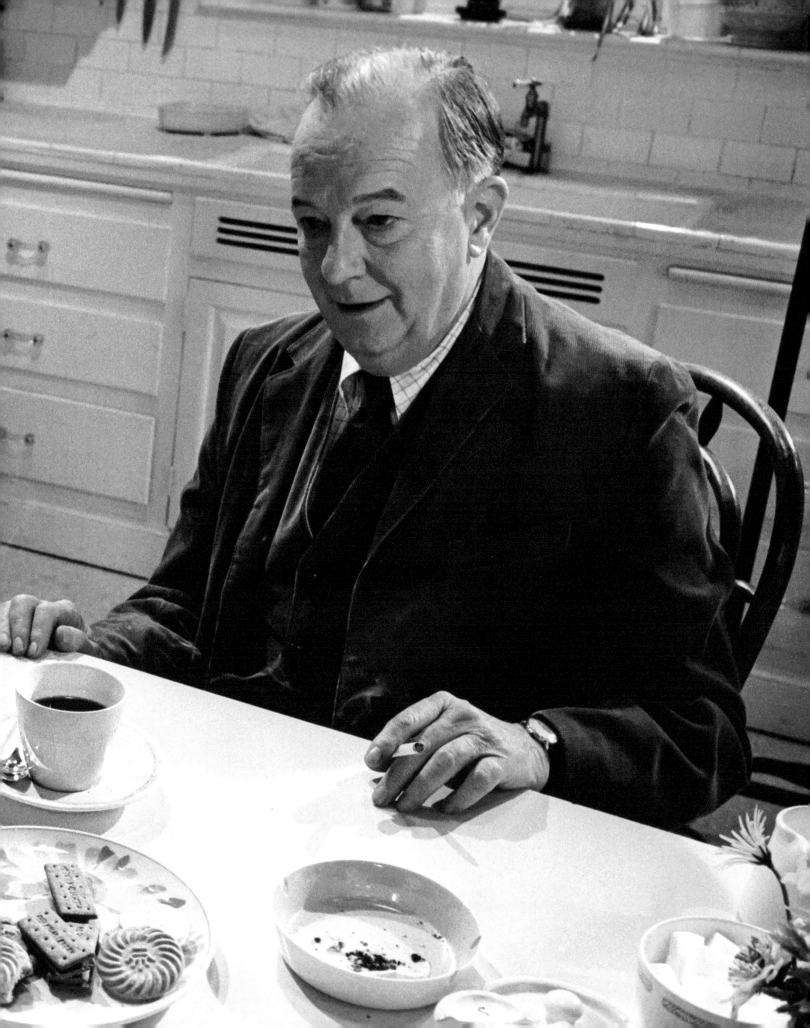

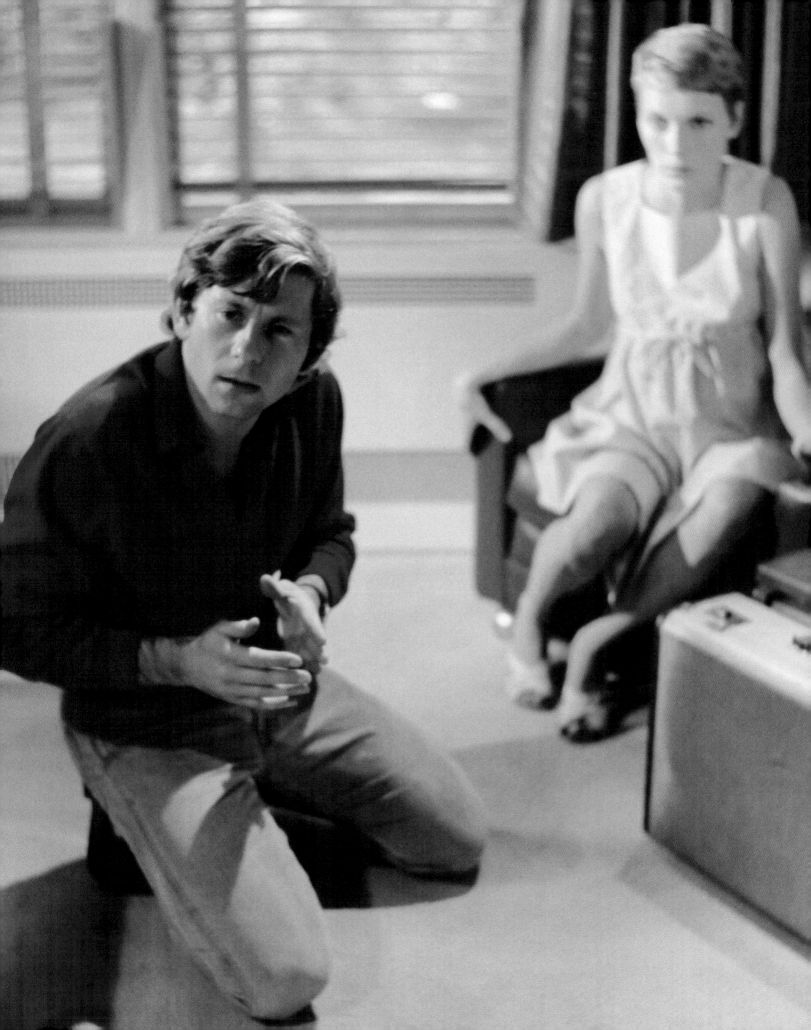

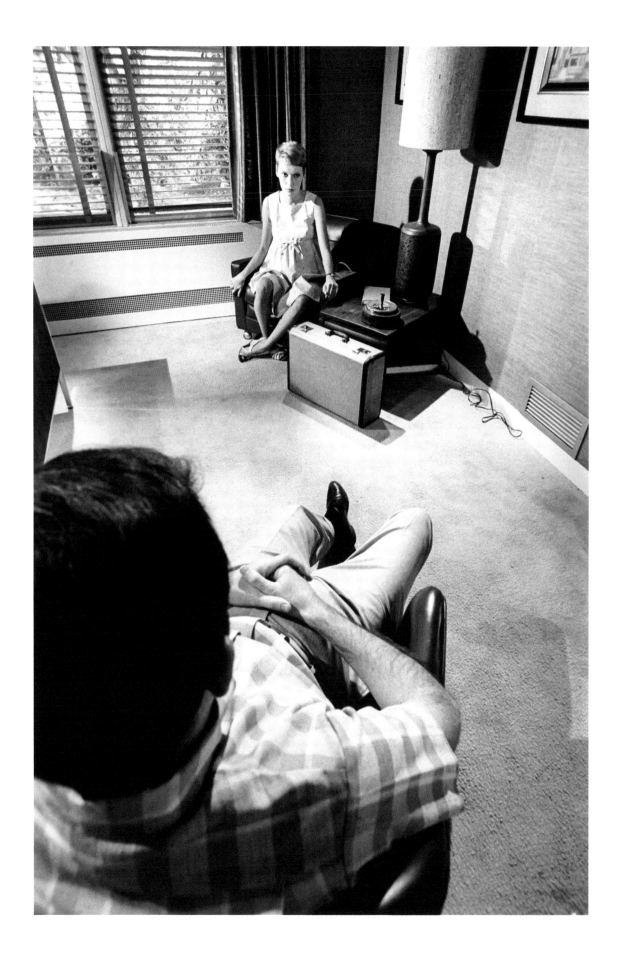

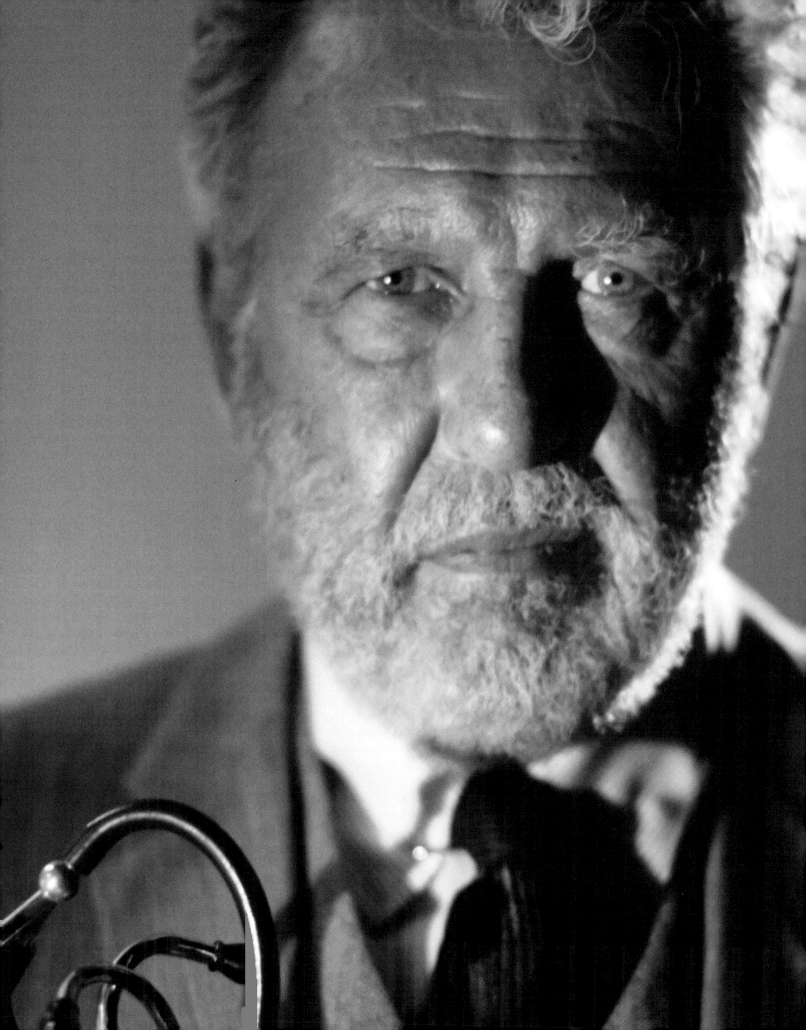

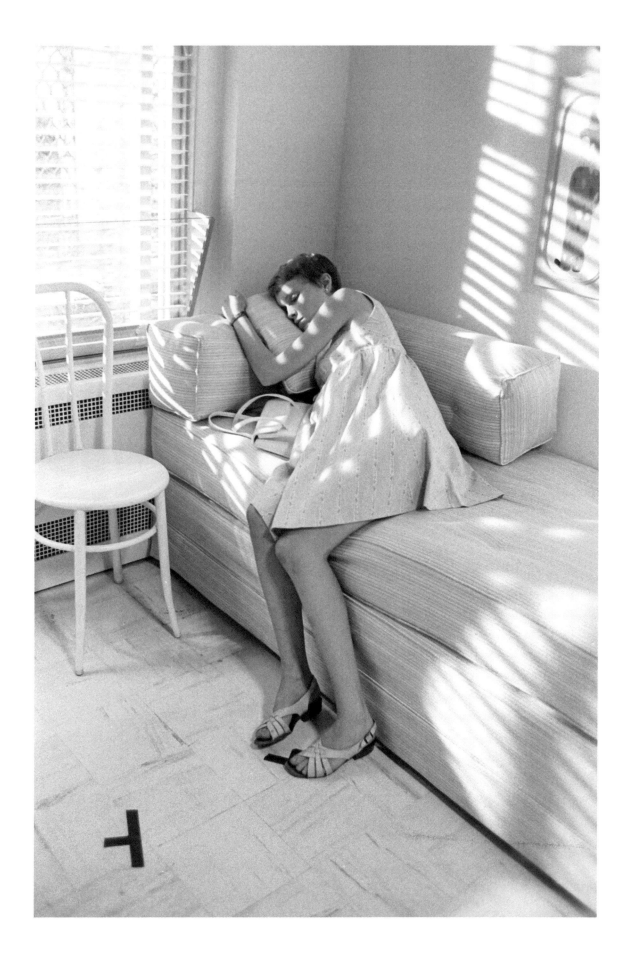

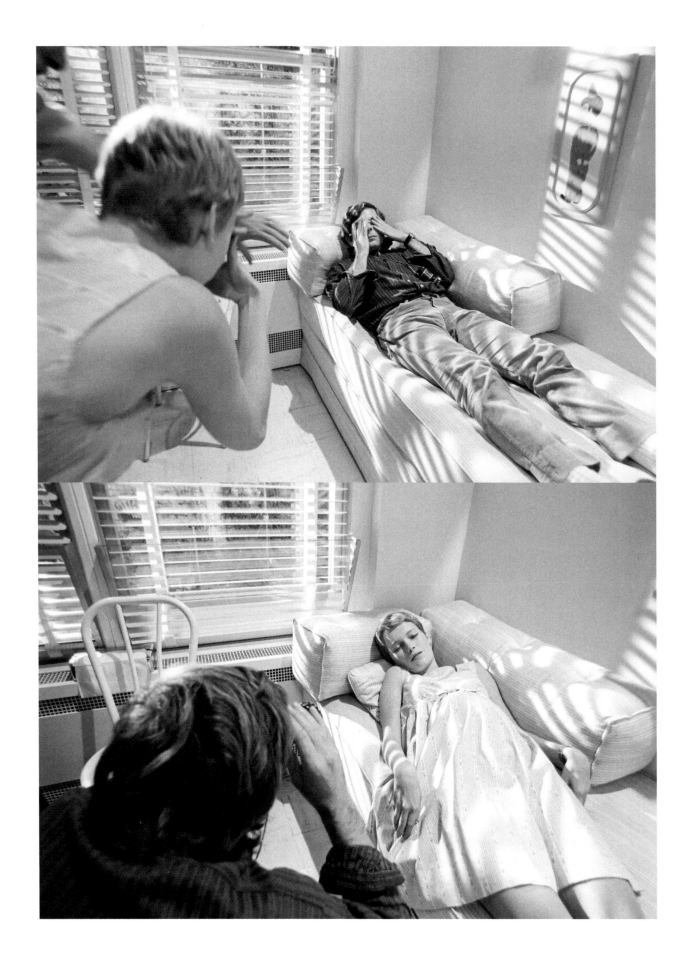

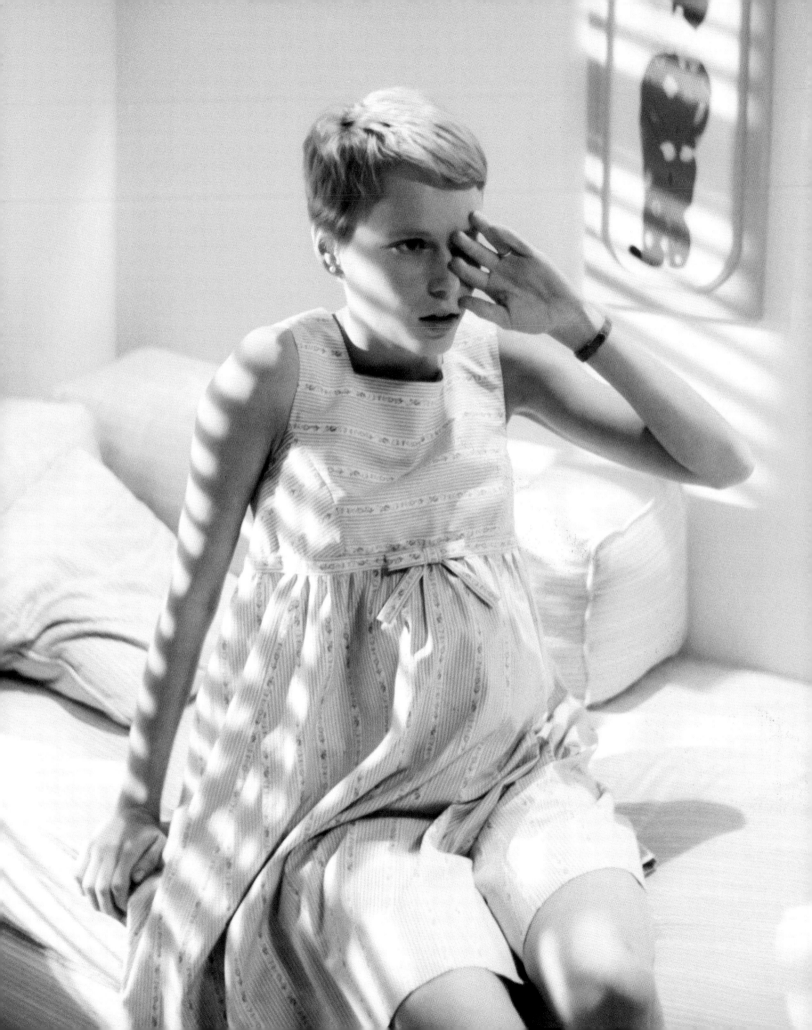

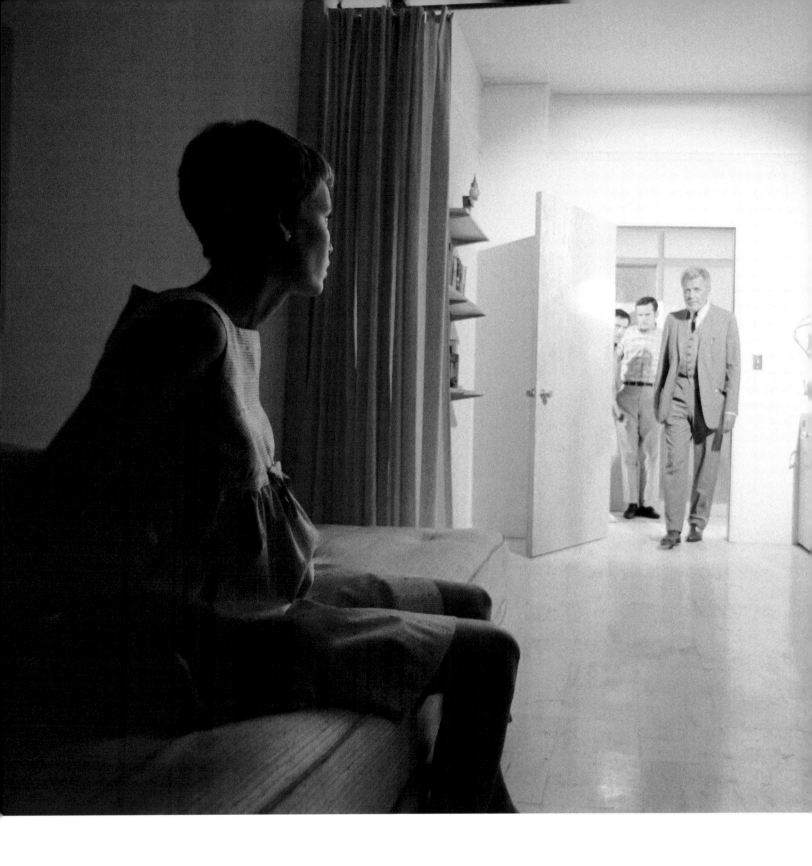

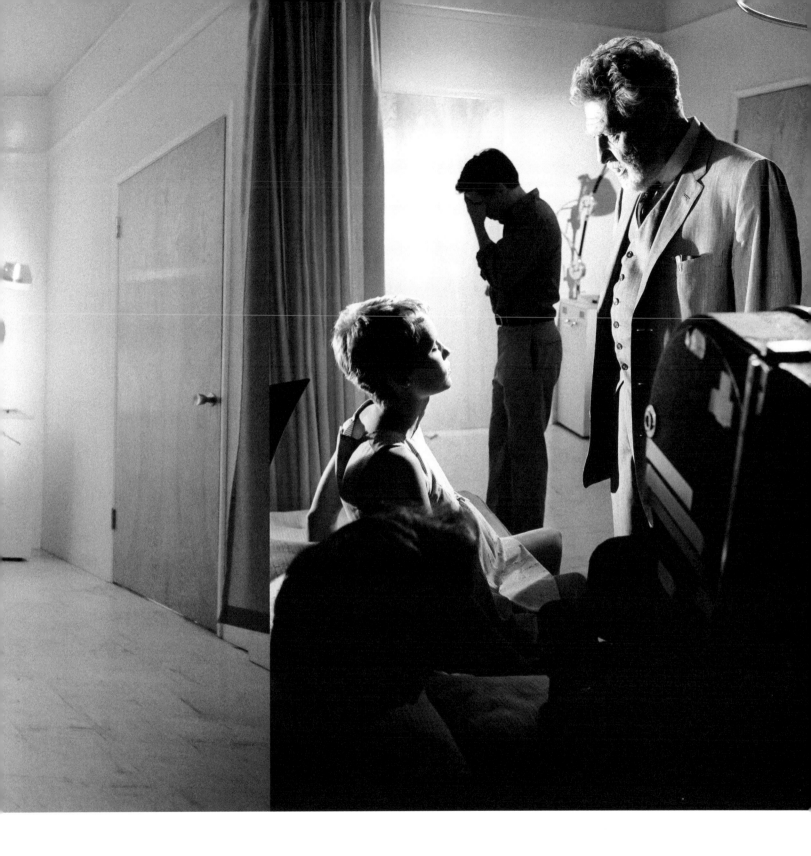

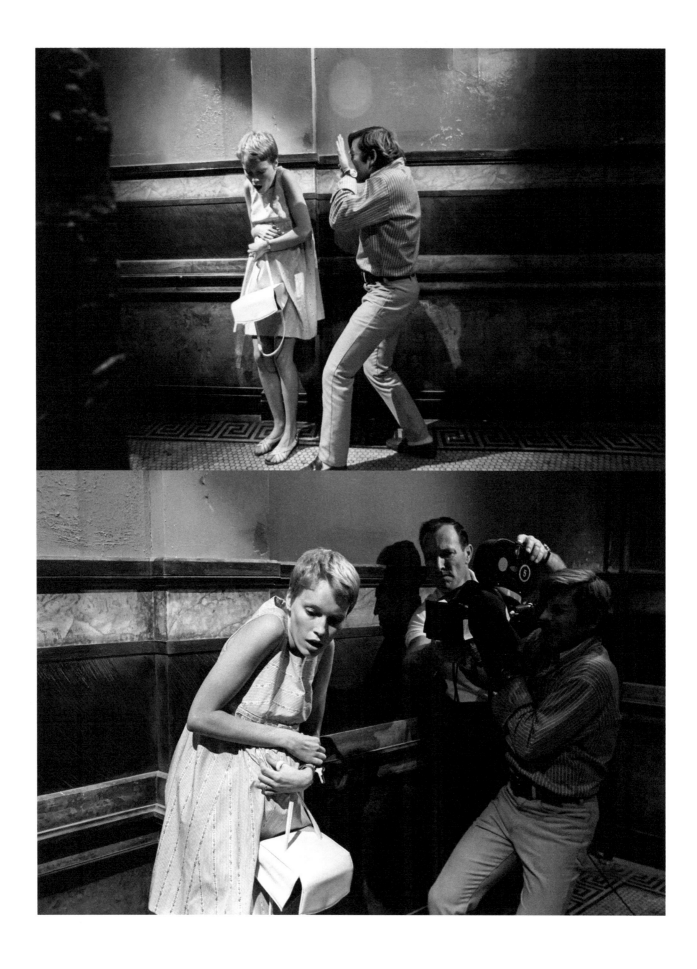

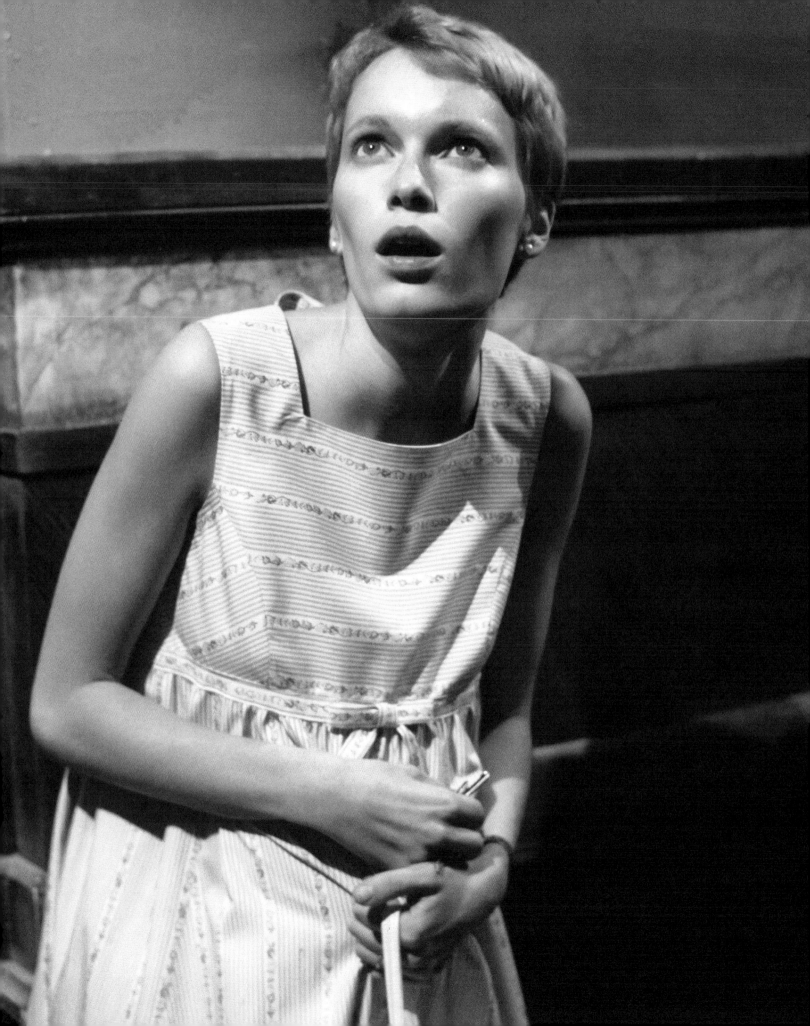

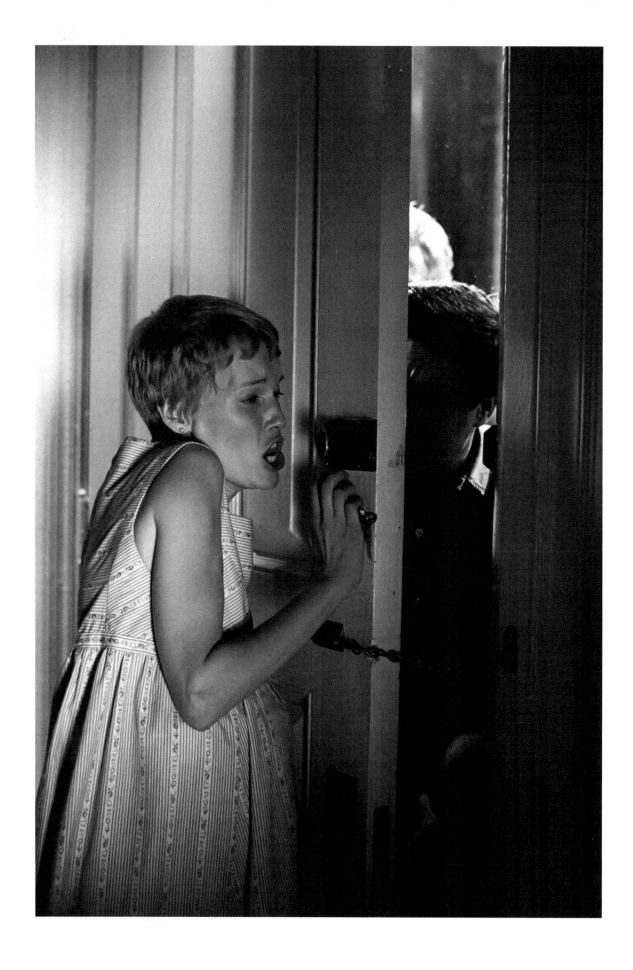

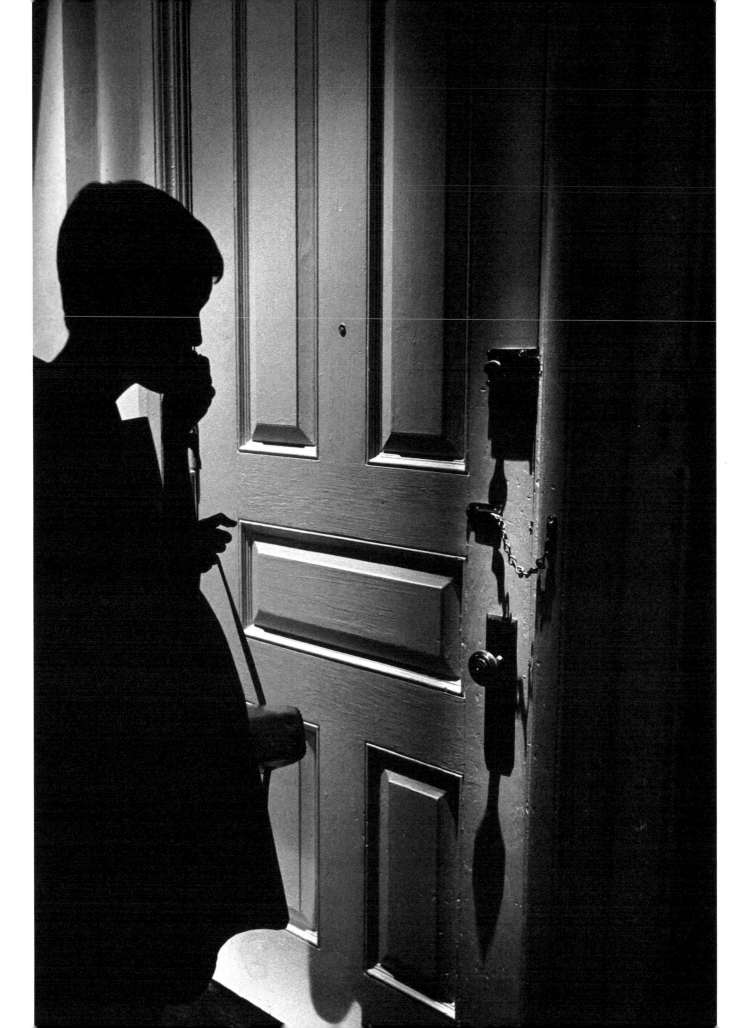

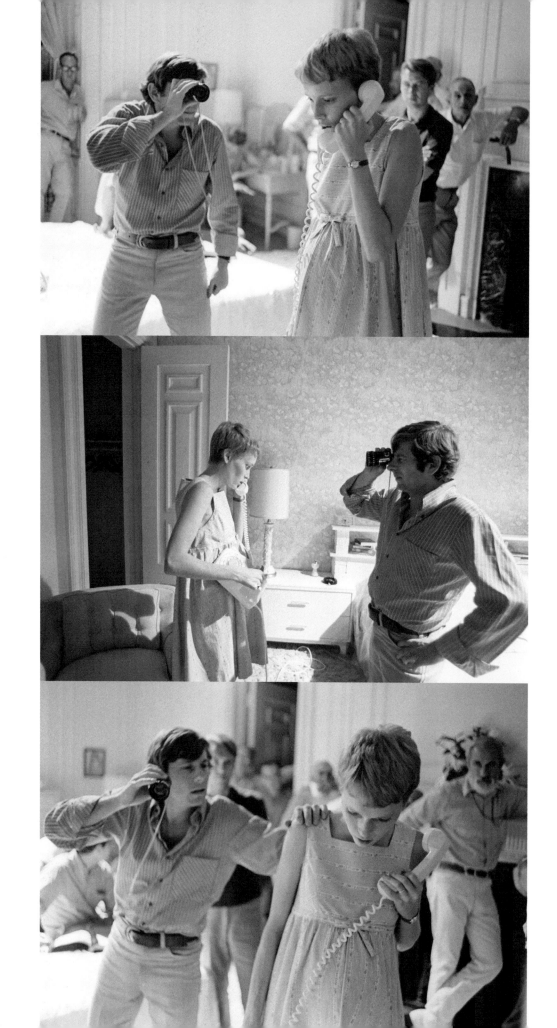

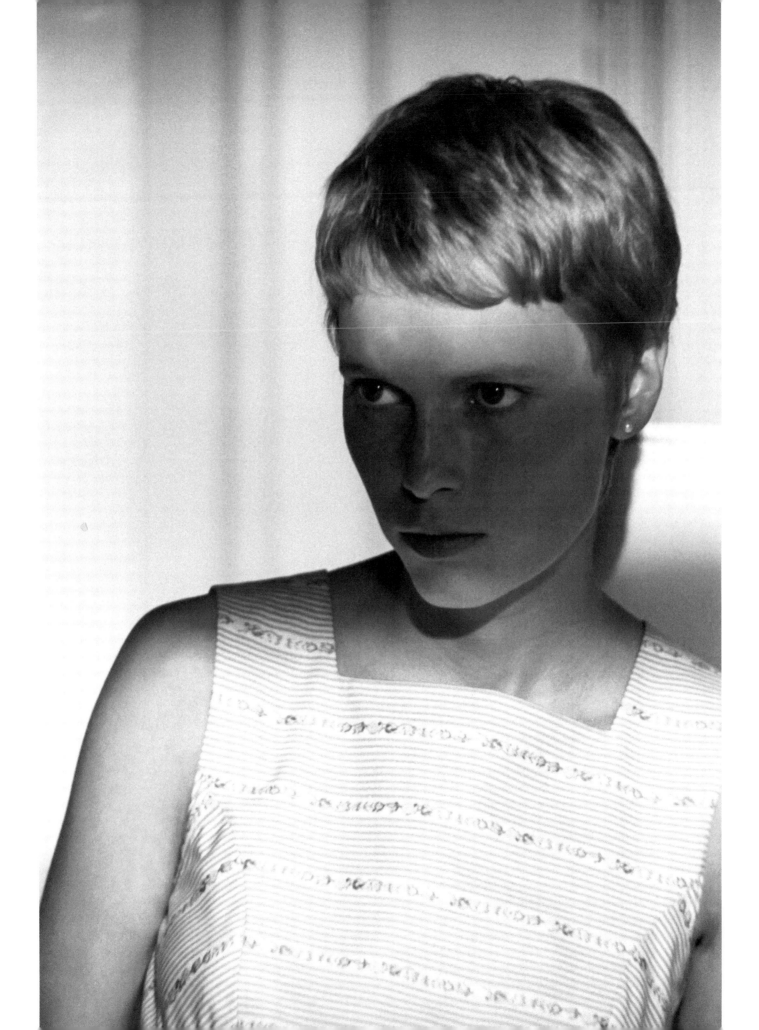

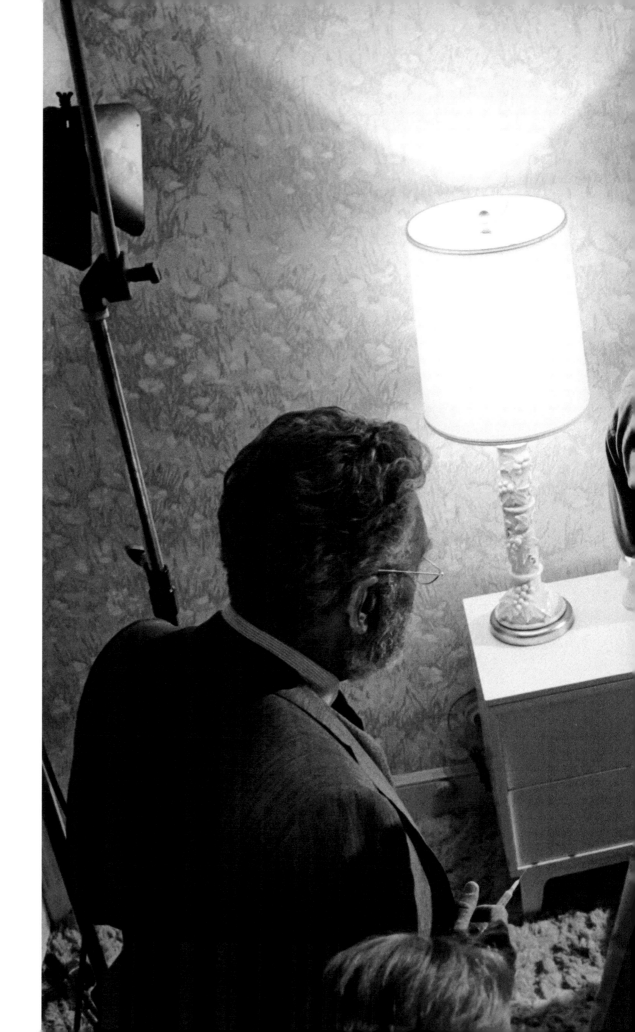

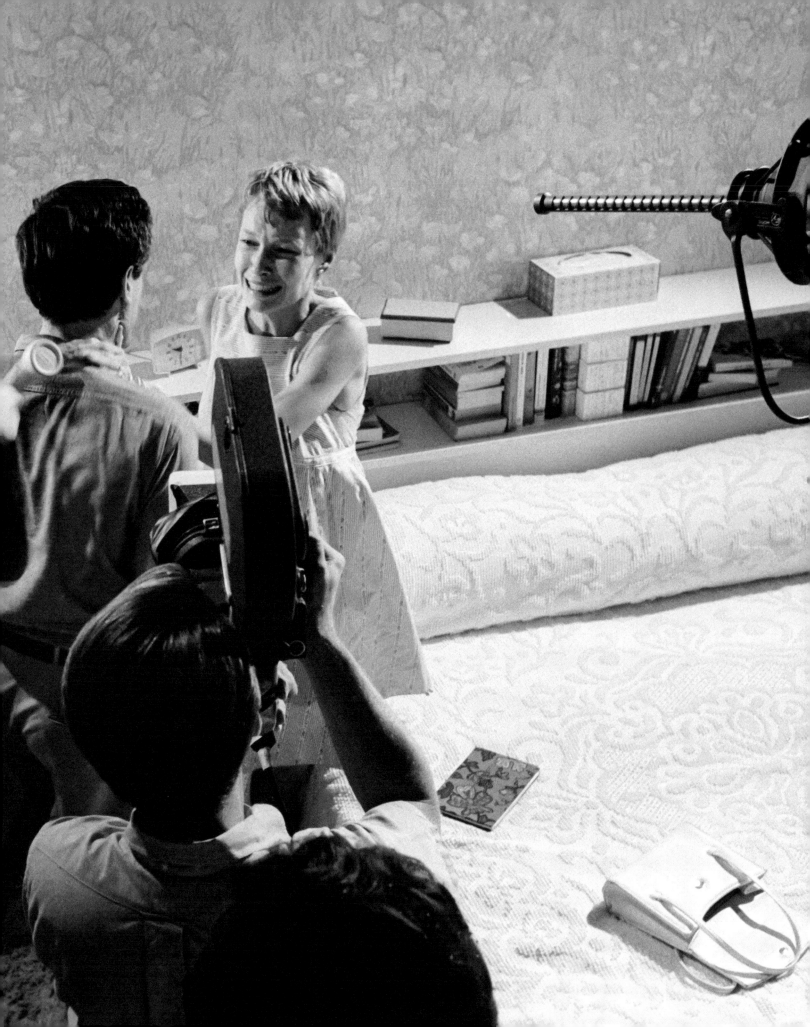

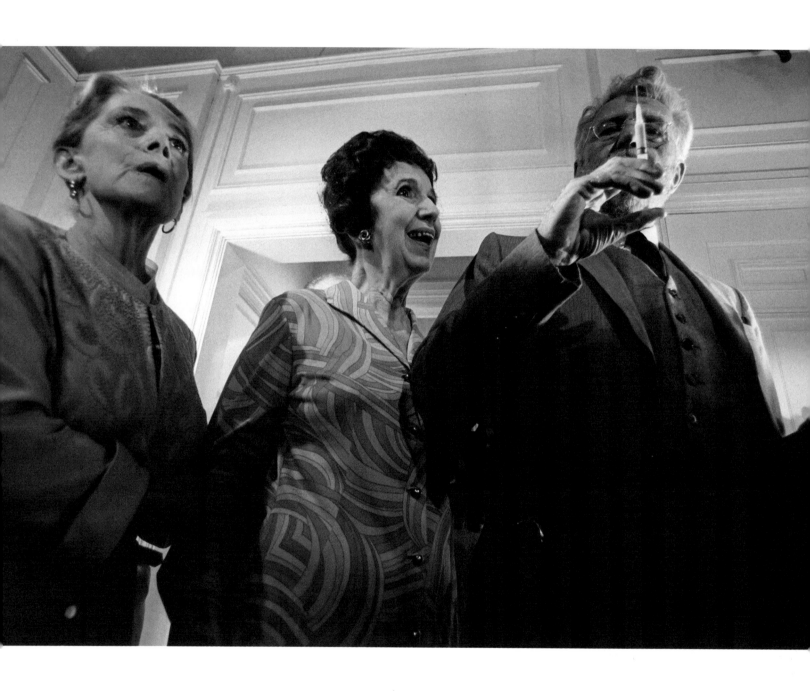

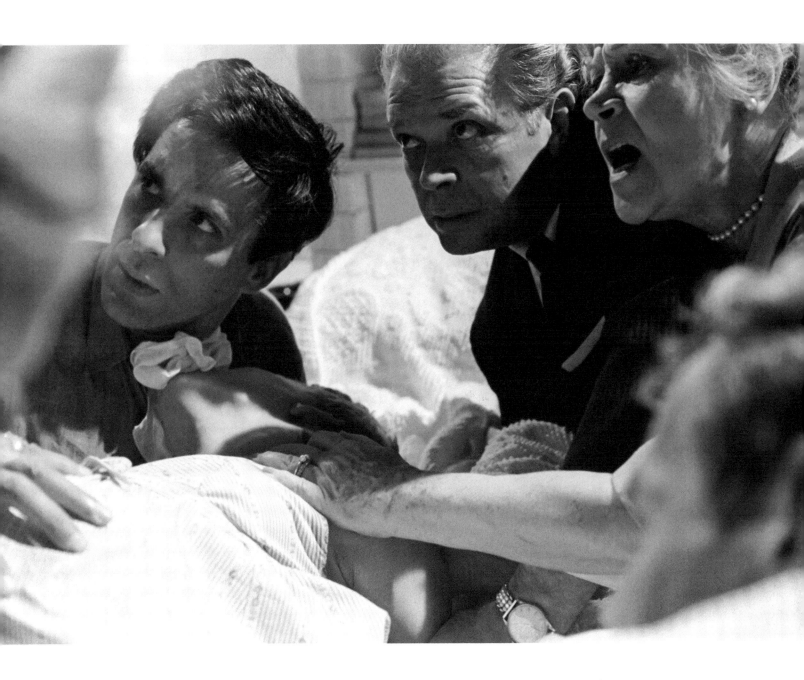

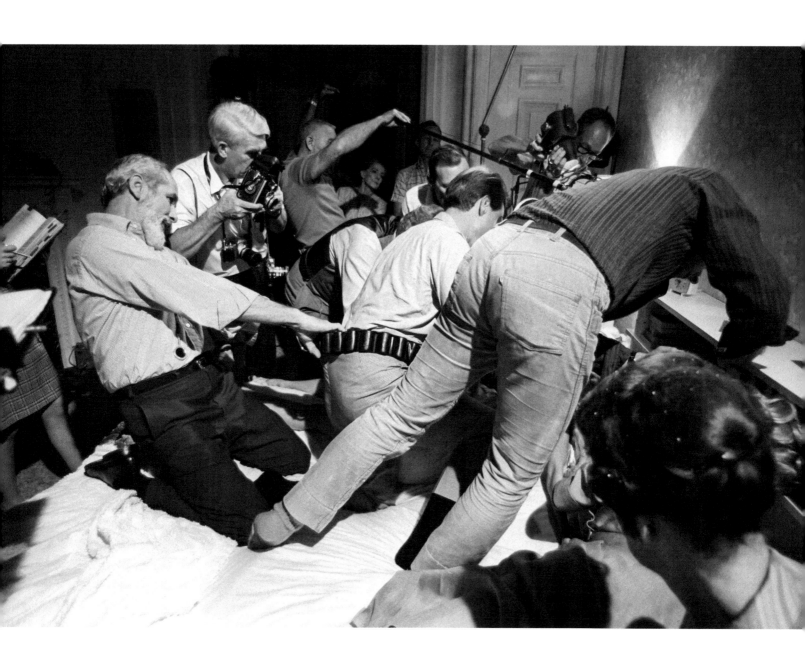

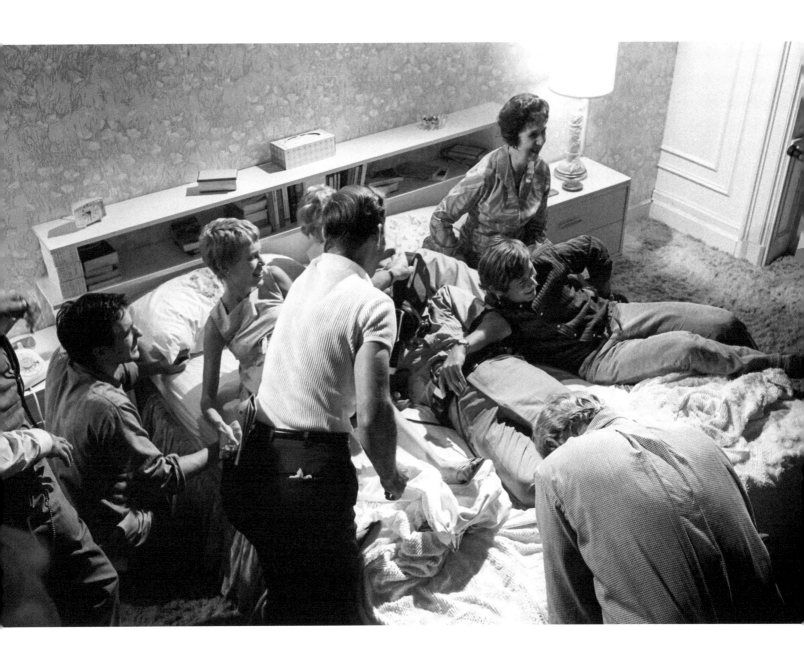

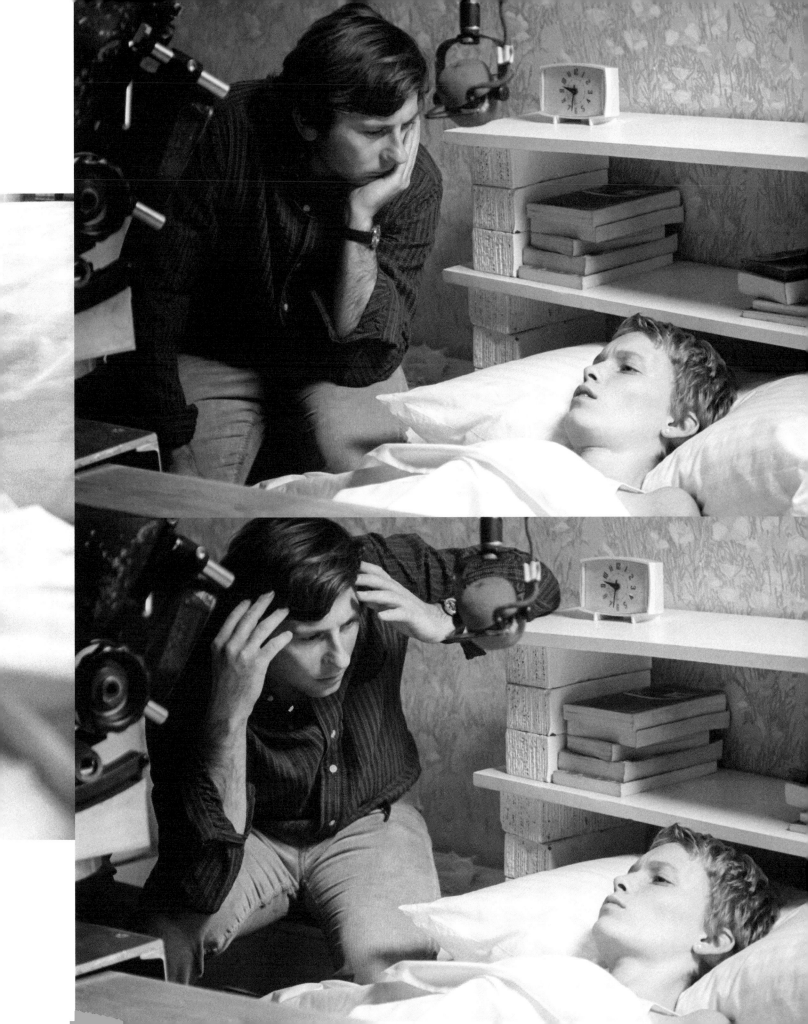

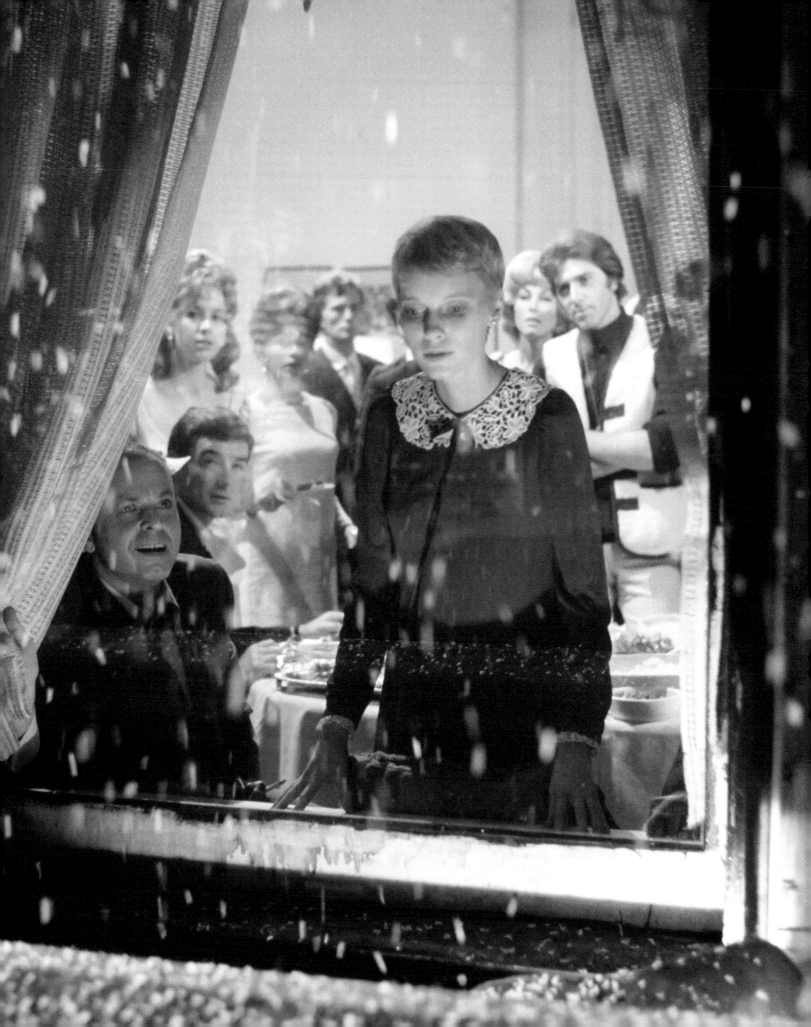

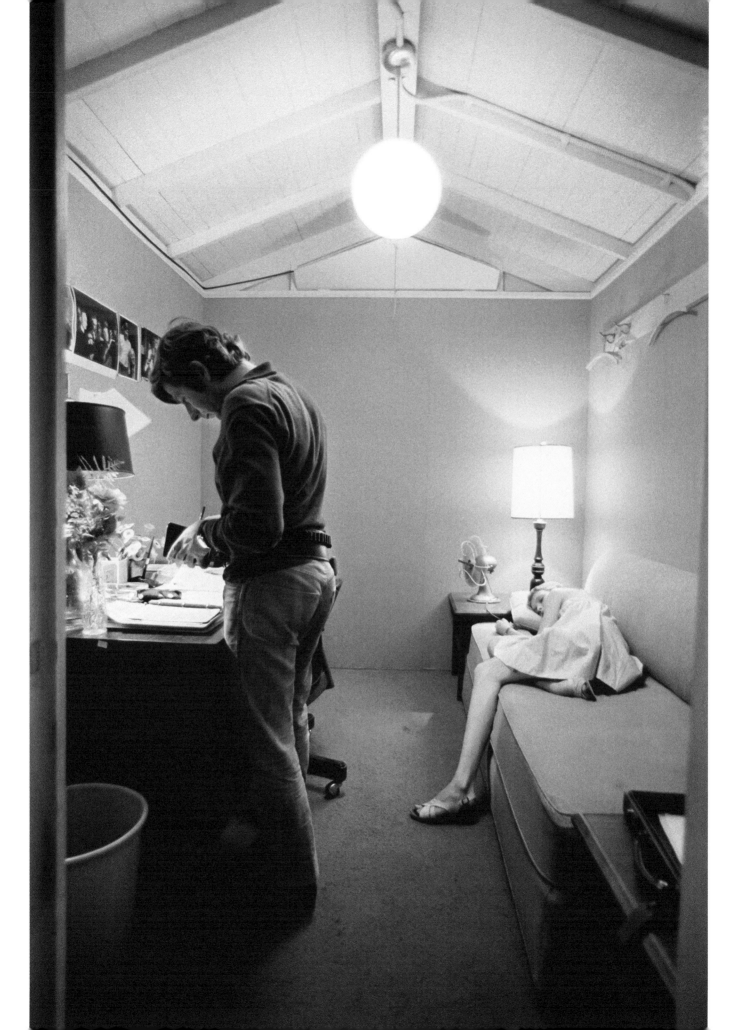

THE FINAL CUT

How dare you show this picture to my kid!

An Alfred Hitchcock drama gave film editor Sam O'Steen his first experience: The film was *The Wrong Man* (1956), the editor was George Tomassini and O'Steen was hired as his assistant. Over time, the assistant editor would graduate to editor with the 1964 drama *Youngbloode Hawke*—the first of 33 career efforts that included *Cool Hand Luke* (1967), *Chinatown* (1974) and a number of Frank Sinatra vehicles. He had followed Frank Sinatra to Paramount in 1964 in hopes of landing a directing gig with the Sinatra unit. Instead, he began his longtime collaboration with director Mike Nichols, editing *Who's Afraid of Virginia Woolf?* (1966) and, over the next several decades, *Carnal Knowledge* (1971), *Silkwood* (1983), *Working Girl* (1988) and *Postcards from the Edge* (1990).

Richard Sylbert suggested that Polanski hire O'Steen, who was currently wrapping up Nichols' second film, *The Graduate*. Farrow—who was friends with Nichols—paid him a visit, telling O'Steen, "I wish you were cutting our picture because Roman's having a lot of trouble with [William Castle's] editor." O'Steen took a look at Polanski's *Repulsion* and knew right away that he wanted to edit the director's first American film. "How'd you like to come cut for me?" Polanski asked him. "You've already got an editor," O'Steen replied, "I don't want to bounce him." "No, he's the producer's editor," said Polanski, "and he's got another picture." And with that, O'Steen became the editor of *Rosemary's Baby*.

Rosemary's Baby would be the first of three collaborations between director Polanski and editor O'Steen. "I sit and drool over his dailies," O'Steen once said. "I love cutting his pictures." The feeling was mutual, and Polanski later called *Rosemary's Baby* "the first of my films that I feel is almost perfectly edited." The

director considered O'Steen to be the one editor he learned from. "He taught me to be merciless," the director said, "to separate myself from scenes that might be good but that have no place in the finished product."

O'Steen arrived late in the game, wrapping up the editing of *The Graduate* while Polanski was nearing the end of the *Rosemary's Baby* shoot. Polanski screened his footage with O'Steen, then left for London to marry Sharon Tate, leaving Sam to put everything in order. O'Steen did more than establish continuity, however, and assembled the entire film after being offered $1,000 to finish a version of the film by July 4. "I don't know who called me," O'Steen said. "I think it was Bill Castle." He commenced to cutting without Roman.

On January 20, 1968, Roman Polanski and Sharon Tate—he in an olive green Edwardian jacket, she wearing a cream-colored taffeta minidress—were married in London. When he returned to Hollywood, Polanski discovered that O'Steen had gone ahead and edited much of the film. Initially taken aback, the director reviewed O'Steen's version-in-progress and told him to go ahead and finish it, which resulted in a stultifying four-hour first cut. O'Steen and assistant editor Bob Wyman set about paring it down and showed a two-hour version to Polanski, Castle and Evans, all of whom seemed to bemoan the loss of scenes they considered favorite or essential. As O'Steen tinkered, the film's length fluctuated from just under two hours to 133 minutes, then 134 minutes, then—at long last—136 minutes.

"There was always a push and pull between Polanski and Sam about length—Sam's American vs. Roman's European sensibility—and those battles were not easily won by Sam," recalled Bobbie O'Steen, Sam's widow. "But because he respected Sam so much he would sometimes give in to his strongly crafted arguments."

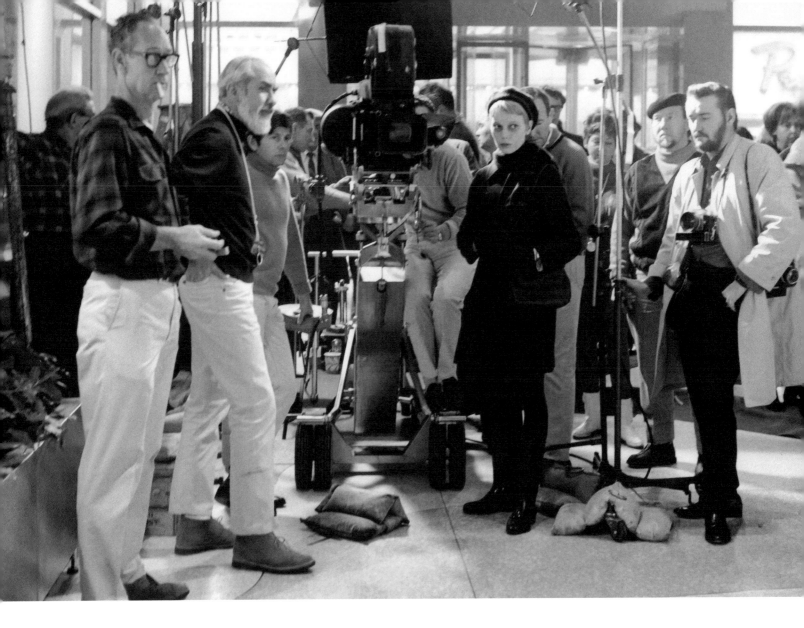

O'Steen's editing of *The Graduate* overlapped with his editing of *Rosemary's Baby*, the former keeping O'Steen away from the latter enough for him to suggest sharing editing credit with Bob Wyman. "[Wyman] was only his assistant, but he was trying to be generous and help his career," said Bobbie O'Steen. "So he gave him co-editing credit—which he felt ambivalence about later and never did something like that again." The credit as it appears onscreen simply reads: Edited by Sam O'Steen and Bob Wyman.

A handful of scenes were trimmed, several more were cut altogether and a few weren't even filmed. Gone were Rosemary and Joan's shopping trip, Rosemary and Elise attending *The Fantasticks* and Rosemary running into Guy's agent Allen Stone while ordering stationery at Tiffany's. Also cut was an early scene at Downey's Steak House where Guy is on the phone lying to a landlord to get out of an apartment lease while Rosemary and Joan wait. The wet, fluffy snowfall during Rosemary's party? On the cutting room floor. Rosemary bringing Terry by the apartment to meet Guy? Sliced away. Other Bramford residents—the Goulds, Mr. Devoe, a little girl named Lisa—were in the final script but also excised from the film.

British censors required that part of the rape scene be removed before *Rosemary's Baby* could be shown in England. Said Sam O'Steen, "They made us cut 15 seconds of it, when she's nude and the devil is boffing her. We worked hard to get the right effect there, and Polanski was pissed, boy … Roman thought it had something to do with there being a lot of black magic and

witchcraft going on in England at the time."

Krzysztof Komeda was a Polish jazz musician who composed for a few dozen films, most from his native country. In 1962, he created the score for *Knife in the Water* (1962) and would go on to score two more films for Polanski–*Cul-De-Sac* (1966) and *The Fearless Vampire Killers* (1967)–before reteaming with the director for *Rosemary's Baby*. British union rules forced him to sit out Polanski's *Repulsion* (1965).

Polanski had admired Komeda's work since he was a student at Lodz Film School. "I already had my sights set on someone capable of providing *Two Men and a Wardrobe* (1958) with the right musical backing–something cool and offbeat enough to underline the absurdity of my characters' predicament–but was wary of asking him to work on something as insignificant as a student's apprentice piece," Polanski said. Komeda provided the music, and a friendship was born.

Nearly a decade later, Polanski asked him to compose the score for *Rosemary's Baby* and was shown a rough cut of the film. His answer was an enthusiastic "Yes." Apart from the general underscoring of the dramatic moments, Komeda–whose first name was Americanized as "Christopher" for the film's titles–created incidental television music for the scene where Hutch calls Rosemary as well as the pop song "Moment in Time," with lyrics by Hal Blair, that was heard in the background during Rosemary's party.

Perhaps the most memorable part of Komeda's work on the film was "Lullaby," an eerie, ethereal waltz heard over the opening and closing credits. Six singers auditioned to hum the tune, but it was Mia Farrow who impressed Polanski the most. "To my surprise and delight," he said, "she proved able to hum quite well, and there's no mistaking the owner of the voice that accompanies the opening credits." Farrow's version, titled "Lullaby from Rosemary's Baby," was released as a 45 single in August 1968. Claudine Longet followed with her own version called "Sleep Safe and Warm," with lyrics to Komeda's melody by Larry Kusik and Eddie Snyder. Both singles failed to crack Billboard's Hot 100.

Roman Polanski and Otto Preminger.

The film's score was recorded in April 1968 at Samuel Goldwyn Studios, "Lullaby" was recorded in June at the Annex Recording Studio and, shortly thereafter, it was time to screen the film for Paramount's upper echelons.

It did not help matters that Charles Bluhdorn, who often fell asleep in screenings, was jet-lagged when he sat down to view *Rosemary's Baby* for the first time. Evans reportedly turned up the air conditioning in a futile attempt to keep the studio head from nodding off. When the lights came up, everyone was happy, save for Peter Bart's wife, who, rather bizarrely, stood up and

exclaimed, "I don't have to sit here and take this shit!" and left the screening room.

After all the tension, disagreements and out-an-out yelling between John Cassavetes and Roman Polanski during the shoot, the actor was quite pleased with the results. "I think it's a very good picture," said Cassavetes. "It's all been very well done, the photography and sets are magnificent. I guess there was a conflict of personalities. Polanski and I just don't like each other, but I think he's a fine director and I'd work for him anytime."

"When they finished the film, the front office, which was in New York at the time, didn't want to release it. They didn't know how to sell it," recalled producer Robert Evans. He turned to Young & Rubicam, an advertising firm headed by Steve Frankfurt, the creative mastermind behind the opening credits of *To Kill A Mockingbird* (1962) as well as a fair share of memorable television ads. In movie campaigns, he had a knack for bold, unexpected visuals and succinct, intriguing taglines—"Boy. Do we need it now." for *That's Entertainment!* (1974), "X was never like this." for *Emmanuelle* (1974), "In space no one can hear you scream." for *Alien* (1979).

But *Rosemary's Baby* was his breakthrough, with what is today considered one of the best movie posters of all time: A simple, layered effort featuring a supine Mia Farrow in profile and the silhouette of a baby carriage perched precariously on a craggy rock formation, with the words "Pray for Rosemary's Baby" underneath. "It made the picture," Evans said. "Without that ... people wouldn't know what it is—and they still didn't know, but they were intrigued."

Bob Willoughby used infra-red color film and defraction grating to create a distinct look for the rape sequence stills and sent those images along with a selection of others to *Look* magazine. They were all set to run when a change of art directors delayed the piece. William Hopkins, the new graphics guy, ostensibly eager to put his own stamp on the visuals, saw fit to run the images with a solid color overlay, to Willoughby's great disappointment. Paramount, nevertheless, was happy for the coverage, which included nutty captions like "Is the man she sees ... the Pope?" and "Is it only a nightmare that her husband turns into a bloodsucking Satan?"

In the spring of 1968, Paramount arranged a couple of sneak previews of *Rosemary's Baby* in Northern California. Polanski, Tate, O'Steen, Richard Sylbert and others flew up to Palo Alto to see the picture with what they expected to be an audience made up of mostly college students. Announced simply as a "Major Studio Preview," the film—for baffling reasons—became part of a double feature with a Disney movie, with children and their parents comprising most of the audience. The reaction was not good. "How dare you show this picture to my kid!" an angry father said to the theater manager. By the time the rape sequence came onscreen, most of the increasingly upset parents headed for the exits with offspring in tow.

Fortunes were reversed the following night in San Francisco—the movie was billed as being for "Adults Only" and audiences loved it. "Except Roman was nervous," O'Steen recalled. "He kept turning the volume higher and higher, and people were saying, 'Turn it down, turn it down!'"

In 1968, as the Production Code was fading away, Jack Valenti, the president of the Motion Picture Association of America, was figuring out a new way to advise the public of more adult content, all the while avoiding the stink of censorship. By November, the MPAA installed a ratings system that still stands—in heavily modified form—to this day: G for General Audiences, M for Mature Audiences (parental discretion advised), R for Restricted (persons under 16 not admitted unless accompanied by parent or adult guardian) and X (persons under 16 not admitted). But *Rosemary's Baby* had yet to be released, and instead bore the label "Suggested for Mature Audiences," MPAA's stopgap designation before their ratings system was finalized.

It was late spring, and William Castle's baby—and Robert Evans's, and Roman Polanski's, and Mia Farrow's—was ready to be born.

JUNE 12, 1968

Rosemary's Baby went before the cameras just as the Summer of Love–a hippie heyday where flower children of all varieties turned on, tuned in and dropped out–was slipping into autumn.

The movie was released within a far more tumultuous year, one that began with the Tet Offensive in Vietnam and was later punctuated by increasingly frequent and fervent anti-war protests (the riots surrounding the Democratic National Convention in Chicago being an exceptionally violent example). In Mexico City, American athletes Tommie Smith and John Carlos raised their fists at an Olympic medal ceremony to protest racial discrimination. In April, Martin Luther King, Jr., was assassinated; in June, a similar fate befell Democratic presidential candidate Robert F. Kennedy.

"Innocence was lost," remarked Terry Castle. "And the horror films were never the same. From there you went into *Night of the Living Dead* where a girl is, you know, *eating* somebody. You used to drop your kids off at a double feature on a Saturday and they would see a horror film or a monster movie or something that was really fun. [*Rosemary's Baby*] just ushered in an age ... it was pivotal ... it was the year the world changed."

In the summer of 1968, a young man named Louis Fantasia returned home to Watertown, Massachusetts after finishing his freshman year at college in Washington, D.C. His high school girlfriend Debbie, attending college in Boston, had gone back to her home in Wellesley and lived there until autumn. Lou and Debbie had managed to stay together during that first year and, now that they were back in the Boston area, were going on a summer date. The movie they decided to see was *Rosemary's Baby*.

"She picked me up in her little red Volkswagen and we went into Boston to see the film," Louis recalled. "She had this backless summer dress on and, you know, I'm just this freshman from college and I have my arm around her and ... the minute the first scary moment in the film happens, she just leaps away and sits on the edge of her seat the whole time. I couldn't make a move the rest of the night."

"We were just as terrified as anybody," he said, "and then when the film was over, you had that sort of frisson, that nervousness and anxiety. Especially back then, there was none of this torture porn or anything–this was all pretty new filmmaking ... we were talking to all hours. And she got home very late–her mother had called my mother wanting to know where she was–and I got home even later. My folks were waiting up and it was just the romance disaster, all because of *Rosemary's Baby*."

Rosemary's Baby was released on June 12, 1968, the same day as *The Detective*, creating a box office war between Frank Sinatra and future ex-wife Farrow. "I arranged that," claims Robert Evans, whose producer fingerprints were all over both films. Screenings of Polanski's modern-day horror film were defined by long lines and enthusiastic audiences, aided in no small part by the book's bestseller status (it had sold 2.5 million copies before the film opened). "*The Detective* opened to real good box office," Evans recalled. "Ah, but *Rosemary's Baby* was the smash hit of the summer. Overnight, Mia was a full-fledged star."

Praise for *Rosemary's Baby* came from all quarters–mostly. Among the movie's detractors was Renata Adler of *The New York Times*, who lamented that "the movie–although it is

WILLIAM CASTLE ENTERPRISES

OFFICES AT
PARAMOUNT STUDIOS
5451 MARATHON STREET
HOLLYWOOD, CALIF. 90038

TELEPHONE (213) 469-2411

January 9, 1968

Mr. Roman Polanski
Paramount Pictures Corporation
5451 Marathon St.
Hollywood, California

Dear Roman:

It is difficult to put into words my appreciation for the
dedication and professionalism that you gave to "Rosemary's
Baby."

Your artistry and great technical skill, I took for granted.
But not your thoughtfulness and cooperation during production
of "Rosemary."

This is the first time that I have written a fan letter, and
especially to a director, but I would like to go on record in
saying that it has been one of the great privileges of my career
working with you. I feel we, in the industry here, have gained
in you, a great and unique talent.

My deepest thanks.

Cordially,

William Castle

William Castle

WC:k

pleasant—doesn't quite work on any of its dark or powerful terms ... for most of its length, the film has nothing to be excited about." Though she accused Ruth Gordon of overplaying, Adler was nothing but complimentary towards the lead actress, stating, "Miss Farrow is quite marvelous, pale, suffering, almost constantly on-screen in a difficult role that requires her to be learning for almost two hours what the audience has guessed from the start."

Kathleen Carroll of *The New York Daily News* also lauded the actress, noting that "Miss Farrow's special magic is her fragility. She reminds one of a fawn in captivity. What she does so remarkably well is draw sympathy to Rosemary who is herself a captive fawn, a totally helpless heroine surrounded by evil on all sides with no way out. Everyone in the audience will want desperately to help her."

Regarding her co-star, Robert Ebert of *The Chicago Sun-Times* wrote, "John Cassavetes is competent as Rosemary's husband but not as certain of his screen identity as he was in *The Dirty Dozen*." Legendary film critic Pauline Kael's positive review also took a gentle jab at the leading man, stating that "Polanski remains generally sympathetic to the Mia Farrow character, while enjoying the in-joke of casting John Cassavetes to play a ham actor."

"The best thing that can be said about the film," wrote Ebert, "is that it works. Polanski has taken a most difficult situation and made it believable, right up to the end. In this sense, he even outdoes Hitchcock ... Because Polanski exercises his craft so well, we follow him right up to the end and stand there, rocking that dreadful cradle."

According to Robert Evans, Mia Farrow wanted to take out a double-page ad in both *Variety* and *The Hollywood Reporter* comparing the box office results of runaway hit *Rosemary's Baby* to the merely respectable numbers of *The Detective*. It was a request that Evans could not grant.

"Everybody wanted to see it," said Hawk Koch. "You couldn't go to a dinner party, you couldn't go out to the drugstore. Everybody was taking about, 'Did you see *Rosemary's Baby*?'" At the height of public awareness, Mia Farrow and Ruth Gordon were enjoying a walk in Edgartown on Martha's Vineyard when Farrow had a suggestion: "Let's get a baby carriage, Ruthie, and you and I wheel it up South Water Street."

Long lines graced movie houses showing the horror film. "Bill Castle couldn't resist touring Westwood Village and feasting his producer's eyes on the crowd that wound its way around the block," said Polanski. "He used to stand and stare and add up the receipts in his head." Terry Castle mentioned one particularly sweet gesture by her father: "I do remember it playing in Westwood in that theater right below Wilshire—is it the Crest?—and it played forever. After the run ... my father went into the theater and gave a tip to every single person that worked there—the ushers, people serving popcorn—for the service that they gave the movie."

Many audience members left the theater convinced that they had actually seen the title character. "I subliminally cut the devil's face in, about four frames," said editor Sam O'Steen about how he was able to allude to a baby that was never shown. "I stole it from the nightmare scene, but a lot of people don't even see it." Said cinematographer William Fraker, "Roman is one of the greatest storytellers I've worked with, and he knew how to control and lead the audience—to make them squirm in their seats. And he used suggestion to do a lot of it."

Rosemary's Baby's true father, Ira Levin, was overjoyed, calling the film "the single most faithful adaptation of a novel ever to come out of Hollywood." Stephen King, in his book *Danse Macabre*, echoed those sentiments: "I used to be fond of telling people, at the time Roman Polanski's film version came out, that it was one of those rare cases where if you had read the book you didn't have to see the movie, and if you had seen

Above: Ira Levin's congratulatory notes to Mia Farrow and Roman Polanski. Opposite: Farrow's thank you note to Levin.

the movie, you didn't have to read the book. That is not really the truth (it never is), but Polanski's film version is remarkably true to Levin's novel, and both seem to share an ironic turn of humor. I don't believe anyone else could have made Levin's remarkable little novel quite so well."

Certain factions, however, did not want anyone to see the film, chief among them the National Catholic Office for Motion Pictures.

With its satanic theme, it was no surprise that *Rosemary's Baby* was condemned by the National Catholic Office for Motion Pictures, an organization that would sputter along for another year or more before losing relevancy altogether. Here were their reasons: "Because of several scenes of nudity, this contemporary horror story about devil worship would qualify for a condemned rating. Much more serious, however, is the perverted use which the film makes of fundamental Christian beliefs, especially in the events surrounding the birth of Christ, and its mockery of religious persons and practices. The very technical excellence of the film serves to intensify its defamatory nature."

"The movie of *Rosemary's Baby* attracted some of the hostility I had worried about while writing the book," said Levin. "A woman screamed 'Blasphemy!' in the lobby after the first New York preview, and I subsequently received scores of reprimanding letters from Catholic schoolgirls, all worded almost identically."

"I know that a good number of Catholics went to see it," said Polanski. "But the staunch Catholics railed against the film, especially in the South where the local censor banned it in lots of small towns, for example Salem—and that's meant to be a witches town!" The director received his share of angry mail, a typical example stating, "I haven't seen *Rosemary's Baby* and

don't want to see it, and I'm grateful to our town sheriff who has saved us from this muck."

William Castle received dozens of letters a day, many unsigned and most bristling with religion-based indignation. In *Step Right Up!: I'm Gonna Scare the Pants Off America*, Castle vividly recalled some of the more virulent messages:

Rosemary's Baby is filth and YOU will die as a result. Lover of Satan, Purveyor of Evil, you have sold your soul. Die. Die. Die.

Your immortal soul will forever burn in the pits of hell where you belong ... I am your mortal enemy and will see that you are destroyed. You have unleashed evil upon the world.

Bastard! Believer in Witchcraft. Worshiper at the Shrine of Satanism. My prediction is you will slowly rot during a long and painful illness which you have brought upon yourself.

"Even relatives stopped talking to him," daughter Terry Castle recalled.

Throughout his career, Charles Grodin found himself in the odd position of having to explain Dr. Hill's actions, or at least hearing people rant about them. To the actor playing him, Dr. Hill was the good guy, the flip side to evil obstetrician Dr. Sapirstein, played by Ralph Bellamy. The audience is relieved when Dr. Hill sits down with Rosemary, listens to her fears and offers her what she and the audience think is a safe haven. When Rosemary awakes, she is shocked to learn that Dr. Hill has called Guy and Dr. Sapirstein to come and take her home. For an audience of Rosemary sympathizers, it is a crushing moment.

"How could you do that?!" people asked Grodin. "She came to you for help and you betrayed her!"

"Hold on a minute," Grodin countered. "Her obstetrician is one of the top men in the field. I, as Dr. Hill, couldn't know this witch stuff was real. It's not like Dr. Hill was watching the

movie with the audience until his scene came up—then went in and betrayed her." But Grodin's explanation often failed to mollify his accusers.

The immediate popularity of *Rosemary's Baby* consequently put its star on a high perch. Mia Farrow became much in demand, finding herself being offered choice scripts, opportunities to work with the top directors and actors of the day, and lots and lots of money. The actress instead chose to go to India with her sister Prudence to meditate and otherwise seek enlightenment with the Maharishi Mahesh Yogi. "At 21," the actress reflected, "I had lost my husband, my anonymity, and my equilibrium, and it was peace I yearned for." After a few weeks, the Farrows were joined by no less than the Beatles, who brought music and paparazzi to the ashram, if not full devotion to reaching any higher spiritual plane.

By spring of 1968, Farrow was back in front of the cameras filming *Secret Ceremony*, an ominously titled psychological drama being shot in London with Elizabeth Taylor and Robert

Mitchum. It was filmed swiftly, edited and scored in a flash and released in theaters by November 1968, quite likely to capitalize on its young star's newfound popularity.

Rosemary's Baby also made Roman Polanski a hot commodity. Robert Evans was anxious to get him back behind the camera and the director himself was deluged with scripts, most of them psychological horror of a lesser kind that didn't interest him one bit. Socially, Polanski was having a grand time tasting all the fruit—parties in Bel-Air and Beverly Hills, hanging out with movie stars both exalted and on-the-rise and, in general, being one half of Hollywood's hippest couple.

Robert Evans showed his appreciation for *Rosemary's Baby*'s success by giving his Polish discovery what the director described as "the biggest, most luxurious office on the Paramount lot." William Castle in turn showed his appreciation by making Polanski an empty promise. "At a mutual friend's wedding reception," Polanski said, "he bore down on me with a glass of champagne in his huge fist. 'Ro,' he said euphorically, 'I'm giving you some points on the picture, and I want Paramount to match me.' It was the last I heard of this plan to cut me in on the profits."

Separate from all the Hollywood hoopla was a special fondness Polanski had for the Brian Aherne beach house he shared with Sharon Tate. Friends would drop by, Sharon would cook, Aherne's old phonograph records would be played on Aherne's old phonograph. Said Polanski, "To this day I can never hear one number—'Baby, It's Cold Outside'—without recalling the radiance of those California evenings, the peace and well-being I felt, the joy of living with Sharon, and the satisfaction that sprang from doing what I most wanted to do in the film capital of the world."

Ruth Gordon proved to be the darling of the awards season, though, overall, *Rosemary's Baby* was not exactly a magnet for glittering prizes. The Hollywood Foreign Press nominated it for four Golden Globe awards—Mia Farrow for Best Actress in a Drama, Ruth Gordon for Best Supporting Actress, Roman Polanski for Best Screenplay and Krzysztof Komeda for Best Original Score. Gordon was the sole winner, foreshadowing how things were to play out Oscar night.

Rosemary's Baby was nominated for just two Academy Awards—one for Polanski's screenplay, the other for Gordon's supporting performance. Gordon once again emerged the film's only award winner and was presented the Oscar by fellow *Rosemary's Baby* alumnus Tony Curtis. The first line of her acceptance speech has entered the annals of memorable Oscar moments, yet her entire oration is an exercise in charm and sincerity:

"I can't tell you how encouraging a thing like this is. The first film that I was ever in was in 1915, and here we are and it's 1969. Actually, I don't know why it took me so long, though I don't think, you know, that I'm *backward*. Anyway, thank you Bill, thank you Bob, thank you Roman and thank you Mia. And thank all of you who voted for me and, all of you who didn't, please excuse me."

John Cassavetes's presence at the Oscars had nothing to do with *Rosemary's Baby* and all to do with *Faces*, a drama he wrote and directed about a failed marriage and its aftermath starring Gena Rowlands and John Marley. It was a film Cassavetes edited at night while playing Guy Woodhouse during the day, and it earned nods for his original screenplay as well as supporting players Lynn Carlin and Seymour Cassel.

One of the oldest movie awards around—the Gold Medal (formerly the Medal of Honor)—was given out annually by *Photoplay*, one of the oldest movie fan magazines around. The first film to be honored was 1920's *Humoresque*, chosen then and throughout the years by the magazine's readers. For 1968, the Gold Medal was won by *Rosemary's Baby* and, as tradition dictated, awarded to the film's producer. Ruth Gordon accepted the prize for the ailing William Castle and would forever praise the producer's approach. "In a machine-made world," Gordon remarked, "he saw to it that *Rosemary's Baby* was a handmade picture."

"Ironically, all my life I had yearned for the applause, approval and recognition from my peers," Castle said, "and when the

awards were being passed out, I no longer cared. I was at home, very frightened of *Rosemary's Baby*, and still very ill."

One of the givens in life is that bad things happen in a ways that sometimes seem random and other times seem interconnected. It is in that spirit of bundled bad news that many people believed—or were drawn to—the notion that *Rosemary's Baby* was a cursed movie. Certainly the devilish nature of the story pushes the idea further, though friendlier fare like *The Wizard of Oz* (1939) was also perceived to be under some sort of evil spell. Curse is a strong word to throw around, yet there are those for whom the word is tragically apt. And for those who wish to connect those dots, their task is fairly easy.

Ill fortune came to Krzysztof Komeda in December 1968 as he and his friends, perhaps a bit under the influence, were walking through the Hollywood Hills. The composer fell, hit his head, was helped to his feet and accidentally dropped, hitting his head again. After a series of headaches and a visit to the doctor, Komeda fell into a coma, diagnosed with a blood clot in the brain. Later that month he underwent brain surgery at Cedars-Sinai hospital in Los Angeles.

Elsewhere in the hospital at that time was William Castle, who had serious health problems of his own. It all started as Castle was planning his next venture, producing the Neil Simon film *The Out-of-Towners*. He had attended a performance of the Simon play *Plaza Suite* at the Huntington Hartford Theater in Hollywood, feeling lousy going into the theater and barely being able to walk back to the car afterwards. On Halloween, he was on the phone with Neil Simon making arrangements to fly to New York to meet with him when he was hit with a sharp pain in his groin and waves of nausea and dizziness. Castle was found on the floor when his wife and daughters returned from trick-or-treating.

Uremic poisoning and kidney stones were the culprits; surgery was the solution. Said Castle of the experience, "Coming out of anesthesia, a patient's first question is usually, 'Will I live?' 'Is it cancer?' I had cried out, 'Rosemary, for God's sake, drop that knife!'" He was back home recovering when things got worse. "*Again*, the stoppage. *Again*, the hospital. *More* surgery, *more*

stones. They couldn't locate the one stone still inside of me—*the devil that was killing me.*"

As for Komeda, he never regained consciousness. His wife Zofia eventually had him transferred from Cedars-Sinai to a hospital in Warsaw where, on April 23, 1969, Komeda died at age 37.

"The story of *Rosemary's Baby* was happening in life," claimed Castle. "Witches, all of them, were casting their spell, and I was becoming one of the principal players." Wishing to avoid any more surgeries, the producer underwent a series of sodium bicarbonate injections in hopes of dissolving his remaining kidney stones, a long, arduous treatment that ultimately worked, though, as daughter Terry observed, "My dad never recovered after that. He was never well again."

"Ridiculous!" exclaimed Roman Polanski, who dismissed any notion of a curse. "If anything caused Bill Castle's illness, it was having too much success with the picture."

Tragedy was soon to visit the director's life in August 1969 when Sharon Tate and four others were gruesomely murdered at the couple's home in Benedict Canyon, just north of Beverly Hills. Charles Manson and his followers were found guilty, but not before attention turned toward Polanski and speculation about his Hollywood lifestyle. "The film was about witchcraft and then there was this unfortunate murder that wasn't solved for a long time," recalled Polanski. "So what do the media do when they run out of ideas? They speculate. They're awfully creative." To escape the press during this profoundly difficult time, the director holed up for several days in an office on the Paramount lot.

More than a decade later, the Dakota apartment building itself was the scene of a shocking murder as, on December 8, 1980, John Lennon was gunned down by Mark David Chapman in the building's entrance.

By the end of 1968, *Rosemary's Baby* was an undeniable hit, finishing No. 8 on the box office list between No. 7 *Oliver!* and No. 9 *The Planet of the Apes*. In the years to come, and as the decades unfolded, it would become a landmark.

LEGACY

I think it's a great movie. I don't think I've done another.

Success often breeds imitation, and *Rosemary's Baby* was not immune from its fair share of spoofs and sequels, with one brave gang of filmmakers attempting a full remake.

For pure parody, *Mad* magazine, prone to skewering the current cinema, gave their readers "Rosemia's Boo-boo," featuring a naked Frank Sinatra, Twiggy as Mia Farrow's nude stand-in, "Satan Place" on the tube and cameo by Alfred Hitchcock (showing up to learn what not to do in his own films).

More than 25 years later, the television comedy *Roseanne* used *Rosemary's Baby* as the theme for their 1996 Halloween episode called "Satan, Darling." An impressive number of references to the film were packed into just a few minutes: a Jackie Kennedy lookalike, tannis root, an amulet, raw chicken parts, witches, a Dr. Sapirstein type, Minnie and Roman Castevet types, anagrams, knife wielding, a secret opening through the back of a linen closet, a strange painting, and dialogue lifted nearly intact from the film's final scene. To top it off, two actors from *Rosemary's Baby*—Phil Leeds and Ernest Harada—took part in the burlesque.

Polanski himself noticed a spoof of a fleshier nature not long after the film became a hit. "In Los Angeles there's a cinema on Santa Monica Boulevard called The Paris," the director said, "and after *Rosemary's Baby*—which has the tagline, 'Pray for Rosemary's baby'—they played a film called *Rosemary's Beaver*. Their tagline was 'Pray for Rosemary's pussy.'"

What actually happened to Rosemary's baby after the film ended was fodder for a couple of sequels, the first with the pithy title *Look What's Happened to Rosemary's Baby*. Sam O'Steen, the original film's editor, directed the made-for-television movie, which aired on October 29, 1976 and starred Patty Duke as Rosemary, George Maharis as Guy, Ray Milland as Roman Castevet and familiar face Ruth Gordon as Minnie. Stephen McHattie played a grown-up Adrian defined by wobbly sense of self and absolutely no discipline when it came to representing the forces of evil. Reviews for screenwriter Anthony Wilson's rather purple conceit were largely negative.

In 1997, Ira Levin advanced his own notion of what happened to Adrian in his sequel *Son of Rosemary*. In Levin's plot, Adrian goes by Andy, his mother's name for him, and is raised by the Castevets. Rosemary awakens from a long coma and reunites with her son, who, she is happy to see, has largely rejected the coven's designs on him and tries instead to do some good in the world. A cataclysmic ending is followed by a coda that, to be charitable, did not sit well with many of Levin's reviewers. Or readers.

Another underwhelming descendant of a brilliant progenitor arrived in 2014 with the television remake of *Rosemary's Baby*, starring Zoe Saldana as the beleaguered mother-to-be. Like the original, the director, Agnieszka Holland, was a native of Poland. And, like the original, the main character was named Rosemary. Beyond that, Levin's tale, adapted by Scott Abbott and James Wong, took several flights of fancy, namely bringing the story up to the 21st century, setting it in Paris and punching it up with blood and guts.

Cinematic depictions of the devil date at least back to F.W. Murnau's *Faust* (1926). Entertainments as disparate as *The Devil and Daniel Webster* (1941), *Alias Nick Beal* (1949)—directed by Mia Farrow's father John—and *Damn Yankees* (1958) all added

Opposite: Orginal US theatrical poster for Rosemary's Baby.

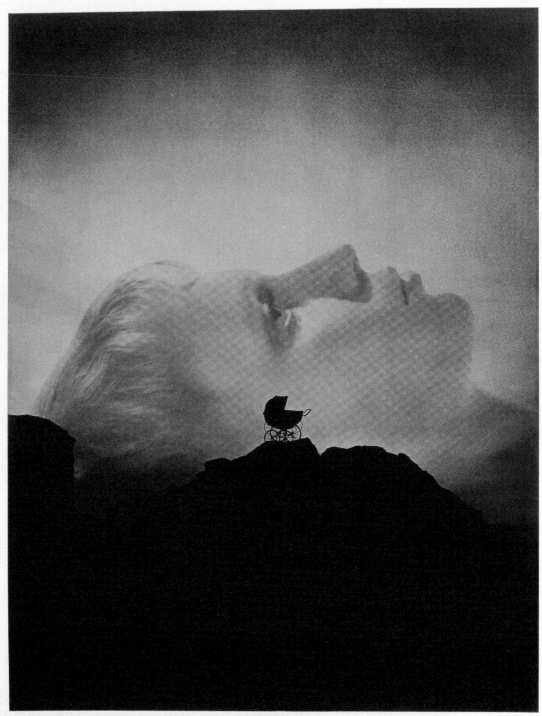

Paramount Pictures Presents

Mia Farrow
In a William Castle Production

**Rosemary's
Baby**

co-starring

John Cassavetes

Ruth Gordon / Sidney Blackmer / Maurice Evans / and Ralph Bellamy

Produced by William Castle / Written for the Screen and Directed by Roman Polanski / From the novel by Ira Levin

Technicolor® / Production Designer–Richard Sylbert / A Paramount Picture / Suggested for Mature Audiences

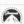

Beelzebub to its cast of characters. But Polanski's adaptation of Levin's subtle psychological horror story—set in present-day New York City and rife with sunny colors, dark humor and ordinary human beings—brought a modern rebirth to the subject matter and revitalized a genre that would go on to include the graphic shocks of *The Exorcist* (1973) and the outlandish grotesqueries of *The Omen* (1976).

"There's only ONE thing wrong with the Davis baby ..." ran the tagline for *It's Alive* (1974), a schlocky horror film whose title echoed a line delivered by Rosemary Woodhouse and, 37 years earlier, Dr. Frankenstein. It was one of many little bundles of satanic horror, most of them drive-in movie fare made on a shoestring. Their titles range from vivid to mysteriously ominous: *Mark of the Devil* (1970), *Brotherhood of Satan* (1971), *The Mephisto Waltz* (1971), *The Devil Within Her* (1975). "Two generations of youngsters have grown to adulthood watching depictions of Satan as a living reality," a wistful Ira Levin said of the phenomenon.

Over past decades, two terms from the pen of Ira Levin have entered the pop-culture lexicon. One is "Stepford," from the novel and film versions of *The Stepford Wives*, typically used to describe the more robotic, soulless, obedient and bland among us. The words "Rosemary's baby" are also tossed into casual conversation, often to intimate the origins of a particularly nasty individual. It is open for debate which term is more popular, and telling that they typically require no explanation.

Two films from 2017 reveal a different kinship. Director/writer Jordan Peele's sharply observed *Get Out* is a film one imagines would make Ira Levin proud. To say it is a spin on *Rosemary's Baby*, *The Stepford Wives* and—why not?—*Guess Who's Coming to Dinner* is to do a disservice to the director's fresh concept, yet it is easy to be reminded of those films as Peele's story progresses. At least where *Rosemary's Baby* is concerned, it was not by accident.

"Even before shooting began on *Get Out*, Jordan Peele told me of his love for *Rosemary's Baby*," said Michael Abels, who composed the score for the film.

And there are indeed a handful of allusions to Polanski's film in Peele's—the secret, sinister society, the lone Asian man at the garden party and even the name of Allison Williams's character, Rose.

"He said he found the main title especially creepy," Abels said. "That gave me great context to understand Jordan's love of scary vocal music. So if there is a common thread between *Get Out*'s 'Sikiliza Kwa Wahenga' and *Rosemary's Baby*'s main theme, it's that they both feature creepy voices that evoke spirits appropriate to their film's subject matter."

With a frenzied plot that keeps topping itself, Darren Aronofsky's *mother!* does not draw any neat parallels with Levin's work. It is, however, the marketing team's audacious co-opting of *Rosemary's Baby*'s famous movie poster that provides the strongest homage.

For many of the cast and crew, *Rosemary's Baby* was either a late-career milestone or an important beginning. In the former group were Ruth Gordon, Sidney Blackmer, Patsy Kelly, Maurice Evans, Ralph Bellamy and Elisha Cook, Jr.—all of them near the fall, if not the winter, of their decades-long careers.

"When I act in plays," Ruth Gordon observed, "some people speak to me. But since the Oscar for *Rosemary's Baby* ... everybody's a friend." The movie career that was rejuvenated with *Inside Daisy Clover* (1965) continued until her death in 1985, with *Harold and Maude* (1971) her biggest post-*Rosemary* effort. In 1979, Gordon won an Emmy for her performance on the television comedy *Taxi*.

For many of *Rosemary's Baby*'s older performers, retirement was simply not part of the equation. Patsy Kelly returned to the Broadway stage after a 39-year absence to appear in the musical *No, No, Nanette*, for which she won the 1971 Tony Award for Best Featured Actress in a Musical. She was nominated once again in the same category for the 1973 musical *Irene*. Sidney Blackmer made a handful of appearances on television and acted in a low-budget film called *Revenge Is My Destiny* (1971) before

his death in 1973. Maurice Evans continued his recurring part as Samantha's father on TV's *Bewitched* and reprised his role as Dr. Zaius in *Beneath the Planet of the Apes* (1970). One of the busiest actors of his generation was Ralph Bellamy, who followed *Rosemary's Baby* with performances in nearly 60 television and film productions, which included *Pretty Woman* (1990), his final film. Elisha Cook, Jr. had him beat, though, appearing in 66 different titles, the horror films *Blacula* (1972) and *Messiah of Evil* (1973) among them.

Shortly after his performance as Guy Woodhouse was in the can, John Cassavetes announced that he and his wife Gena Rowlands were off to New York to live because of the Los Angeles smog. "Besides," he said, "New York is more exciting for an actor." Of his director and chief opponent, Cassavetes conceded, "You can't dispute the fact that he's an artist, but yet you have to say *Rosemary's Baby* is not art."

Polanski's view of the actor was less generous. "He's not a filmmaker," the director said. "He's made some films, that's all. Anyone could take a camera and do what he did with *Shadows* ... It's more the people he surrounds himself with who actually make the films. When he became a filmmaker he got the chance to work within the studio system and showed he was completely incapable of doing so, whatever he might say about it being Hollywood's fault. I went to Hollywood and it worked okay for me. He's a very inconsistent actor and we had to clean up his performance a great deal in the editing."

As for cinematographer William Fraker, his next gig saw him clutching a camera while strapped to the front of a speeding Mustang as the car maneuvered the hills of San Francisco. The film was *Bullitt* (1968); the scene was the famous car chase where a couple of hit men pursue Steve McQueen. Fraker would

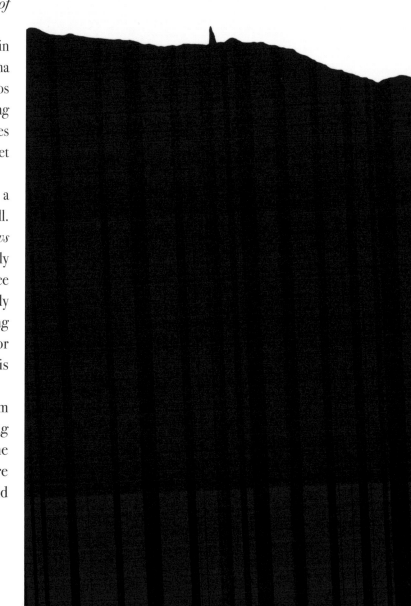

lens dozens of films up until 2002 and receive seven Oscar nominations in the process.

Editor Sam O'Steen gave directing a shot, lensing six television movies, including *Queen of the Stardust Ballroom* (1975) and the aforementioned *Look What's Happened to Rosemary's Baby* (1976), as well as two feature films. Production designer Richard Sylbert brought his talent and keen eye to a total of 44 feature films, earned six Oscar nominations, won for *Who's Afraid of Virginia Woolf?* (1966) and *Dick Tracy* (1990) and was a frequent collaborator with Mike Nichols, Warren Beatty and Robert Evans. Costume designer Anthea Sylbert created wardrobes for more than 20 films before becoming a film producer in the 1980s and '90s.

All three of them—O'Steen, Sylbert and Sylbert—were reunited for *Chinatown* (1974), Roman Polanski's noir mystery written by Robert Towne and produced by Robert Evans. Also on hand was the dialogue coach for *Rosemary's Baby*, Hawk Koch, now working as assistant director. "The one person Bob Evans and I missed sorely was Krzysztof Komeda," O'Steen said. "Roman and I never argued during *Rosemary's Baby*," remembered Anthea Sylbert. "In fact we have had only one disagreement, and that was on *Chinatown* when I didn't want Faye Dunaway to wear red nail polish. He won."

Decades after the release of *Rosemary's Baby*, scandal visited two of its cast members. One was Victoria Vetri, aka Angela Dorian, who was making headway as an actress with dozens of small parts on a variety of television shows. She made a strong impression in the pages of *Playboy*, becoming Playmate of the Month for September 1967, and, eventually, Playmate of 1968. Hers was reportedly one of the more popular centerfolds among Vietnam War soldiers. She held her own opposite Mia Farrow in *Rosemary's Baby* and would go on to more scantily clad fare like *When Dinosaurs Ruled the Earth* (1970) and *Invasion of the Bee Girls* (1973) before the acting jobs became less and less frequent. In 2010, an argument with husband Bruce Rathgeb escalated, a gun was drawn, shots were fired, and Vetri was found guilty of attempted voluntary manslaughter. She was sentenced to nine years in a women's correctional facility. Her husband survived; their marriage did not.

Notoriety of a different sort surrounded one Michel Gomez, a bit player appearing as a guest at Rosemary's party. Clad in a white turtleneck sweater, his entire performance consists of a wordless reaction shot that lasts two to three seconds at most. The Venezuelan native came to Hollywood to make it big, conducted a few acting workshops, claimed to be a casting director and agent, became a hypnotherapist and appeared in gay porn films. When his acting career stalled, Gomez formed Buddhafield, a gathering of young people seeking spiritual enlightenment, with Gomez—who would change his name to Andreas, then Reyji—as their leader. His followers were mostly white, mostly young and attractive, and all completely devoted to their leader, who was often clad in little more than a Speedo bathing suit.

He demanded that his disciples live a life of celibacy, while, allegedly, he secretly and sexually assaulted his male followers. As word of his abusive methods got out, he would move the group from California to Texas to Hawaii, a journey chronicled in Will Allen's engrossing documentary *Holy Hell* (2016). "He'd use his hypnosis, his spiritual understanding and his acting methods and they all kind of merged into this way of coming to God," said one of his followers. "He was an actor," said another, "and I assumed probably a good one ... until I saw some of his acting."

Set photographer Bob Willoughby went on to shoot for 20 more productions before retiring in 1986. "Looking back after all this time, I really think it was one of the most enjoyable films to work on in that period, in spite of the

subject matter," said Willoughby of *Rosemary's Baby*. "It was a small set, a good crew, we worked like one unit. The actors were relaxed (except for John, for that was not his nature), and I think everyone was somewhat sad when it was all over. And that's a rare feeling, I can assure you!"

With *Rosemary's Baby*, Robert Evans was just beginning to turn Paramount back into a profitable studio. By the time he left to pursue independent production, he had been involved with some of the biggest box office hits of the day—*Love Story* (1970), *The Godfather* (1972), *Chinatown* (1974) and *The Godfather Part II* (1974). Evans had the kind of life that would make for a good book or movie. And it did. His lively memoirs, *The Kid Stays in the Picture*, was published in 1994; the documentary of the same name was released in 2002. Though a series of strokes slowed him down in 1998, he never stopped working. As he says at the end of the film, "One thing I do know, I ain't dead, I ain't wealthy, I ain't destitute and I ain't retired. Can't afford any of 'em. Gotta keep standing. Stay in the picture."

After his debilitating illness, William Castle produced only a couple more films—*Shanks* (1974), starring Marcel Marceau in a macabre tale of a mute puppet master, and *Bug* (1975), about mutant cockroaches—and made cameo appearances in *The Day of the Locust* (1975) and *Shampoo* (1975). "Because he got sick, he lost the opportunity to produce *The Out-of-Towners*" Terry said, "so then he was relegated to doing these really horrible B films and he never kind of got his mojo back. And all he ever wanted to do was A films, because he's living in Hollywood and he's thought that's the way to be accepted. Little did he know his B films are revered and loved by so many. *Rosemary's Baby* was a great film ... it had the horror, but it didn't have the William Castle innocence that the other films did. And I think that innocence was something to be proud of."

In *Rosemary's Baby*, Mia Farrow appeared in every scene, carried the entire narrative on her shoulders, made a triumphant journey from television actor to movie star and worked steadily for decades following. She played Daisy Buchanan opposite Robert Redford's Jay Gatsby in 1974, made *A Wedding* for Robert Altman in 1978, and appeared in 13 films directed by Woody Allen (until, of course, their very public falling out over Allen's involvement with her adopted daughter Soon-Yi). And, in a faintly relevant bit of casting, Farrow played the sinister Mrs. Baylock in the 2006 remake of *The Omen*. She is a human rights activist devoted to a great number of charitable causes. She remained friends with Frank Sinatra until his death in 1998.

In a 2012 interview, Farrow looked back on the film that made her a star. "You know, you can't really judge anything you're in," she said, "but I was stunned by what Roman had done ... Yes it's a horror movie and maybe the theme isn't so serious, but I think it's a great movie. I don't think I've done another ... I know I didn't get another role as fine, that asked as much of me, and I know I've never worked with a director that was as precise with me ... It was the happiest work experience, the most fulfilling, that I ever had."

After the success of *Rosemary's Baby*, Polanski poured his time into *Downhill Racer*, the skiing drama Evans used to lure him onto the lot in the first place. A script was developed, logistics were sorted out for placing camera equipment on skis, and locations at European ski resorts were scouted, all for naught. "In the end, Paramount and I agreed to differ," the director said. "They wanted the picture made in the States; I wanted it all shot in the far more photogenic Alpine resorts." Instead, Michael Ritchie was tapped to direct the picture, which was to star the would-be Guy Woodhouse who Paramount sued for breach of contract—Robert Redford. "Hollywood feuds were short-lived, it seemed," remarked Polanski.

He went to Europe after the Manson murders and made

Macbeth (1971) followed by *Che?* (1972) before returning to Los Angeles to shoot *Chinatown* for Paramount. In a highly publicized 1978 trial, Polanski was convicted for statutory rape of a 13-year-old girl and left the United States to avoid prison. Career highs–along with *Knife in the Water* (1962), *Repulsion* (1965) and *Rosemary's Baby*–were *Chinatown* (1974), *Tess* (1979) and *The Pianist* (2002), the last of which earned him the Oscar for Best Director.

"I find that there are lots of things in my work I don't like anymore," Polanski said. "but this isn't the case with *Rosemary's Baby*, which I feel is told very fluently, and which I'm not embarrassed to watch today." And yet, he admits that the movie does not work on him the way it works on others. "I'd like to take some sort of drug that would let me forget all about this film, and then go and see it for the first time just as my friends have done. Then I'd experience a bit of the fear that other people have felt. Unfortunately, as I made the film and I don't believe in either God or in the Devil–which makes my case even worse–I'm doubly incapable of being frightened by my own creation, and that really bothers me."

Director Atom Egoyan called *Rosemary's Baby* "one of the most powerful and deeply affecting horror movies ever made, a shocking examination of a marriage, a pregnancy, and a morbid fear of both." *Gremlins* (1984) helmer Joe Dante praised its fidelity to Levin's novel, considering it "the single movie adaptation of a book that was done exactly as I'd envisioned it when I read it ... no other book-to-film production has ever come close."

For Ang Lee, the film was a forbidden commodity. "I never got to see *Rosemary's Baby* in Taiwan–movies like that were censored back then," the director said. "I had to wait until 1980, when I was a film student at NYU. I paid $2.50, the student rate, and sat through a Polanski double feature at the old Bleecker Street Cinema. I saw *The Tenant* (1976) first. It was the scariest movie I'd ever seen–and then came *Rosemary's Baby*. Talk about paranoia! I was totally freaked out by the end of the day. *Rosemary's Baby* is an absolute masterpiece. It terrorizes you honestly, from deep within rather than through external sensation. Polanski is such a master. He goes places that few others dare. His films are scary as hell, but also touching and, for me as a fellow 'tenant'–an outsider living and working in America–inspiring."

Ira Levin once asked, "If I hadn't pursued an idea for a suspense novel, would there be quite as many religious fundamentalists around today?" It was a hint of regret the author would express on more than one occasion about *Rosemary's Baby*, arguably the best known and most successful of his seven novels. "It played a significant part in all this popularization of the occult and belief in witchcraft and Satanism," Levin explained, "some of which seems to me such nonsense–I mean all these people who hear backward messages in song lyrics and stuff like that–and I really feel a certain degree of guilt about having fostered that kind of irrationality." The author added, "Of course, I didn't send back any of the royalty checks."

Motion pictures are, of course, a collaborative art, and the ways in which to screw it up are legion. A miscast actor, an intrusive score, hackneyed dialogue, poor lighting, sluggish direction–any of these could sink the ship, or at least make it list to port. When it all works, when everyone involved is at the top of their craft, it's a rare thrill, that profound difference between movies that achieve brilliance, ones that merely flirt with it, and those that miss it by a mile.

Rosemary's Baby is not just one of the best horror movies of all time, but one of the best *movies* of all time. And its brilliance lies in Ira Levin's seductive novel, Mia Farrow's exquisite performance, and Roman Polanski's instinctive understanding of those vital connections between audience and story that so many directors miss. *Rosemary's Baby* delicately and precisely sells the willing viewer a preposterous idea. If only for a moment, you believe it.

ACKNOWLEDGEMENTS

This book exists due to the varied and vital contributions of five key players—Andy Howick at MPTV Images, Tony Nourmand of Reel Art Press, author Cathy Whitlock, the estate of Ira Levin, and Christopher Willoughby, son of photographer Bob Willoughby.

Aiding my research considerably were the sharp minds of Steven Bingen, Ned Comstock, Louise Hilton, Justin Humphreys, Tim Lanza, Stan Rosenfield, Gary Rubin, Natasha Rubin, Dan Scheffey, Andrew Shearer and Faye Thompson.

Along the way I was privileged to hear candid recollections of *Rosemary's Baby* from the likes of Michael Abels, Rutanya Alda, Terry Castle, Joe Dante, Atom Egoyan, Louis Fantasia, Charles Grodin, Taylor Hackford, Ernest Harada, Jack Knight, Hawk Koch, Ang Lee, Craig Littler, Ken Luber, Bobbie O'Steen, George Robertson, Marianne Gordon Rogers, Anthea Sylbert and Sharmagne Sylbert. Their engaging observations are the book's lifeblood.

And finally, I received a generous amount of advice and good will from Rory Bruton, Tom DiRenzo, editor Alison Elangasinghe, Kathy Harmon-Luber, David Harrington, Abby Herget, Salvo Lavis, Scott Linn, Graham Marsh, Jane Munn, Andrew Pincus, Maile Pingel and Steve Vaught.

To all, a most sincere thank you.

BIBLIOGRAPHY

Adler, Renata, *Rosemary's Baby* movie review, *The New York Times*, June 13, 1968

Abele, Robert and Eames, John Douglas, *The Paramount Story*

Abels, Michael, Email, July 1, 2017

Alda, Rutanya, Facebook messages, July 2017

Alda, Rutanya, *The Mommie Dearest Diary: Carol Ann Tells All*

The American Film Institute, "Producing the Film" Seminar, February 17, 1976

American Society of Cinematographers

Austen, Davis, "Masks and Faces," John Cassavetes interview, *Films and Filming*, September 1968

Bettancourt, Scott, *Rosemary's Baby* soundtrack booklet

Boucher, Anthony, *Rosemary's Baby* book review, *The New York Times*

Carroll, Kathleen, "Rosemary's Baby is horribly frightening," *The New York Daily News*, June 13, 1968

Cassavetes, John, Letter to Ruth Gordon and Garson Kanin, February 5, 1969

Castle, Terry, Email, January 2, 2018

Castle, Terry, Interview, April 15, 2017

Castle, William, *Step Right Up!: I'm Gonna Scare the Pants off America*

cbsnews.com, "Former Playmate Victoria Rathgeb sentenced to 9 years for shooting her husband," September 8, 2011

Couri, Dr. Peter J., "Hope Summers: Rifles, Pickles & Rosemary's Baby," *The Peorian*, March 1, 2012

Cronin, Paul (ed.), *Roman Polanski Interviews*

Crowther, Bosley, *The Dirty Dozen* movie review, *The New York Times*, June 16, 1967

Curtis, Tony, *Tony Curtis: The Autobiography*

Dante, Joe, Email, July 31, 2017

The Dick Cavett Show, October 16-17, 1980

Evans, Maurice, *All This and Evans, Too*

Ebert, Roger, *Rosemary's Baby* movie review, *The Chicago Sun-Times*, July 29, 1968

Egoyan, Atom, Email, August 23, 2017

Evans, Robert, *The Kid Stays in the Picture*

Fantasia, Louis, Interview, September 15, 2017

Farrow, Mia, "Setting the Record (and the Hair) Straight," *The New York Times*, January 23, 2013

Farrow, Mia, *What Falls Away*

Fox, Margalit, "Ira Levin, of 'Rosemary's Baby,' Dies at 78," *The New York Times*, November 14, 2007

Fraker, William, "Things I've Learned: Cinematographer William Fraker's Eight Rules of Filmmaking," *MovieMaker*, Issue 56, 2004

Gardner, Sonny, interview with Ernest Harada, *Devil in the Details* blog

Gordon, Ruth, *An Open Book*

Gordon, Ruth, *Myself Among Others*

Greenberg, James, *Roman Polanski: A Retrospective*
Grodin, Charles, Email, April 4, 2017
Grodin, Charles, *How I Got to Be Whatever It Is I Am*
Grodin, Charles, *It Would Be So Nice If You Weren't Here*
Grodin, Charles, *We're Ready for You, Mr. Grodin*
Harada, Ernest, Interview, April 5, 2017
Highham, Charles, "Polanski: Rosemary's Baby and After," *The New York Times*, September 23, 1973
Hollywood Drama-Logue, "William Fraker: Cinematography, Murphy's Romance," March 20, 1986
The Hollywood Reporter, April 29, 1969
The Hollywood Reporter, "Time-Tested Talent," February 18, 2000
Holy Hell (2016)
IBDB
IMDb
Jordan, Joe and Page, Thomas, *Showmanship*
Kael, Pauline, *Rosemary's Baby* movie review, *The New Yorker*
Katharine Hepburn papers
Kaufman, Leslie, "Stephen Frankfurt, Artist on Madison Ave., Dies at 80," *The New York Times*, October 2, 2012
The Kid Stays in the Picture (2002)
King, Stephen, *Danse Macabre*
Knight, Jack, Interview, March 22, 2018
Koch, Hawk, Interview, May 2, 2017
Lee, Ang, Email, August 24, 2017
Levin, Ira, *Rosemary's Baby* Afterword, New American Library edition, 2003
Littler, Craig, Interview, March 16, 2017
Luber, Ken, Interview, March 14, 2017
LOOK Magazine, "Rosemary's Baby, From bestseller to movie chiller," June 25, 1968
Mad Magazine, January 1969, #124
Mandelbaum, Ken, *Not Since Carrie: Forty Years of Broadway Musical Flops*
Mia and Roman (1968), produced and directed by Hatami
Miller, Stephen, "Ira Levin, 78, Revived Horror in 'Rosemary's Baby,'" *New York Sun*, November 14, 2007
Mordden, Ethan, *Open a New Window: The Broadway Musical in the 1960s*
Motion Picture Association of America, Production Code Administration records
Musto, Michael, *Village Voice*, villagevoice.com, January 9, 2012
Nelson, Valerie J., "Bob Willoughby dies at 82: still photographer shot on movie sets," *The Los Angeles Times*, December 22, 2009
News from Cinema Center Films, 1970
O'Steen, Bobbie, Email, August 2017
Paramount Pictures Scripts Special Collection, Academy of Motion Picture

Arts & Sciences
Park, Ed, "It's Alive!" *Rosemary's Baby* DVD booklet, Criterion, 2012
Polanski, Roman, *Roman by Polanski*
Rausch, Andrew J., *Fifty Filmmakers: Conversations with Directors from Roger Avery to Steve Zaillian*
Remembering 'Rosemary's Baby' (2012) produced by Karen Stetler
Robertson, George R., Email, March 16, 2017
Rogers, Marianne Gordon, Interview, July 25, 2018
Roseanne, "Satan, Darling" episode, October 29, 1996
Rosemary's Baby call sheets, Paramount Pictures
Rosemary's Baby DVD booklet, "From the Notes of Ira Levin," Criterion, 2012
Rosemary's Baby final script, July 24, 1967
Rosemary's Baby "Location Movement to New York" document
Rosemary's Baby pressbook, Paramount Pictures
Rosemary's Baby production notes, Paramount Pictures
Rubin, Sam and Taylor, Richard, *Mia Farrow: Flower Child, Madonna, Muse*
Sandler, Suki, Interview with Ira Levin, March 12, 1992
Sanford, Christopher, *Polanski, A Biography*
Shearer, Andrew "Athens native Marianne Gordon Rogers looks back on her role in 'Rosemary's Baby,'" *Online Athens*, September 30, 2016
Spine Tingler! The William Castle Story (2007)
Sylbert, Anthea, Email, April 2017
Sylbert, Richard, *Designing Movies*
Thegze, Chuck, "Film Editor: Unsung Celebrity of Cutting Room," *The Los Angeles Times*, February 6, 1972
Vallance, Tom, "William A. Fraker: Celebrated cinematographer who shot Steve McQueen's famous car chase in 'Bullitt,'" *The Independent*, July 27, 2010
Vannicola, Joe, "An Interview with Playboy Playmate Victoria Vetri," *A Joe's Eye View* blog, infosack.blogspot.com
Variety, August 21, 1967
Variety, April 28, 1969
Variety, Sam O'Steen obituary, October 17, 2000
Visions of Light (1992)
Warga, Wayne, "Cinematographer Fraker Turns Director," *The Los Angeles Times*, September 14, 1969
Williams, David E., "William Fraker," *The Hollywood Reporter*, November 20, 2000
Willoughby, Bob, *Hollywood: A Journey Through the Stars*
Willoughby, Bob, *The Platinum Years*
Willoughby, Bob, *Rosemary's Baby*
Willoughby, Bob, *The Star Makers*

First published 2018 by Reel Art Press
an imprint of Rare Art Press Ltd, London, UK

www.reelartpress.com

First Edition
10 9 8 7 6 5 4 3 2 1

ISBN: 978-1-909526-58-7

Front cover and all photographs from p.65 to p.183 inclusive: © Bob Willoughby/mptvimages.com
All other images: mptvimages.com except p15: Paramount Pictures/Getty Images

Copyright © Main Text: James Munn
Copyright © Foreword Text: Taylor Hackford
Copyright © All text in format: Rare Art Press Ltd, 2018

Pre-Press by HR Digital Solutions

Printed by Graphius, Gent

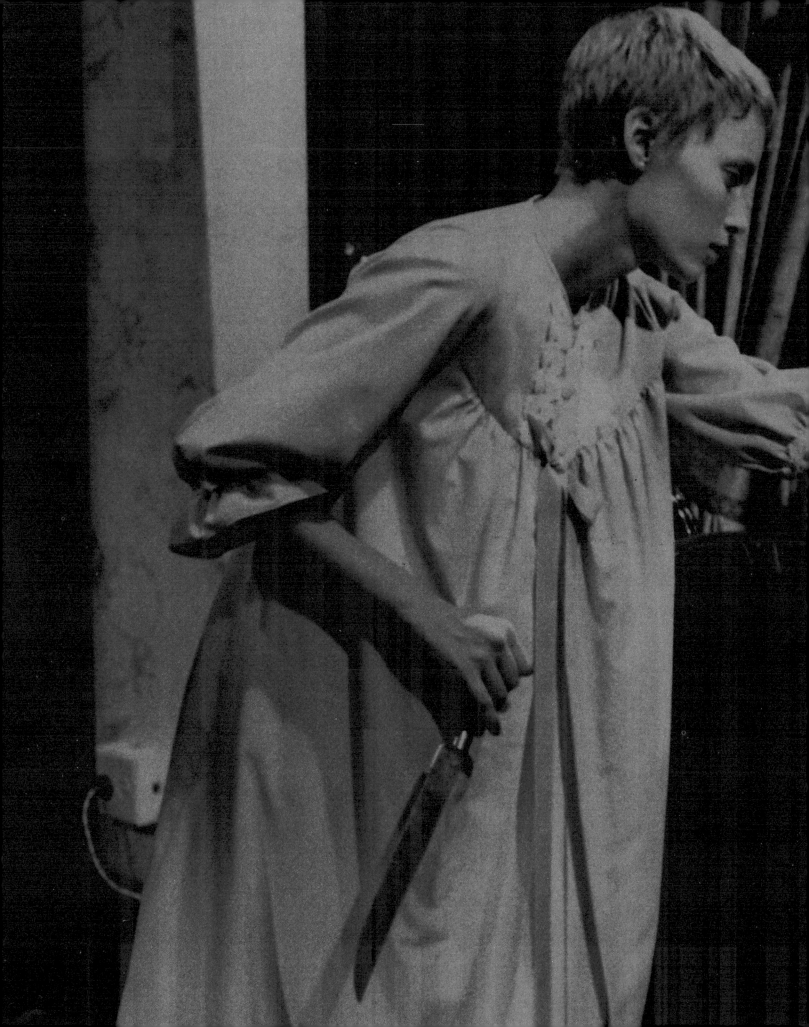